UK

Bernadette Kerr
31 Belsize Avenue
London
NW3 4BL
UK

Tanya Kovats
111 Shoreditch High
Street
London
E1 6JS
UK

Atta Kwami
PO Box 101
College of Art
University of Science
& Technology
Kumasi
Ghana

Simon Lee
111 North Tenth Street
New York 11211
New York
USA

Miche Lewin
16 Wanborough Road
Oxford
OX2 6HZ
UK

David Lillington
The Church house
Wellclose Square
London
E1 8HY
UK

Robert Loder
Gasworks
155 Vauxhall Street
London
SE11 5RH
UK

Annie Lovejoy
98 Romney Avenue
Lockleaze
Bristol
BS7 9TJ
UK

Sebastian Lowsley

82 Cambridge
Gardens
London
W10 6HS
UK

Tom Lubbock
205 Camden Road
London
NW1 9AA
UK

John Maine
The Old school
East Knoyle
Salisbury
Wiltshire
UK

Andrew Malone
118 Preston Street
Faversham
Kent
ME1 38NZ
UK

Sophie Mason
39 a Tackleway
Hastings
TN34 3BU
UK

Michelle McQuinn
173 Cornwall Road
London
N15 5AX
UK

Margery Mellman
2225 Sixth Avenue
New York 10014
New York
USA

Tim Millar
17 Davey Street
Bristol
BS2 9LE
UK

Andy Monks
47 Crowndale Court
Crowndale Road
London
NW1 OPB
UK

241 Plashett Grove
East Ham
London
UK

Martina Muller
Paschold Frauenplan
899423 Weimar
Germany

Joseph Muzondo
553/9 Chaminuka
Street
PO Chikato
Massvingo
Zimbabwe

Jules Mylius
Red Cow
Larnaca Works
Grange Walk
London
SE1 3AG
UK

Carlos Navarrete
Casilla 3395
Santiago
Chile

Anthea Nicholson
21 Cobourg Road
Montpelier
Bristol
BS6 5HT
UK

Tony Okpe
Department of Fine
Arts Ahmadu Bello
University
Zaria 75013
Nigeria

Annabel Parmenter
Flat 1
10 Cleveland Place
Bath
BA1 5DG
UK

Lee Paterson
37 Store Street
no 311
London
WC1E 7BS
UK

Dominique Paul
1479 Rue Aylwin
Montreal
Quebec HIW 3B6

D1574952

RM16 3BX
UK

Maziar Raein
Flat 3
38 Chester Way
London
SE11 4UR
UK

Koka Ramishvili
Dimitri Uznadze str.
2/63 380002 Tbilisi
Republic of Georgia

Sue Rees
POBox 126
North Bennington
Vermont
05257
USA

Richard Reynolds
20a Ropery Street
London
E3 4QF
UK

Francoise Rod
Unit 1
25 Vyner Street
London
E2 9DG
UK

Mario Jorge
Rodrigues
R Das Manteigas
Casa Do Alpendre
Fountainhas
Santarem Portugal
2000

Luis Romero
P.O Box 62.280
Altamira

Venezuela

Gwendolyn Rc
39 Deloraine

Sawi
'remy

Kossciusszki
Poland

Margot Schm
Liegnitzerstr
10999 Berlin
Germany

Rowena Sedd
Shave Farm
South Brewha
Bruton
Somerset
BA10 OLG
UK

Marcus Senio
41 Oaklands C
London
W14
UK

Martha Sforn
Via Borgonuo
20121 Milano
Italy

Dominic Shep
28 Castle Stre
Brighton
East Sussex
UK

Yinka Shoniba
Battersea Art
Lavender Hill
London
SW11 5TF
UK

Louise Short
60B West Stre
St Philips
Bristol
BS2 OLB
UK

Occupational Hazard

Critical Writing on Recent British Art

Edited by

Duncan McCorquodale,

Naomi Siderfin

and Julian Stallabrass

Contents

Its 'point of origin' is commonly considered to be the series of 'DIY' shows mounted by young, at the time unknown, artists in disused warehouse spaces in London's Docklands. Shows such as *Freeze, Modern Medicine* and *Gambler* were mounted at a time when the London art scene was still as buoyant as anywhere else. The commercial sector was still in a fairly healthy state, British art history and theory were on the international cutting edge, making for a productive conjunction between theory and practice that existed within art education at such places as Goldsmiths, and within the pages of what was the liveliest and most informative art magazine of the 1980s, *Artscribe International*. Also, the Saatchi Gallery had mounted what were the two most important and influential exhibitions of contemporary art to be held in Britain since the Tate's shows of American Abstract Expressionism in the late 1950s: the *New York, New Art* shows of 1987-88. The scene was well informed, and the level of debate was at an unprecedented highpoint; the success of the *Freeze* generation was an index of these conditions.

These 'DIY' shows were not an attempt at a 'Young Unknowns Gallery' agenda, however, but were a successful attempt on the part of well-connected, scene-sharp young artists to circumvent the conventional process of becoming a professional, exhibiting artist. But there was nothing really new about the work that emerged out of these shows, although many of the artists marketed at the time under the 'Goldsmiths' tag are still referred to as nBa's. For the most part, it consisted of cool and competent-looking derivatives of a generic, late post-modern period style that had its origins elsewhere. One variant consisted of re-rehearsals of the, by then, textbook strategies of 'Endgame' painting (Fiona Rae, Perry Roberts, Ian Davenport, Gary Hume's work at the time), another of Neo-Arte Povera poetics, or the 'arty' subjectivisation of once 'radical', problematic processes (Anya Gallacio, Cornelia Parker, Rachel Whiteread and many others), or the illustration of theory (Langlands & Bell and a few others). The work of its biggest star, Damien Hirst, consisted of a diluted variant of 1980s appropriation art, Anglicised and ontologised into aura-laden tableaux that dealt, not with the seriality or sign-value of the commodity, but with the timeless universals of the 'human condition'. The regressive, conservative nature of his art was masked, however, by the coolness and slickness of its presentation, and by his own self-promotion. In the latter, he was aided by his ambitious young dealer, and by an art scene eager to establish the profile of a new generation by providing

it with a figurehead. Hirst, however, quite rapidly ceased to be a point of reference for nBa's, and at the moment, it is questionable whether he any longer operates within the remit of contemporary art; he is rather a media phenomenon, and his single contribution to the new British art is to have been responsible for the revival of the knowing 'shock' tactic, and a now widespread infantile narcissism and a craving for attention of any variety.

The new British art proper emerged from a different context, and it is largely, and paradoxically, a product of the early 1990s recession and the hiatus that followed. Commercial galleries scaled down, relocated or closed altogether, *Artscribe* folded, and, gradually, it became apparent that an era was at a close. The career and financial expectations of artists were no longer the same as they had been in the 1980s, and artists began to adapt to a new set of circumstances. Created by the boom-and-bust climate of the 1980s were semi-redeveloped areas of London, full of unlet office, retail and warehouse space, and, initially in an attempt to replicate the success of the *Freeze* generation, artists began to mount similar DIY shows in these spaces. Around this, a new scene started to emerge, populated by the graduates of an art school system that overproduces more well-educated artists than any other city in Europe. This, and the fact that the recession hit the London art world harder and earlier than anywhere else, meant that this new scene was unique. This new context also forced into existence a new attitude to the art of the recent past. The lack of career opportunities, together with the kind of places and spaces within which art was being made and displayed, meant that 1980s-style professionalism and production values no longer seemed to apply. Gradually, 'museum art' seemed less relevant. The reason for this stems partly from the fact that the instrumental claims made for the art of the 1980s did not seem to stand up in this context either. Claiming to be undermining 'the scopic regimes of modernity' from within the confines of the pristine spaces of transnational postmodernism was one thing; reading the same claims on a press release of an exhibition by unknown artists in a disued shop-front in Shoreditch seemed slightly embarrassing. Considering such claims in the seminar room was a different matter to considering them while signing on in Brixton.

Furthermore, it became increasingly apparent that the critical strategies of postmodernism were in themselves less problematic than they once were. A particular kind of theory had become institutionalised in the 1980s, and, by the

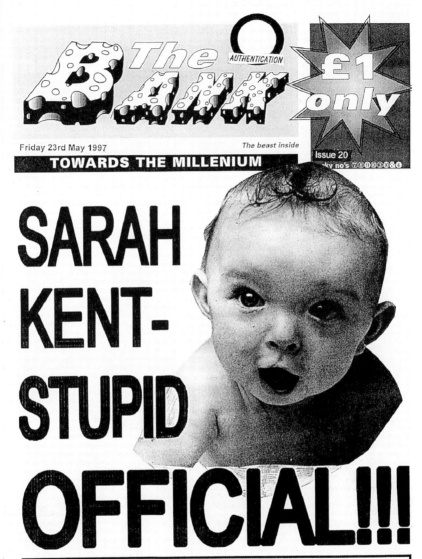

Friday 23rd May 1997

The beast inside

Issue 20

ky no's 789030&4

AUTHENTICATION

£1 only

TOWARDS THE MILLENIUM

SARAH KENT- STUPID OFFICIAL!!!

Sarah Kent - Time Out critic - was fuming yesterday when an official at a well known gallery behaved in a stupid manner.

FUMING
A close friend allegedly said "This stupid official really had Sarah's blood boiling.

I've never seen her so angry. She's such a perfectionist she doesn't tolerate fools gladly". (CONTINUED INSIDE)

Frontispiece: Pedro Romhanyi (director), Pulp, Babies *video, 1995*

Above: BANK, The BANK 23 May, *1997*

1990s, it had become too easy to read first-order 'critical content' off the surfaces of art. In other words, the relations between theory and practice had become too close, and it had become too easy to 'illustrate' theory; instrumentalism seemed self-certifying and formulaic. What was seen to be a 'crisis of representation' in the 1980s had now, perhaps, ceased to be a crisis, and there no longer seemed much point in continuing a formalistic critique of the sign. Work made 'on' representation was now, for most educated young artists, already 'in' art; certain theoretical issues had ceased to be issues, were taken as read and had become part of a fairly conventional way of making art. The refusal by many younger artists to brandish theory, to wear it on their sleeves, can, therefore, all too easily be misperceived as an anti-theoreticism. What all this meant for a younger generation of British artists was that they had to look beyond abstract theoreticism, and an alternative route was opened by another way in which this new context forced itself between theory and practice. This might be described as the experience, shared by many young artists, of a palpable sense of contradiction between the kinds of experiences, practices and pleasures that, if one were a critical, deconstructing postmodernist artist, one was supposed to keep an ironic, or otherwise, distance from, and those spaces and sensations that were constitutive of one's sense of identity. This was a contradiction that had become far more difficult to repress in this new situation.

Some of the best of the new British art comes out of this contradiction, and as such is not motivated by a counter-chauvinistic desire to revel in the 'profane' and the 'base', as many accounts would have it. What takes place in Sarah Lucas' work, for example, is a conscious and problematic return of the repressed dimensions of the local and the low. Hers is not a one-dimensional enunciation of invective as a counter to 'Art', but a quoting of other voices in a dialogic manner. There is thus a distance from the 'everyday' in her practice; she works, as she has stated, in the space between 'the ideal' and 'the actual'. She takes previous practices concerned with identity politics (that, unlike most of her peers, she has clearly engaged with) and 'tests' their claims against other contexts, while those other spaces, practices and experiences are brought within the orbit of art, along with all their attendant contradictions. It is not an 'oppositional' practice; she does not fall into the trap of privileging one voice over another, and the 'everyday' is not therefore taken as a given and thus affirmed. Her work, like that of Tracey Emin, while concerned with the intensities of base pleasures,

is at the same time concerned with an 'everyday' of degradation, decay and absurdity. As a consequence, such work possesses a particular 'grain' to its voice, retaining an edge, an awkwardness lacking in much of the nBa.

Not so long ago, there seemed grounds for optimism regarding the apparently 'carnivalesque' openness of the new scene in London. What predominates now, though, is a carnival of fetishised and mostly facile populist gestures, within which the repressed has returned in a quite different way. The vacuum created by the above hiatus has been filled by an anything-goes free-for-all, lacking any coherence or agenda other than careerist attention seeking. What looked like potentially significant gestures a few years ago, have become tediously ubiquitous ways of making modish 'wannabe' art. It is no longer big news to be told that you can be an artist and like Techno music; it is no longer a novelty to dance to it in shopping centres or play it in galleries and call it art. For established artists to say that memories of the film *Grease* are as important to them as those of the Falklands War might still be stunningly arrogant, but making work about one's investment in 'trivia' now amounts to little more than a one-dimensional gesture. That such work is still ubiquitous is largely the result of a paradigm shift, or rather, the disappearance of any coherent paradigms created by the contemporary crisis of criticism. Artists are no longer answerable to criticism; there is no longer a critical economy in London to speak of, and artists are above all part of a scene economy. Hence, a 'scene art' proliferates as a counterpart to a 'scene punditry' that passes for criticism.

This crisis in criticism could be anticipated when *Frieze* magazine began to assume the market-leading position of the defunct *Artscribe* in 1992. A change of agenda was apparent from the outset; flash production values seemed to take precedence over content, and there was a notable diminution in the level of debate. This escalated as the fashion cycle turned over and it became cool to say that theory was 'out'. For many, though, it had never really been 'in', and at the same time as the crisis in critical postmodernism manifested itself, there occurred an opportunistic marginalisation of 'Theory' or anything 'difficult' that might threaten to spoil what was turning into a very good party.

An upshot of this was a shift in power relations within the art world. When criticism had some power in the 1980s, perhaps more validatory power than it had had for over a quarter century, this meant that there was a displacement of power away from those who normally controlled the distribution of art. The

hiatus of the 1990s has, however, been rapidly exploited by a constituency who had no stake in the 'failed project' of critical postmodernism, and validatory power is now squarely back in the hands of those who hold the purse strings, and whose main interest is market liquidity. Business as usual has resumed. Validatory and promotional power is now also shared with that mutant phenomenon of the 1990s: the curator. These part would-be writers, part would-be artists, and total art-careerists have stepped in to fill the space vacated by the critical constituency of the 1980s, who have largely fled the art world and gone back to academe. Curators have also exploited the space created by a generation of artists who have largely disavowed their claims to authorship, who create a deliberately 'dumb' art that refuses to answer back, that can, therefore, be neatly slotted in to any 'theme' or group exhibition 'authored' by a 'big name' curator. Without any attendant critical discourse, however, the scene cannot really be much more than the curated spectacle that it is at the moment.

This spectacle is, nevertheless, enthusiastically devoured by the media across the board. The most significant factor behind this is clearly the fact that that art is a lot more streetwise, sexy and media-sharp than it has been before in Britain. A perhaps less obvious reason why the media, particularly the newer lifestyle and pop culture magazines, are interested in featuring 'Art' is that it makes them appear less trivial and superficial than they actually are. One of the effects of the media profile of the nBa phenomenon is that it can be packaged in such a way as to function as a convenient counterpart to the Britpop wave in music. In the current context of the touting of London as 'the coolest city on the planet' the popular spectacle of the nBa can then be made to provide the 'Swinging London of the Nineties' phenomenon with a form of high-cultural validation. The problematic implications this has for any claims regarding the 'cultural politics' of the nBa scene are obvious. Furthermore, another function of the hyped spectacle of 'success' is to completely elide the economic conditions within which art is currently produced in London. Many nBa's, including quite a few of its prominent figures, are still forced to live off state benefits. While London might be 'swinging' for a few people, it certainly is not for the majority of people involved in the art world.

Gavin Turk, Pop, *1993*

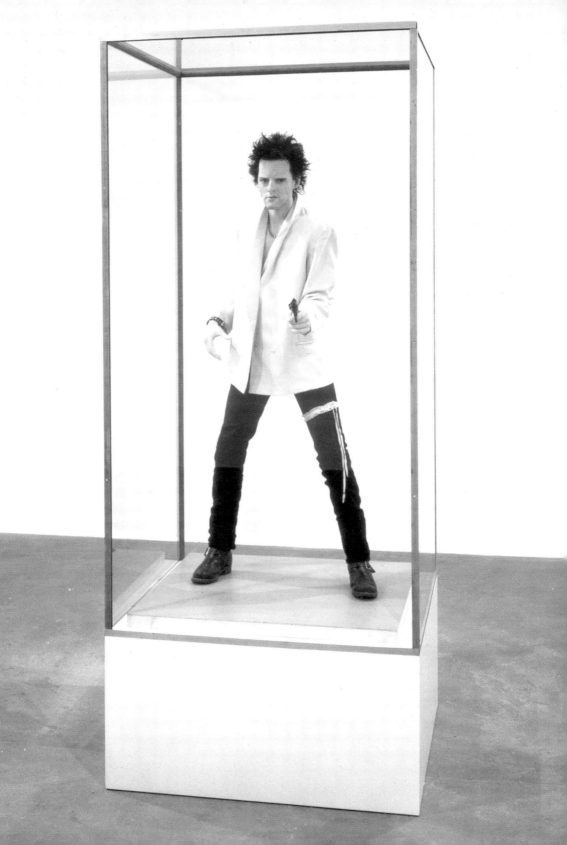

There has been a quantitative transformation in terms of the content of the commerce between art and popular culture, but there has been no substantive change in the form of the interface between high and low, and the 'Great Divide' is no closer to being bridged. Low culture profits from its commerce with art, while profits are at stake in the popularisation of art. Art institutions are keen to promote this exchange because it creates the impression that there is a wider audience for art than there actually is. What this broader audience is probably consuming, however, is the spectacle itself, and the populist element in the art that provides the kinds of pleasures and sensations available elsewhere in culture. How many more informed spectators the nBa has created is also questionable, considering the paucity of rigorous analyses of the phenomenon, and the general lowering of the level of debate around the scene.

Nevertheless, there is a substantial body of work being made in London that does attempt to sustain the momentum of post-conceptual practices by incorporating within itself a critique of criticism. Gavin Turk, in a work such as *Pop*, for instance, quite presciently anticipates a number of aspects of the popular reception of the nBa phenomenon. He anticipates the ways it would be caricatured as punkish, 'in-yer-face', 'Bad Boy' attitudinising, and implies that neo-Situationist shock tactics generate no more gravity than the title of the work. Others, such as Jake and Dinos Chapman, also parody *détournement* and the recent cults of 'abjection' and 'bodyism' in art, while Chris Offili parodies and refuses both the stereotypes of blackness and the cultural authority of the post-colonial critic. The group practice, BANK, have launched a relentless assault upon every aspect of the nBa scene. Their self-curated 'theme' shows have embraced all the predominant tropes of the 'Slacker' generation—'baseness', 'dumbness', 'banality' and 'profanity'—in such a way, however, that they are 'quoted' and thus sent-up rather than enacted. No reputation or pretension has been spared within the hilarious, faux-tabloidese pages of their art-zine *The BANK*, which tells a few home truths about the London art scene that you certainly won't read in the art press. This sharpness to the ways in which their activities are circumscribed means that such artists' work constitutes a practice, rather than simply amounting to a gesture. It is a practice conducted on the terrain of the popular, but one that retains a degree of reflexivity, an agenda of its own, and it does not, therefore, end up affirming what at any given moment passes for the popular.

It was inevitable that British art would align itself with British popular culture, once shifts in the class-profile of culture generally were eventually reflected in the art world, and once the demise of critical postmodernism meant that there was nowhere else left to go. The popular is now the backdrop against which art conducts its own self-definition. There is nothing wrong with art being popular, or of artists being opportunists, careerists or rampant hedonists, except for the fact that none of this can add up to a significant practice. However, the populist momentum within the nBa scene seems recently to have reached its nadir with the recent ICA exhibition *Assuming Positions*. Universally panned by critics, this exhibition purported to 'evoke a new romancing of pop and the promotional—so different from the critical knowingness of postmodernism [sic.]'. It consisted of an assortment of bits of designer furniture, a TV advertisement, a pop video and some art, assembled to demonstrate the 'increasing elasticity' of the boundaries between art and non-art; and it was certainly an exhibition that, a decade ago, anyone with any 'critical knowingness' would have thought twice about curating. However, this was an exhibition that was not intended to stand up to any critical scrutiny; it was not a serious attempt to look at the distinctions between high and low, but another disingenuous example of art aligning itself with the popular—one of the oldest and easiest moves in the book. It was clearly an instance of curators, like their many artist counterparts, trying to be hip, a promotional gesture, primarily directed at the media. But, people don't have to go to art galleries to see Jarvis Cocker or TV ads, and when art ceases to be popular, when Britpopism's novelty value inevitably wears off, its new audience will go back to consuming popular pleasures in the spaces in which they were intended to be consumed. Such populist gestures have a limited shelf life and this exhibition's reception indicates that a timely backlash is underway.

𝒜𝒹𝒹𝑒𝓃𝒹𝒶 〇 Ref. an imaginary curation of reality and its tapering corollaries, the curation of culture and thereon of the phenomenon of self-conscious culture that we call Art. The imaginary is an alternating current in space, it cuts across disciplinary borderlines, the action of its curation moving simultaneously in opposite directions.

−1 June 1958. The first issue of the *Internationale situationiste* shows an aerial photograph of the city of Paris with the caption 'New Theatres of Operation in Culture' above it. The operation is not a flight from reality but an engaged ground beating which appropriated the city for new unities of experience. Central to the 'New Theatres of Operation' is the Situationist *dérive* or pedestrian drift. The *dérive* was a departure from the nineteenth-century flâneur whose gaze was determined by visual projection, appropriation and distance; in contrast, the *dérive* chose blindness for an uncontrolled immediacy and *contact*. Through cutting up the map of Paris, now renamed *The Naked City*, the Situationists constructed a psycho-geography: a total reconstruction of the perception of contemporary reality through a pursuit of emotionally significant continuities, bypassing all imposed boundaries. The city was virtual, the subject material; a reconfiguration which made the *dérive* unrecoverable experience. It could not itself be a curatable subject for a prescribed framework.[1]

The *dérive* pre-empted the plane of representation by establishing itself in the preceding space: the plane of production. It made real the possibility of an individual recovery of space, a raw curation of reality on the blind side of the spectacle.

> The oldest social specialisation, the specialisation of power, is at the root
> of the spectacle. The spectacle is thus a specialised activity which speaks
> for all the others. It is the diplomatic representation of hierarchic society to
> itself, where all other expression is banned. There the most modern is also
> the most archaic.[2]

The spectacle was not simply an effect of mass dissemination of representation but a mediation of *all* social relationships. The Situationists called for a bombardment of the spectacle with impossible desires, counter-desires. A surge of counter-currents through which the subject could disinter the city and morph with social space: thus *The Naked City*. The social was to be stripped to allow a direct contact outside of the spectacle's configuration of space. 'Blindness' would make apparent the very forms of contact that the spectacle sought to disguise, to make real lines of contact beyond its reach; the naked city as an arena for impermissible connections.[3]

+2 In Hans Christian Anderson's fairy tale, *The Snow Queen*, the mirror which reflected the ugly features of everyone fell and splintered into millions of pieces, each so tiny that the eyes of those they entered never even noticed.

When the mirror disappears, its role doubles. It is both transcendent and immanent. So with the spectacle, integrated and interiorised to parallel the infinite complexities of consumer culture. The spectacle is fully habituated; it is the television left on all day in cramped, over-crowded

homes the world over, its dialogue mingling with those of the everyday, framing every conversation, filling gaps and silences. Just as it infiltrates the private, it also allows escape from the private.[4] Along its trace lines, isolated pools of desire merge and filter back to the centres of production. The interiorised spectacle never sleeps, it is a relentless process at work, reciprocating, reconstructing the external mirror, accommodating a counter-traffic, its filters sifting out the rough edges of opposition. A frictionless counter-flow necessary to the formation of the mythic: the reservoir of contemporary desire as a perceptual, flickering one-dimensional Dream Time.

−3 When the mirror disappears, so do the visible traces of resistance to its image. An oppositional ground has to be rebuilt on different conceptual planes. The resistance has to re-contextualise, re-configure with new symbols as in Deleuze and Guattari's body-without-organs: the body without organisation which breaks free from the old maps, from the structures of representation to roam on new maps—rhizomes. The rhizomes are planes without static points or positions, maps on which any point can be connected to any other; pure lines of connectivity.[5]

+4 As the spectacle enmeshes itself in what Lukács called second nature, its own representation splinters into representational clones in new spaces of virtual reality, psychedelia, robotics, automatons and bio-sciences. Cellular and mutating, it knits new web-lines, new networks between the interior and exterior which entangle in the spectacular net as aesthetic shorthand: Cyberculture, Virtual Reality. In the process, violating paradigms begin to articulate. For instance, Simcult—*culture* of the *sim*ulacrum.

Simcult seems to be hopelessly anti-intellectual. But what appears to be anti-intellectualism is actually a call for alternative intellectual practices... On the assembly line of knowledge, the intellectual produces print, which, in turn, produces the intellectual. Networking unravels these cycles of production and reproduction to create new intellectual instrumentalities.[6]

With Simcult, the communicative subtexts of discourse, gesture, posture, intonation—in short, Style—acquire parity in the formation of critical discourse. 'Media philosophy is philosophy for children.... Ours is the age of post-literacy'.[7]

HE THAT IS GREATEST AMONG
YOU SHALL BE YOUR SERVANT

ST MATTHEW XXIII·11

Occupational Hazard

Naomi Siderfin

In the early 1970s Richard Hamilton laid out ideas for an 'Alternative Income Tax' based on an economic logic that would encourage people to become artists and, in so doing, expect less from and give more to society.[1] Perhaps he assumed that the perceived benefits of living the life of an artist (flexible working hours, freedom of thought, spiritual gratification, license to be depressed, license to drink, doing what you want you want when you want to do it) outweighed the disadvantages (the necessary self-discipline, moral responsibility and frequent despair, the high incidence of alcoholism—and sustained poverty).

Twenty years on, by accident or design, Hamilton's vision has achieved a certain odd realisation. To contemplate the sheer number of practising artists in Britain is sobering. The cumulative effect of recruiting increasing numbers of art students since the 1960s has meant that in the 1990s all those stating their occupation as 'artist' represent the successes and casualties of thirty-odd years of art school production. Yet it could be argued that the professional obstacle race is so constructed that the majority expect more and give less.

Given the circumstances of artists, their sheer numbers are baffling. Apart from anything else, to officially admit to that occupation generally ensures a zero credit rating with banks, building societies, Hire Purchase agencies and the like. What is it that motivates so many people to live in penury for art? The pursuit of glamour might be a motivating force for a younger generation who have studied in the 1990s alongside the rise and rise of the new British art. 'Natural talent', coupled with a 'troubled soul', affecting large numbers of British youth, might be another (or the same) explanation. Wanting to make art is an important motive, of course, but moral pressure might come closer to the truth. For the thousands of individuals officially sanctioned (through education) as artists, the pressure to 'continue working' after art school is intense. There is an unwritten code, absorbed at college, which insinuates itself into the artist's psyche: it says that the art school graduate should continue to practice, whatever the odds, or risk exposure as a failure or, worse, as 'never really an Artist in the first place'. This romantic pressure results in low expectations on many levels and breeds a type of decadent puritanism. Even the most narcissistic of 'successful' artists seldom fail to emphasise the perspiration factor, and exhibit the trappings of achievement with a pride that not only reflects a belief in their own talent

Frontispiece: Ronnie Simpson, contribution to catalogue, Creative Curating MA course 1997

Above: Clare Tindall, Tête à Tête, *Nosepaint 1992*

but the self-righteous knowledge that they have worked hard enough to deserve recognition. However, the low levels of income on which artists (like intellectuals) are still prepared to survive and the extent to which, by so doing, they wittingly or unwittingly subsidise national culture, make Hamilton's ideas seem prophetic.

Every year, from institution to institution across the country, fine art departments prepare their final-year students for life after education. Preparation for professional doing, selling or teaching (and preferably all three), has more recently been supplemented by art schools offering their students the tools to survive in a cut-throat professional environment—PR and marketing skills, contacts and confidence. Even these pearls borrowed from the business world have limited use, since the international market for contemporary art, even when healthy, can only absorb a fraction of the practising artists in Britain. In addition, educational establishments are increasingly spending less money on teaching staff, and without this standby, the majority of fine art graduates (and post-graduates) in Britain are finally levelled by the Department of Social Security.

For the large numbers of students enrolled on art courses, conviction in their vocation is contradicted by the lack of official acknowledgement for the occupation in the world outside education. Once signed on for Income Support, contrary to popular belief, it is not easy to earn enough as an artist to sign off. In the course of negotiating the state benefits system, the 'unemployed' artist might be directed by their benefits office to examine a hard copy directory, entitled *Occupations*, to search for a more feasible

Left: Myles Stawman, Pecu, belt, *1997*

source of income. Any unemployed person with an inkling that an occupation known as 'artist' (fine) exists (because they have a degree or post-graduate qualification in the subject, or have been practising for several years or may just read the arts sections in the newspapers) may be shocked to find that this definitive guide to employment contains no confirmation that fine art is an occupation which relates to the world of work or to the economy as a whole. By the same token, whilst any number of applied arts are listed, the prospective fine artist will search in vain for a relevant entry under 'P' for painting, 'S' for sculpture, 'F' for fine—or even 'V' for visual. This exclusion implies that the contribution made by contemporary fine art to the national economy is negligible, and thus that the activity is irrelevant—a bias which is reflected in the distribution of publicly administered funds for art. A corresponding lack of respect for its practitioners follows within a society which only understands cultural production in terms of spectacle and stardom.

Establishing the culpability for educating so many people for such poor returns is difficult. To compensate for their exclusion from public life, large numbers of disenfranchised artists in Britain have exacted revenge by creating their own self-perpetuating, hermetic world patrolled by dealers, funders, critics and educationalists. To negotiate this world requires the special insider knowledge which comes from being there and doing it. And the effectiveness with which the sprawling network of the art world can be marshalled to collude with the interests of commerce, kudos and national self interest has recently been demonstrated by the way a few key dealers and critics have engineered a swing in attention to Britain as the centre of the international art world. However welcome this might be for British artists, it is open to question whether the effects are all positive. The way in which a small, core section of official art has been manipulated to sustain attention and fill coffers was neatly exemplified by a significant exhibition which carries with it both a sense of inevitability and a whiff of irony. *Sensation*, mounted at London's Royal Academy of Arts in September 1997, featured the acquisitions of the only major collector of contemporary art in Britain, whose dealing necessarily affects the whole market—Charles Saatchi. However, the fact that this show was merely a public airing of a private collection (in the same vein as, say, the Thyssen Bornemisza collection, also shown at the Royal Academy in 1990) was not highlighted. Instead, the marketing emphasis was more on the media

profile of the exhibitors as representatives of the current British art scene. *Sensation* was championed in a special souvenir pull-out section in the best-selling London listings magazine, *Time Out*, whose visual arts editor also happens to have written a series of catalogues and brochures for the collection under discussion. Because the magazine enjoys the largest circulation of its type, the journalism within its pages has exercised a very powerful influence over its readers' cultural sensibilities. Giving one exhibition such an exclusive profile ensured maximum public attention and, by extension, entrance fees which had special significance for the Royal Academy at a time when that bastion of the British cultural establishment was heavily in debt. It was safe to assume that the show would be a blockbuster since the British public was being presented with a bunch of stars to which it could relate, of which it could be proud, and by which it wanted to be shocked. These are the stars who people the myth of the new British art, now so thoroughly absorbed by every jobbing artist that the art world itself is in danger of believing the hype. Those artists exhibited in *Sensation* may have avoided the hazard of obscurity but, by occupying a prominent place within the market, will also face the pitfalls associated with the commercial and collecting circuit: a high profile does not always lead to enhanced creativity when the market is focused largely on signature style. It is unlikely that the public will have had any idea that, of the self-employed stars in this show, only a few make a decent living from their work.

Despite its rarefied status, there is very little money to be made from contemporary art—when compared to average income levels—at least, not for artists. Whilst the current phenomenon of new British art draws on fantasies about the enterprise culture fostered in the 1980s, the economic prerequisites of small businesses and the realities of negotiating the art world remain incompatible. Cash flow forecasts and balance sheets, either for a self-represented individual or for an artist-run organisation, can never make sense without some portion of income coming from patronage, be it state, commercial or private. The net effect of the international 1980s art boom on practitioners in Britain was a widespread, over-inflated optimism, an over-emphasis on professionalism and the effective devaluation of art works and artists, as art became equated with interior design. All of this was turned on its head when the bottom dropped out of the market in 1990. In response,

at the time when the seeds of the myth of the 'young British art' were being sown just prior to the recession, a number of alternatives to the now mythologised warehouse scene were being explored by various groups of artists graduating from many different institutions. These idealistic and independent activities played as crucial a part in laying the foundations for the energetic and inventive art scene that garnered international attention by the middle of the decade, as did the artfully nurtured personality artists who now serve as figureheads for the whole scene. *Sensation* represented the tip of a vast iceberg, its visible part buoyed above sea-level with cash.

Each week, a tidal wave of invitations to view exhibitions of artists' work hits every curatorial organisation or individual in the art business. Artists are showing work in every conceivable combination in every conceivable place. Whilst daunting, this is also a reflection of the positive examples of proactive practice set at the turn of the decade.

The artist-led initiatives of the late 1980s and early 1990s articulated the desire of artists for more direct control over their professional lives. Disillusioned with the idea of stock-piling canvases and objects, there emerged an interest in how artists could produce and exhibit without the mediation of bureaucrats, curators, dealers or gallery-owners. The drop in pressure to aspire to commercial success which accompanied the recession opened up other avenues for art makers, allowing them to experiment once more, after a decade focused on commodity art. There followed an eruption of activity which often broke with the highly aestheticised norms of art exhibition and, at the time, proved contentious. The 'alternative' scene was

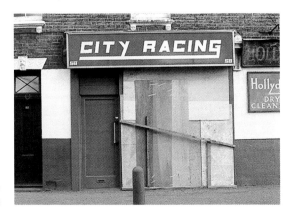

Right: Ridgeway/Bennett, RAM,
City Racing 1992

largely responsible for the swing away from the production of gallery-oriented work and towards the temporary and ephemeral, and contributed to the development of new audiences for contemporary art.

Widespread demonstration of professional skills began to dispel the stereotype of the disorganised, air-head artist, and the subsequent rise of the artist-as-curator has represented a new twist in the balance of power during the 1990s. Artist-curatorship is often dismissed as mere self-promotion and, indeed, in many cases has been just that. But beyond the idea of showing your own work within a group because nobody else will show it for you (the well-established City Racing, freely admit that this is where it all started for them), there are other, more political and theoretical reasons for artists taking control. One has been simply to make things happen in the absence of institutional support. The Infanta of Castile, active in the early 1990s and now the key personnel at the permanent exhibition space, accident, feel that the most important aspect of their work has been simply to enable artists to continue working: 'Our role has really been to bring things together—ideas, works, spaces, ways of looking or thinking. It has been a question of mediating and orchestrating—of bringing diverse elements into play with one-another'. Another objective (and outcome) has been to catalyse change. The artist Alastair MacLennan wrote in 1993, 'In the 1990s it is proving fruitful for artists to come together from diverse parts, to self-initiate programmes and develop models for working together, based on co-operation and sharing in a spirit of open camaraderie, rather than divisive, modernist competitiveness'.[2] Four years later, writing of the '*Sensation* generation', the critic Sarah Kent reminisced,

Left: accident, Collaborative Installation, *accident, 1997*

'Survival depended on mutual support. The artists shared studios, included one another in shows, attended each other's private views, had affairs and drank together.'[3] Perhaps the latter behaviour contributes towards the former vision.

Even so, the symbiotic relationship between the International Curator with the International Artist (and dealer) has been a crucial factor in consolidating institutional art power in the 1990s and ensures that the British art scene as a whole still operates far from the ideals expressed by MacLennan. Yet there have been specific attempts to address this problem. The dominant cult of the personality in recent British art has to some extent been undermined by collaborative artists' projects which open up possibilities for artists of all ages, types, levels of experience and size of reputation. These multi-faceted projects, unlike the much-hyped 'alternative' group shows, have more at stake than the list of artists included in them. As a result, they have not proved overly popular in terms of press coverage or theoretical debate—they are largely excluded from mainstream art criticism. Projects such as *Woodwork* or *Zombie Golf* were not just instances of 'issue-based' art but placed more emphasis on a broad agenda than on individual virtuosity.[4] The apparently suicidal tendency of such initiatives to erase the identity of their participants—either as artists or curators—may go some way to redress the prominence of the star syndrome, although it is clearly the case that group identities such as BANK, Beaconsfield and accident could be digested by the system as exhibiting artists in the way that Art & Language, Langlands and Bell and Critical Decor have been. However, the work of the more recent groups is often specifically related to the particular contexts they have created for it, and to the ambiguous nature of their function. Such identity games are not perhaps so easily assimilable, and the reason that such groups may not proceed far along the route to 'reputation' in this guise may be because self-promotion is not their primary aim, nor the source of their power.

The erasing of the art star becomes even more of a possibility with the 'new media'. As digital technology becomes more and more accessible, the potential of faceless exchange via global communication systems opens up endless speculation about the end of art as we know it—yet again—but maybe this time for real. Some artists are specifically facilitating debate in this area. Pauline van Mourik Broekman, of *Mute*, writes,

Though it would be hard to disagree with anyone placing the Internet within its proper historical context—as emerging from a Western, academic and military background—analogies between contemporary artistic interest in the Internet and previous technoid inspired art movements are also becoming convenient excuses for non-participation. In the UK the last ones interested in shaping, discussing or working with digital media and the Internet are the much fêted Brit pack or not-so-new generation of 'avant-garde' artists who, after all the lip service to pop culture and mass media, have resolutely adopted the 'wait and see' position.[5]

Many artists who facilitate the work of others are loathe to call their work 'curation', feeling that it is more an extension of their fine art practice. And this is the nub of it. The most significant 'artist-led' organisations have developed a practice as catalysts and so explore much subtler issues within contemporary art than those bland expressions of professionalism demonstrated by the ubiquitous group show with a catchy title. The development of strategies which not only 'exhibit' in the conventional sense but illuminate the nature of 'exhibition' and its relation to practice, often transcends the need for a curator. This has not stemmed the recent popularity of curating courses although there is a sense that the students of these courses wonder about their role as much as anyone. 'HE THAT IS THE GREATEST AMONG YOU SHALL BE YOUR SERVANT', reads one, ambiguous, graduating manifesto of 1997.[6] Escaping categorisation has its advantages along with its uncertainties in the unresolved dilemmas which characterise current modes of practice within the artist-curator equation. The traditional ideas about what is required of artists to retain their status still haunt them. How good a curator must you become to cease being an

Right: Silvia Ziranek,
A Deliberate Case of Particulars,
The Basement 1983

artist? At what point does escalating bureaucracy (forced on organisations particularly by state funding bodies) engulf any claim to continuing artistic practice? Is it really the same to mastermind projects for other artists as 'making your own work'?

Despite recent increases in audience levels at visual arts events and exhibitions, the Visual Arts department of the Arts Council of England continues to receive only two per cent of the total Treasury budget for the arts to distribute for exhibitions, publications and symposia.[7] At the same time, it is a well-aired concern that of this allocation only a small fraction will be distributed directly to artists (via curators and administrators) for the production of their work, while the bulk will be used for the exhibition and promotion of art as part of an increasingly significant leisure industry. It is the case at most exhibition spaces—there are a few honourable exceptions—in a sector where supply exceeds demand, that artists, gratified to have been invited to exhibit, pay in time and materials for the work to be made.

Establishing the credibility of the artist-as-curator within the art world has, however, had the healthy effect of disturbing the balance of administrative power within the sector. The reactive public funding bodies have had to scurry around rewriting funding criteria to accommodate the artist-led constituency. A small proportion of public funds has been redistributed directly to the practitioner sector, largely on a project-to-project basis. Where artist-led organisations have scaled the lower rungs of public project funding, a level of independent operation has been achieved. However, the allocation of public money has remained on a short-term basis and, without regular funding

Left: Anna Best,
Bring and Buy Sale, *Shave*, 1995

from somewhere, the initiatives which are now coming to maturity are doomed to run out of steam. The question has to be asked whether it is in institutional interests to support properly an agenda set from below, or whether it is more convenient, when budgets are so tight, to drip-feed—since artists are used to being poor anyhow. Short-term funding, arbitrarily switched from one programme to another, has had the effect of preventing consolidation and, when it is suddenly withdrawn, due to increasing competition from a growing sector of activists, the results can be devastating. Moreover, the habitual pattern of artists producing high quality work on very low budgets, whilst initially appearing to undermine overly bureaucratic institutions who quite often produce mediocre work on very high budgets, in reality, has created an under-class of artist-curators and administrators who continue to live on the bread-line while bolstering a lively contemporary scene and laying the foundations for future cultural growth.

Those foundations are more often laid in studios than exhibition venues and, redressing the balance, some artist-led activities are not primarily exhibition-oriented. The group Shave annually invite artists from different countries to debate and make work together in one place, over a limited period of time in a rural context. In placing artists and critics in a non-urban space 'issues raised have revolved around the question of a "universal" visual or artistic language, the relationship between artist and critic within and without the market, the responsibility of an artist in positioning their practice in their own society and in another, how the notion of "difference" can be embraced in the context of a multi-cultural art world and in terms of the individual'.[8] Rather than referring to a homogeneous visual language which can be comfortably exhibited in any First World context so long as it is curated by the right person or institution, such activities are significant because they open up communications between groups and individuals who do not necessarily subscribe to the concept of the 'international' in curators' parlance, and may be contributing to the establishment of long-term cultural links in post-Cold War, post-colonial Britain.

Transmission Gallery occupies a special position among British, venue-based artists' initiatives. Presumably started in desperation at the lack of contemporary exhibition spaces in Glasgow—whether commercial or institutional—Transmission is unique for its longevity and national profile.

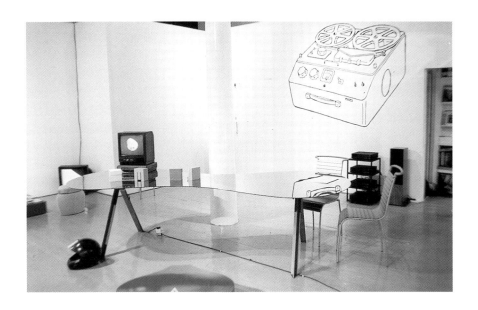

Above: New Rose Hotel, *Transmission*, 1995

The co-operative is notable, too, as one of the most transparent cases of drip-feeding by the state to enable artist-led organisations to continue indispensable work—on the cheap. Fifteen years on from its inception, the gallery is *still* the only credible space in Scotland for eclectic contemporary talent and fulfils an indispensable national function. The Scottish Arts Council maintains Transmission at minimal cost, and Transmission willingly continues to raise the profile of Scottish art abroad, shows international art in Glasgow, expands its own reputation and acts as a nursery for young talent to be hand-picked for greater things—all on a quasi-voluntary basis.

This is one example of the pitfalls associated with setting up structures for the exploration of new ideas. As an art space or organisation gains a reputation, the danger is that it closes its doors to risk to protect that reputation. Attentiveness is needed to avoid the inevitability of watching an artists' initiative become a sorting office for endless objects and individuals on their way up in the world. What then will be the next phase? Public funding is fickle, institutional recognition requires certain compromises, and going commercial requires a fairly serious degree of tarting. If these types of organised initiatives are to have more than a limited useful life, a firm agenda beyond that of being 'artist-run' is paramount. The term 'alternative' is already a cliché and it does not take long for the vanguard to become institutionalised—after all London's Institute of Contemporary Art was in part initiated by artists.[9] Groups with a shared identity are generally dependent on the vision of the founding artists and the test is whether that vision can transcend individuals. There comes a point when the artists who have founded,

Right: Sonia Boyce,
... they're almost like twins,
Beaconsfield, 1995

directed and curated entities which have become larger than themselves, must, and will, make decisions about how to negotiate the politics of the art production racket.

It would be hypocritical for anyone entangled in the art world to deny the importance of a lively contemporary art scene to the health of the national and international culture industry and, by extension, its importance to their own survival. However, in the current climate of art media stars, the single most significant occupational hazard for a living artist is lodged within the concept of Reputation. (It is no longer good enough to get one when you're dead.) Success, in many cases of late, has become synonymous with notoriety and is almost always related to personal profile. It is one thing for the disenfranchised artist to self-initiate his or her own route to the salesroom, but such success is tainted by the effect of its merely increasing the odds stacked against other artists less able at self-promotion. By the same token, it is also easy to dismiss the explosion of the 'artist-led' phenomenon in the 1990s as a fashionable fad and another form of self-serving. Given the numbers of practising artists, it is correct to read these trends as aspects of a practical self-help movement, but survival of the fittest no longer seems an appropriate philosophy—if it ever was.

These issues would not be such a problem if ideas about what constitutes 'success' were less rigid. Not all artists want their work to be too easily absorbed into mainstream culture, fearing that commodification may change content and shift meaning, even though absorption might superficially seem to represent access to the 'broad audience' required by all public funding bodies and desired by most artists. Negative comment about aspects of new British art can easily be dismissed as sour grapes but the rumblings of dissatisfaction about the current status quo are not only to do with the culture of exclusion perpetuated by an established art Mafia, but also with the uncritical stasis of the new art. That this situation has been allowed to develop at such a pace is as much the fault of the (now) carping critics, as of a slacker generation of artists who did not quite realise what was going on. The history of (contemporary) art, in the end, rests in its documentation. If it is not documented or talked about, it may as well not have happened. To subscribe to the claim that the 'alternative' has now, paradoxically, become the mainstream, is to ignore actual dissenting practice by not reporting it. Dissent makes the whole self-congratulatory business uncomfortable.

The accuracy with which history is written may depend upon whether the critical community choose to have a symbiotic or a parasitic relationship with the artistic community about whom they write: whether they continue to take a reactive stance, positioning themselves within the action only after it has happened or whether they begin to engage proactively with the making of art on a broad scale. The opportunities for critics to act as mediators between artists and their audiences offer a practice far more expansive than the indulgent commentary that so often passes for criticism. While the dangers associated with particular artistic trends having pet critics should be acknowledged, a shift in emphasis could have the potential of diffusing the competitive and ultimately negative climate in which artists currently make and exhibit art.

In a country where art is most often valued as interior design, asset management or a therapeutic teaching aid, it is difficult to articulate other values in a language that can be heard. This is a bleak landscape for the thousands of art graduates who continue to leave art schools. If, as many feel, tensions between different constituencies indicate that British art is on the cusp of change, it will be interesting to see from where the new generation takes its cue—whether it follows the tail of the 'young British art' comet (subscribing to the careerism which fuels those parts of the art world less concerned with engaging in art than bartering it) or whether it becomes active in reclaiming art practice for art's sake in a meaningful bid for self-determination. It would be good to think that the current boom will finally benefit not only its acknowledged engineers—the artists, dealers, educationalists and funders who have publicly colluded to manufacture a 'renaissance' in British Art—but also the unseen thousands who continue to practice, ingenious in their survival techniques and vitally underpinning the more obvious success stories.

Notes

1. See Lynda Morris, *EAST International*, exhibition catalogue, Norwich Gallery/Norwich School of Art and Design/Sainsbury Centre for Visual Arts, University of East Anglia, Norwich, 1997, p. 7.

2. Alastair MacLennan's communication to Nosepaint in 1993, confirming his participation in and support of the *Woodwork* project held in Vauxhall Spring Gardens.

3. 'It's a Sensation but is it Art?', *Time Out*, 10-17 September 1997.

4. *Woodwork*, Vauxhall Spring Gardens, London, May 1993, conceived and curated by Nosepaint; *Zombie Golf*, Burbage House, Shoreditch, London, May/June 1995, conceived and curated by BANK.

5. Pauline van Mourik Broekman is editor of *Mute: The Art and Technology Newspaper* published by Skyscraper Digital Publishing, London.

6. *Dispatch 1 in Creative Curating*, published by the Visual Arts Department, Goldsmiths College, University of London, 1997.

7) For detailed statistics, see the Arts Council of England's annual reports available from 14 Great Peter Street, London, SW1P 3NQ.

8. See Shave international artists' workshop, 6-12 August 1994, catalogue.
Recent catalogues available from Shave Farm, South Brewham, Bruton, Somerset, BA10 0LG.

9. The ICA was founded in 1947 as an alternative to the establishment by a mixed group of individuals involved with contemporary art as a result of widespread discussion amongst artists. Among its founders were Herbert Read (writer and critic), Roland Penrose (painter), Eric Gregory (editor of the *Burlington Magazine*) and Peter Watson (socialite).

44:45

Another Lovely Day

Matthew Arnatt

Of course I can say everything I want to about current art just by saying what interests me most about the shows (of younger contemporary artists) I see in London now: it would go something like, 'Because I try, and because it's possible, to see only shows I know I'm going to enjoy, it's a smoothish ride'. I don't think it makes much sense to think of having an interest in contemporary art that imposes issues on new art that the latter studiously avoids. So there's a kind of tension already—what is this book about? But, then, who lays down rules about how to be interested?

It's best to think of new art as a people thing. I want to do this because I just don't see any sense in which challenging the terrain, or whatever assumptions are in place, to mark-off new art as new art offers any kind of insight that hasn't already been written-off by practitioners of new art, the people who set the limits. It isn't that there are no goal posts to talk about: to find contemporary art interesting we have to share some assumptions about what is interesting, and the 'goal posts' are wandering about flashing nifty trainers and drinking sponsored beer—and being interested. If we see, harmlessly and blandly, contemporary art practice as a field circumscribed exclusively by each individual's sense of their orientation to other 'insiders', other people, the insight simply and most usefully acknowledges the *ordinariness* of art production. As far as how we feel about new art is concerned, thinking about the ordinariness of the motivation of, say, artists, counts for little beyond usefully bringing our expectations down to earth—if they weren't there already. Of course this is a line I'm feeding you. My big idea that shifting to consider art practice as just an effect of various independent practitioners attempting to best-guess the course of maximum professional return should not affect anyone's enjoyment of contemporary art. This is just a depressingly familiar description of how we find interest as well as utility in the familiar. We are, mostly, this realistic anyway.

There are already working in London a number of youngish people (a bit like the Monkees) who are content not to stress any idea of art beyond an acknowledgement, for what it's worth, of something like art's potential as entertainment. It's difficult to know what might be achieved by contrasting an idea as loose and inclusive as 'entertainment' with more traditional conceptions of art's (Art's) capacities for... seriousness. Perhaps it's enough to drop any excess seriousness—I think so. If this is the beginning of a shift in self-image,

then the shift has little explanatory power and probably underestimates the possibility for complexity and sophistication in our regular entertainments. Even *old people* have entertainments which they take very seriously.

So far so bad then. I'm either appearing to redescribe in depressingly familiar terms what might be nice if it were exotic, or, worse, I'm merely describing the depressingly familiar. What I really want to say is that winners in this slippery old/young world of satisfactions integrate an appreciation of what it takes to seem just to be having fun with the proper and serious business of advancing their careers. If this is done well, seamlessly, then it becomes difficult to track changes in rhetoric—which is what the claim to be 'just having fun' is. Further, nothing is lost or gained—barring records of, as it were, 'previous convictions'—if we just take such strategic claims (there's no obligation to resolve them as rhetoric) at face-value and as being the whole story. The whole thing is only painless and only works if you're interested, *really interested*. Like me trying to go to shows that I know I'm going to enjoy, the 'thing' works best with some co-operation. What could be less depressing? What kind of musty old belief are you going to drag out of the belief closet to contrast with this fluff? If your closet is as clean as mine, then the belief that it's another lovely day and a fine one for looking at shows will be enough. Why scratch where it doesn't itch?

Not thinking about 'art', just that long line of shows, or, I prefer, just thinking about shows (about which I remember saying 'I liked that') seems alright to me. On the whole, we are not under any obligation to explain our likes and our irritations. My guess is that it would be difficult to talk or write about why we do or don't like shows. If this seems banal, I'm sorry—I just want to emphasise the feeling I have that to fail at all, shows of contemporary art have to fail catastrophically. When we can simply say, 'I didn't like that', why should we, or what tempts us to, formalise or 'objectify' our dislike? Why should there be any kind of tension as a result of our simply not liking a show? Do we always think of things we don't enjoy as being failures?

I want to stress the only kind of sense that I can make of engaging in criticism of 'bad' shows: to move our relationship to shows to a level at which it becomes meaningful or interesting to criticise, our attention must rest on the mechanisms, the justifications, conventionally staged to support groupings of art-works. Our understanding of these justifications is discounted

to what we guess are their authors' (artist's, organiser's, curator's) strategic ends. If it weren't for exposed interpretative strategies, it wouldn't seem possible to find a place, a hook, on which to hang any kind of judgement. If there are shows out and about (those younger people again) that positively court only like/dislike responses, then this is in itself an interpretative strategy played out in relation to the standard dumbness of collections of art-objects, ideas or performances.

I don't think it's necessary to think of art, art-works or shows working in any *interesting* way. Because I see contemporary art shows as entertainment, sometimes feeble entertainment, my point is that I'm not obliged to qualify my value judgements. Neither am I tempted to posit critical self-awareness about the sources of my preferences—like most of my contemporaries, my beliefs and my enjoyments fuse uncritically in a 'good' show.

To here my motivation has been to familiarise a sense of the practice of contemporary art because I want to reach a point (with others, I think) where theorising 'contemporary art' at all appears consistent with having a *peculiar* interest in contemporary art. As a straight succession of pleasures, which might be what exhibitions should be, we are not under any obligation to link or fit those experiences of pleasure into a regulatory expression of what the experience, as a whole, of pleasure should amount to. I think our tolerance of contemporary art is linked to our sympathy to the goals of the people who do it. We enjoy contemporary art best when we understand the limits within which these people work, and when we set aside their (artists', organisers', theorists') claims to large consequence. I don't see anything missing. There is no loss if we stop using the term 'Art' as if, on it's own, it had any explanatory or regulatory force.

If there ought to be consequences from this shift in self-image, and if we stop worrying about something we shouldn't miss, then they would include dropping obscure and arcane confusions—ideas about ideas—relating to art's supposedly transcendental and noumenal capacities, to art's abilities to, er... redirect lives, etc.. Making and doing stuff now (the argument might go) for an intelligent and relatively knowing audience requires a degree of realism about possibilities and expectations that cuts both ways. Ideas that might count would be as distinctly 'effable' as, for instance, what it's possible to know of artists' relationships with galleries, who is in what shows, artists'

social backgrounds—the sort of stuff that dealers spew out—as well as your guess as to what Damien doesn't want you to know about his mother. Everything that ever counted or really touched artists, dealers, critics, audiences was never that mysterious anyway—at least no more mysterious than your life and not so mysterious that nobody stood to gain anything nice and tangible.

Who could possibly be offended by the pursuit of success? That's what people do, isn't it? The production of contemporary art is not without reasons.

If I've done anything to convince you that rhetorical shifts are genuinely useful, I should now be able to say that what this last shift disposed of was, anyway. just another shift. The ascription of values to 'Art' independent of our experience of, and capacities to verbalise, our experience of just art (shows and stuff) was, and still is, a serviceable idea cooked up by old-school Svengali types.

Organisers of contemporary art shows, 'curators' even, might be irritated by, or just have no use for, my denigration of the art-object or the art-idea as idea. To successfully devalue a promotional claim, there has to be some belief in circulation that the claim no longer works. It still is in a number of people's interest to claim that shows are consequential only and directly as a function of the display of qualities that attach to art-works. The belief that art-works are fundamentally interesting in themselves, is useful and lubricates all the standard mechanisms for doing business that constitute, as you know, the 'art-world'. Very few people can afford not to signal allegiance to such beliefs. Most people genuinely and warmly believe—what? That art-works have some essential life of their own? That art-works contain a sort of Platonic seed, always ripe and ready for radical self-reinterpretation? I ask you.

One further and useful consequence of relativising claims for the effectiveness of contemporary art shows to *what we can know of their success*—or failure—is that scaling down our expectations leaves more room *for* success. In this sense, it is no more facile to think of a show succeeding within the terms of a complex of possibilities directed at the extension of professional opportunity (knowable, or at least guessable) than it is naive to imagine that any type of show is 'just' a show in relation to Art's old-haunted-house capacities. Shows ghosted and transcended by luminous and creepy 'idea' ideas. The theoretical (theological) and ideological props that support shows are interesting in so far as they serve the interests of their authors. Interests

that we may track as a result of an amused familiarity with the motives of our contemporaries. The belief that there is an end to art independent of, and ideally distanced from, the immediacy of its own reception would be a delusion in respect of states that nobody has yet realised—at least, not so as not to fall at the first hurdle: the 'difficulty' of the public realisation of interiorised idealisations.

Finally, I hope that what I've been saying doesn't add up to too much more than an acknowledgement of one type of complicity between knowing producers of new art and a small, fickle, but informed audience—an audience after kicks. We can, of course, strain our ideas about what things should be about, but, when we are dealing with people we think we know, we tend to make allowances. It may not be a very interesting thing to say, that when I think about, for instance, dustbin men, I don't always want to be thinking about what their dustbin collecting *really* amounts to. As far as dustbin men are concerned, it seems reasonable to assume that what counts for them, as far as dustbin collecting is concerned, is that their employers recognise that they are collecting bins. If dustbin men in numbers started making competing claims for the value and necessity of the essential and timeless dustiness of their bins, it wouldn't be me who would fire them. I would just be interested. A bit.

Frontispiece: Helen Robertson, RCI/1995/Liverpool, 1995

Addenda −5 The faith is placed in the network as an agency for a transformation of consciousness. A transformation made possible purely through technology which carries the seeds of change; in ideologies, philosophies and the relations of production. The faith is a pre-emptive projection, an instrumentality that is itself a post-instrumentality. It materialises in common symptoms: a rash of institutionalised radicalism, ideologies of self-correction, habituated reflexes and internalised anarcho-fantasy projections. It is the space that capital creates, that discourse fills. In that order. At the level of practice, what it represents is the aesthetics of inevitability, the discourse of subsequence; a form of Balkanisation. We can only look on as reality takes its course. What unfolds is its own justification. The ambit of cultural production is so strategically defined by three activities: appropriate, represent and market. It is a coming home of Benjamin's saying that the only form of communication left to modern man is voyeurism.

The subject of voyeurism is the image of the existing state of desire. Media philosophy provides the place for this image, the place to watch the image developing, changing, growing, with its inclusions and exclusions, its structural bandwidth as a cultural genome. The image is that of a child being dragged through strange streets by a faceless stranger. Its fantasies and expectations are irrelevant to the hands that drag it.

+6 As the spectacle diffuses the oppositional ideologies of the 1960s by marketing the Pleasure Principle, in the age of accelerated mass traffic of bodies, it seeks a new face: the face of *difference*. Through an ironic adoption of Adorno and Habermas' concept of the *culture industry*, there appears a final solution to the question of difference. In a relativised field, only capital is ecumenical and through the global culture industry, anything and everything can be accommodated *and* represented. The global culture industry is a two-tiered operation—assimilation at the level of subjects to reveal a new exchange of consumers and producers. Beneath the perceptual plane is the relentless incorporation of difference into a common hierarchical relation of exchange.

A vast strategy of simultaneous extension and containment, electronic outreach and electronic fencing, global linking and global de-linking in which the *Massen-Individualverkehr* (the mass traffic of individual bodies) is merely contingent. The movement that matters is the mechanised flow of desire linked to the marketable through the networks of exchange. The flow is atomised, dependent solely on the network without which it would dam up.

The invisible architecture of the networks, like that of all meaning systems, is labyrinthine: the perfect arrangement for propulsion of manufactured desire, its uncontrolled proliferation. The labyrinth is a super-processor, a refinery for converting stray emotion, disconnected desire into marketable patterns of circulation and communication. Its passageways promote endless protraction, acceleration, deferral and diffusion: what lies at the centre is usually either deadly, or more probably simply vacuous.[8]

52:53

Pop Art, the Popular and British Art of the 1990s

John Roberts

Since the 1960s in Britain, the troubled relationship between art and popular culture has been a recurring source of self-doubt, hyperbole and fantasy for artists and critics alike. With this the new art in Britain marks out yet another set of self-conscious moves around the 'popular' and the 'everyday'. Yet the intellectual and aesthetic continuity of the debate on popular culture is something that is rarely discussed in detail. Why has Britain become the principal location for the high culture/ popular culture debate in the way France was from 1860-1900, the Soviet Union and Germany from 1917-30, and the USA from 1940-65? What are the ideological differences and continuities that form this legacy? As such, what is at stake in the new art? Does it ground fundamental changes in the culture of art put in train by the critique of modernism since the late 1960s, or is it a localised reiteration of long played-out moves of 'back to the popular' that have characterised crisis periods of modernism itself? Below I want to examine the debates around the 'popular' that have defined some of the most interesting art in Britain over the last thirty years. In this we can discern how the 'popular' and the 'everyday' have come to function as markers of value.

In the 1960s, the signs and stereotypes of a modern post-war Englishness entered art in Britain with self-confidence. The vision of a newly commodified England, brash, 'sexually liberated', culturally polymorphous, secured the ambitions of many artists intent on 'seeing-off' the non-vernacular internationalism of an ascendant American modernism and the remnants of an earnest, regional 1930s British figuration. The new and expanding industries and their advertisers (white goods, car manufacture), the rise of quality British pop music, the libidinal spread of style and fashion through the new illustrated magazines and on television, divested a generation of their perceived cultural inferiority. The intensities of post-war urban American experience may have dominated the imaginary horizon of artists, writers and film-makers, but the modern English, metropolitan experience (predominantly London-based) could now take its place next to the seductions of Americana.

The widespread appropriation of the signs and emblems of this new commercial English culture within Pop Art was thus inseparable from considerations of what constituted an English national tradition in art. English Pop Art brought to an abrupt end the comfortable and accumulated sense of Englishness in art that was either attached to the landscape (as a symbolic escape from

Frontispiece: Spice Girl Doll, TV still, 1997

Above: Peter Blake, Illustration to the cover of Face Dances (*detail*), *1981*

alienation or sign of patriotic longing) or the urban vernacular milieu (as a sign of the constraints of class and industrialisation). Englishness in art was invariably constructed out of these polarisations, presenting the 'everyday' as something ground down by the history of Britain as the first industrialising nation. Every rural landscape and seascape from the 1840s carried with it the promise of nature's 'freedoms', just as every brown, murky interior and industrialised subject consigned the everyday down to the brute facticity of material reality.

My polarisation is no doubt crude, but it brings into sharp focus how culturally disruptive Pop Art in Britain actually was in relation to the construction and reproduction of English national observances in art. Even the modernism of the 1950s seemed in keeping with the older forms of cultural allegiance, with its emphasis on the landscape as utopian sign or Gothic threat, or its post-Cubist stylisation of the domestic interior or conventional still life. Hence what Pop Art offered was a distinct but familiar mode of attention, which in locating the desires that followed the logic of the modern commodity itself, reinvented the spaces out of which identifications of Englishness and Britishness could take place.

Pop Art in Britain, produced as it was mainly by young working-class and lower-middle class men, was the first moment in British post-war culture in which the commodified experiences of the modern were situated in the art-work as the shared experience of the declassed artist. In this sense, the use of commercial signs, brand names, representations of celebrities and so on, was a means of redirecting definitions of the modern back to the social and cultural location from which the majority of artists had emerged. This work was produced out of the pleasures and cultural identifications of the first socially confident post-war generation of working-class art students—the 1944 Education Act had enabled working-class students with a proven record of artistic ability to attend art school. Their coming to consciousness about the distinct pleasures of popular culture, then, represented a significant shift in the social relations of artistic identity. For the first time in the English national tradition, artists did not look to 'low' subjects to provide a moral or political commentary on national identity, or as a form of titillation for a bourgeois audience used to the pleasures of the culturally illicit. In Pop Art, the artists' identification with the symbolic materials of popular culture (Hollywood film,

Above: Richard Hamilton, Swingeing London 67, *1968-69*

advertising, commercial graphics, pulp fiction) meant that the artists did not set out to represent the popular as a 'problem' or a *soi-disant* theme. In the work of David Hockney, Derek Boshier and Allen Jones, for instance, the dissonant allures of sexual commodification are treated as a shared and common space of fantasy, in contradistinction to what is perceived as the academically eroticised female and male body of the modernist tradition. Clearly there are instances where these dissonant signs of the everyday fail to signify, the artist knowing full well the limits of the 'popular', as in Hockney's highly coded gay 'graffiti' paintings from the late 1950s or in Pauline Boty's pre-feminist ironic *femme fatales*. But the prevailing voice of Pop is one in which the shared habits and tastes of the consumer of popular culture are taken to be largely inclusive on class grounds. This, conventionally, is why the critical reception of Pop Art has been so weak or condescending.

Pop Art's appropriation of commercial graphic forms is viewed as culturally assimilative. Indeed, since the late 1960s, its popular success—the fact that its images were rapidly reprocessed commercially by the culture industry itself— has been identified as symptomatic of the art's lack of intellectual and formal ambition. This sense of aesthetic weakness has also not been helped by the tone of Pop Art's most articulate defenders in the 1960s, such as Lawrence Alloway and Reyner Banham, whose reactive pro-American defence of its illicit commercial pleasures was tainted by the worst of the period's promotional zeal. However, if the prevailing criticisms of Pop from within the discipline of art history made little impact on its popular reception, they had an enormous impact, on the way Pop Art was read culturally. In response to the fast and easy distribution of Pop images by the media, art history and the sociology of art looked on Pop as an aberration, a point where the imaginary appeal to some modern notion of accessibility and the popular overtook the historical and ethical problems of art's formal self-definition. The cultural impact of Pop on the institutions of art is treated with scant attention, if at all. Although there had been (tendentious) studies of Andy Warhol, for instance, as a social critic, there was an absence of serious work on Pop as a mode of attention. In a way, it took the development of cultural studies in the late 1970s, and the theoretical adaptation of French semiological models within the New Art History itself, for the cultural implications of Pop Art to be given any credence.

These changes emerge with the work done at the Centre for Contemporary Cultural Studies in Birmingham in the 1970s and, in particular, the writing of

Dick Hebdige in the early 1980s. Hebdige's 1983 essay, 'In Poor Taste: Notes on Pop', is perhaps the first attempt to locate the moves of Pop Art in relation to social and cultural division and therefore as something the effects of which were far from aberrant. Hebdige's thesis, heavily influenced by Bourdieu, is that Pop reveals the power and arbitrariness of cultural division and the distinctions of taste. He discerns that, for the first time, artists appropriated popular cultural sources as worthy of consideration in their own right, pointing up what he describes as the 'complicity between aesthetic taste, and economic and symbolic power'.[1] More significantly, however, he argues that Pop's cultural currency lies in its problematisation of the hierarchical distinction between culture in its conservative sense as what is 'good and true', and culture as the 'distinctive patterns, rituals and expressive forms which constitute the "whole way of life" of a community or social group'.[2] In the late 1970s, cultural studies invested heavily in this latter notion of culture, as both a polemical and pedagogic disruption of an exclusionary concept of value dominant in traditional art history and literary studies. Popular cultural forms (such as television) were not evaluated in relation to a canonical model of taste, but in terms of their effects—how they produced pleasure and secured the interest and participation of their audiences. Accordingly, popular culture was analysed in relation to how it was put to use by particular audiences, and consequently how it produced a sense of popular culture as a shared and inclusive social experience.

Hebdige's reading of Pop Art, is clearly motivated by what he discerns as its interruptive and productive manipulation of the signs and forms of popular culture, as distinct from the view of Pop Art as a contemplative or prurient assimilation of popular stereotypes into the high genres of art. With its emphasis on the disruptive and ironic recoding of the remaindered products of mass culture, the best of Pop Art produces a consciousness of the pleasures of the popular. Thus, for example, in Richard Hamilton's *Swingeing London* (1968-69), and Peter Blake's *Monarch of the Glen* (1966), their appropriation of tabloid photography and an icon of 'popular painting', respectively, invites the spectator to connect the subject of the image to its generic conditions of production. Hebdige calls this 'a politics of pleasure'.[3] As such, he claims, Pop Art works to reduce the distance between the culturally exclusive spectator of art and the culturally inclusive consumer of popular culture by giving the spectator permission to employ their scepticism and powers of reason on that with which they are most familiar. 'Pop "politics" reside in the fact that

it was witty, decorative and had visible effects on the look of thinks, on the looking at things; in the way it opened up the range of critical and creative responses to popular culture available to those who possess a modicum of cultural capital'.[4]

This ethical commitment to the rights of the non-specialist spectator is, of course, not particular to the moves of Pop Art, but marks the very history of the modern in art since Romanticism. Under modernity, art has invariably sought to renew its claims to 'truth' and 'authenticity' through the rejection of academic and specialist modes of attention. The 'popular' spectator is judged to hold at bay the 'corrupt' professionalisation of art. Yet for the modern avant-garde, although the appropriation of dissonant everyday forms and practices has played a key part in the formation of this non-academic spectator (think of Abstract Expressionism and the extemporisations of jazz; minimalism and the 'ordinariness' of artistic labour), at no point has the crisis of art's social identity ever become identifiable with the defence of a *popular* spectator. The non-academic renewal of art's conditions of production and reception from Cubism onwards has been a matter of bringing scepticism to bear on the legitimacy of ruling aesthetic protocols and categories, and not on the legitimacy of specialist protocols and categories *tout court*. To do so would be to dissolve rather than prosecute the crisis of art's public.

What we need to ask of Pop, therefore, is whether its relationship to this dialectic is simply reactive? That is, whether it appears to endorse the non-academic renewal of art's spectator from inside a normative account of the popular, or whether it provides a critical revision of the avant-garde itself?

Left: John Stezaker, The End, *1995*

The overriding evidence would suggest that Pop made far too much of its claims to accessibility, and that it was too comfortably ensconced within the corrupted world of public relations and glamorous distraction. Pop's populist defenders have not been slow to talk about it as if it was interchangeable with popular culture. Yet, as Hebdige points out, where Pop Art is successful, it is so precisely because of its sensitivity to the textual possibilities of the recontextualisation and recaptioning of images and objects, as an identification with the ironic, fan-based pleasures of the consumer of popular culture itself. Indeed, what distinguishes Pop, and brings it into notional alignment with early conceptual art, is an attentiveness towards mass culture as an infinite source of 'ready-mades', as material to be reinscribed ideologically.

It is easy to understand, therefore, why Hebdige wrote 'In Poor Taste' as he did and when he did. Hebdige's reclamation of Pop from the glare of condescension is first and foremost an attempt to rewrite Pop from within the framework of an emergent postmodernism and the resurgence of the high culture/mass culture debate. Although 1983 was the year Hal Foster's essays on postmodern culture were published, the term was beginning to be used in art history and cultural studies as a point of departure from modernist forms of 'authenticity' and taste.[5] In this respect, it is not too difficult to see how Hebdige's Pop Art might be seen as a tributary of critical postmodernism. As the key themes of postmodernism begin to fructify—an aesthetics of textuality (the turn to parody and pastiche), the displacement of the sign from its referent, the image as spectacle, and the theorisation of art as part of everyday cultural practice—Pop Art's intertextuality looks increasingly prescient and inviting. Accordingly, Pop Art is judged to be the beginning of a now familiar cultural narrative: that moment in the 1960s when high modernism begins to lose its authority in the face of the extension of what is taken to be meaningful cultural experience. Thus when Hebdige talks about Pop Art as a 'whole way of life', he is talking about this wider process of cultural transformation within capitalism: the enculturalisation of everyday life itself, or rather, the commodified expansion of culture into social life generally.

Hebdige's intertextual reading of Pop, then, arrives at that point when cultural studies and definitions of the 'popular' in Britain are undergoing a methodological shift. The turn to culture as 'discursive practice', via post-Althusserian and post-structuralist theories of language, forms the beginning

of an alliance between art theory and cultural studies that was to dominate the production and study of advanced art in Britain in the 1980s. A good example of this is Stuart Hall's 1982 essay 'The Rediscovery of "Ideology" — Return of the Repressed in Media Studies'.[6] Although the aim of the essay is to outline a new 'discursive' paradigm for cultural studies in the 1980s, and has no immediate connection with art practice, by extension and implication it draws together many of the theoretical moves which were to underwrite the new critical postmodernism in Britain and the USA, expressly, the notion that art is positional not just within the 'history of art' but within the wider culture of representations and social practices.

Attacking the 'vulgar Marxism' of the populist school of anti-modernism, and the orthodox mass cultural content-studies of 1950s and 1960s American sociology, Hall argues for a 'non-reductionist conception of dominance', in which 'meaning is... not determined... by the structure of reality itself, but conditional on the work of signification being successfully conducted through a social practice'.[7] That is, the ideological contents of cultural practices and forms are not fixed by their class location, but opened up to other possible readings depending on their context of reception. Hence what is at stake is the way in which 'different social interests or forces might conduct an ideological struggle to disarticulate a signifier from one, preferred or dominant meaning-system, and rearticulate it within another, different chain of connotations'.[8] In short, Hall's account (which owes much to Voloshinov, Ernesto Laclau's early work on ideology, and late 1970s debates in *Screen* on popular film) expands the interventionist ideal of cultural politics to the struggles of the counter-hegemonic. In the late 1970s, debates on hegemony had found their way from social science to the sub-cultural theory of the new cultural studies. Hebdige's reading of the 'popular' in Pop is directly in line with this, opening out Pop's dominant message of conformity and affirmation of commodification to the play of its insurbodinate connotations as the disruption of modernism's 'pure gaze'.

By the early 1980s, this opening up, of the 'popular' to the counter-hegemonic dominated the horizons of advanced art. Indeed, Hebdige's and Hall's essays appear after a period of intense revision in art theory and practice after the implosion of conceptual art in the early 1970s. In 1973-74 there was a move on the part of a number of artists in Britain towards rethinking the relationship

Above: Image of uncertain origin, courtesy Transmission

between art and mass culture. Rejecting both late modernist and Frankfurt School notions of 'negative distance', and populism, art is placed in a specific critical-semiological relationship to the forms of mass culture. Indebted as much to Situationism's 'parasitic' practices, as to Ferdinand de Saussure's language-model of the visual, art's focus of production shifted to the photographic reinscription of the dominant uses of photography, leading to the concept of art as a form of intervention *into* the 'popular' and the 'everyday'. One artist pursuing this line was John Stezaker who, unlike most artists of his generation formed by analytic conceptualism, saw Pop Art as a moment of instructive social renegotiation for art. In the mid 1970s, at a time when the dominant opposition to modernism was a formulaic social realism, he was arguing for something close to a counter-hegemonic practice. As he said in 1977, 'by engaging with the products of mass culture... what one is acting upon is the sphere of thought and yet what one is acting in is the sphere of action, the common-sense framework of bourgeois society and the social reality of every-day living, i.e. the ideological and political spheres'.[9]

This interventionist rhetoric was soon to diminish for Stezaker, but never-theless the tone here captures that moment in the mid-1970s where art was repositioned within the orbit of mass culture and popular culture. As Stezaker declared, what was of crucial importance was the lowering of the distance between the 'popular' and the cultural identifications of the artist. 'The reflexes of aesthetic distaste for the familiar and the stereotyped are something to resist. They belong to a sphere of culture which has progressively buffered itself by the rarefied zones of modernism, let alone involvement with the cultural forms which are the essence of social existence in the latter part of the twentieth century'.[10]

By the early 1980s, the theoretical elision between art, the popular and the counter-hegemonic was beginning to gain influence through a conver-gence of post-conceptual photographic theory, the new cultural studies and the New Art History. In fact, by 1982-83, there was a growing body of theo-retical and artistic work which took the 'popular' as the ambiguous site of knowledge and pleasure. The magazine ZG, for instance—with which Stezaker was identified for a while—began to promote a new generation of artists and writers whose intellectual and aesthetic interests were based overwhelmingly

Right: Cindy Sherman, Autoportrait, *cover image,* ZG, no. 7, 1983

80p $3·00

ZG

No 7

DESIRE

on popular culture. However, what distinguishes *ZG*'s content is its revisitation of a Situationist aesthetics through its dissemination of the new writing on the sumptuary power of late capitalism then emerging from France and being translated out of the USA by Telos Press and Semiotext(e). In short, *ZG* is one of the conduits through which Jean Baudrillard's theory of the sign-as-commodity and the implosive effects of the media emerges into art discourse in Britain in the early 1980s. This gives the writing in the magazine a political location which actually is at odds with the overtly counter-hegemonic theorists of the new anti-modernist photographic theory emerging around Victor Burgin, in the journal *Screen*. More wary of the claims being advanced for the new 'politics of representation', *ZG* was increasingly attracted to an entropic account of art, communication and the everyday under capitalist spectacle. That is, its writers argued following Baudrillard's notion of the abstract universality of the media, a counter-hegemonic art of the everyday needs to recognise and stage the functional logic of this phantasmagoria, if it is not to assume that it can transcend this deadlock. As Rosetta Brooks, the editor of *ZG* was to declare in issue number 7 in 1983 about the artist John Wilkins' *Ovaltinies* series (1980-82), 'The work becomes about living within the available — in a confrontation with the repressive, rather than the emancipatory aspects of the image. A diversion of "the system of objects" to one's advantage (perverse enjoyment)'.[11] The point here is that the artist's immersion within the phantasmagoric logic of the commodity does not result in the 'deconstruction' of the stereotype and repressive symbol, but the enunciation of the effects of the spectacle itself (surrender to the other, feelings of dread, loss of self-consciousness). In this respect, this work and *ZG* generally were preoccupied with the vantage point of the consumer in a way that was culturally unavailable to Pop Art and its early critics. For, by the early 1980s, mass culture and popular culture were being theorised as the primary sites where subjectivity is constructed and dominant ideologies reproduced. The outcome of this is that *ZG* theorises its representative artist-spectator as being subsumed under the 'law' of mechanical reproducibility and the spectacle: the constant dissipation and reconstitution of desire for desire itself. As such, whereas Pop Art enjoyed an almost sanguine immersion in the turnover of the image, John Stezaker's collages form a frieze of 'little deaths'. The modern industrialised image becomes a process haunted by cold repetition and funereal dread.

With this shift to an understanding of the death-in-life of the mass-produced image there is a profound reorientation of the 'popular' during this period, as 'newness' is openly associated with waste, turning the debate on the popular/high cultural divide back to the founding texts of the 1930s (Benjamin, Adorno, Bataille). Stezaker's contribution to this was to give an ontological grounding to the fate of the post-traditional artist and spectator. In becoming immersed in the mass-produced found image as a collector and *monteur*, the artist is able to produce a form of attention—of empathy—in which the spectator is able to glimpse his or her own deathly desires through the death of the commodity. Warhol may have invoked something similar, but British and American Pop Art rarely thought itself so spectral.

With the dissemination of Baudrillard in the mid-1980s, terms such as phantasmagoria, expenditure, seduction and dread bring the language of the pathological to critical postmodernism. But for all the success of this kind of thinking on the production of a great deal of media-based art in Britain and the USA, it is the contestatory claims of an interventionist model of the counter-hegemonic that was to provide the major realignment between art and the 'everyday' within critical postmodernism in Britain. It is perhaps mistaken to call this tendency 'deconstructionist', but in contrast to the Baudrillard-Bataille axis, it opens up the encounter between art and popular culture to questions of subjectivity and identity. By 1982-83 the women's movement had provided quite another set of co-ordinates for addressing the sumptuary logic of the spectacle. The writings of Laura Mulvey on film, in particular, opened out the vantage point of the consumer to issues of sexual difference: who is looking at whom and with what kind of scopophilic investment. Her 1975 essay, 'Visual Pleasure and Narrative Cinema', not only marked a paradigm shift in film studies through its use of psychoanalysis, but contributed to the transformation of how women artists experienced their own fascination with, and alienation from, the woman-who-is-to-be-looked-at within popular culture as a shared set of pleasures.[12] The notion of immersion within popular culture as a shared set of pleasures, therefore, was never really so untroubled as many of the male anti-modernists made out. Moreover, the turn to the metaphors of pathology and entropy to describe the 'totalising' logic of the spectacle was to give way to the subjectless subject. And it is this absence of an adequate account of subjectivity and identity that underwrites the openly interventionist concept of the counter-hegemonic.

In 1980 Victor Burgin published 'Photography, Fantasy, Fiction', followed in 1982 by his edited collection *Thinking Photography*.[13] The term 'postmodernism' is mentioned in neither publication, but the post-Althusserian dictum that the ideological is produced in practices of signification characterises the writing. In 'Photography, Fantasy, Fiction' he argues that there can be no practice of art given in advance of a specific historical and institutional conjuncture. As such, the relationship between art, the 'popular' and the 'everyday' is discursive, that is *how* and *what* art means at a given historical moment isembodied in the language claims that 'cross and contain' the work.[14] There can be no concept of the 'popular' or 'political' that proceeds or overruns this process of construction. The 'real is... constituted through the agency of representations'.[15] In broad outline, this theory of practice is little different from Hall's discursive model, but the implications for art are underscored by a more emphatic questioning of the subject itself. If the real is constructed in representation, then the fantasy of absolute sexual difference is brought under scrutiny. Femininity and masculinity do not represent pregiven biological destinies, but the effect of the subject's insertion into language and ideology. This disarticulation of the feminine and masculine from the morphological is the major source of intellectual and artistic endeavour for the new photographic theory, establishing what was to dominate the programme of left critical postmodernism from 1983 onwards: the conjunction of the counter-hegemonic with the *unfixing* of sexual difference. In the wake of *Thinking Photography*, then, a post-Althusserian 'politics of representation' is increasingly opened up to Lacanian psychoanalysis. A good example of this elision is Jacqueline Rose's 'Sexuality in the Field of Vision' which was written for the Britain/USA show *Difference: On Representation and Sexuality*. As she says, introducing the issue of psychic identity into art 'sets itself the dual task of disrupting visual form and questioning the sexual certainties and stereotypes of our culture'.[16] Hence the 'chief drive' of postmodernist practice is to 'expose the fixed nature of sexual identity'.[17]

This unfixing of identity also underwrites developments in post-colonial cultural theory and gay cultural theory, as the discursive model of culture becomes allied to the new 'identity politics'. In 1983 Homi Bhabha published 'The Other Question...' in which he moves beyond the 'deconstruction' of the racial and colonial stereotype to a questioning of the mode of representation of racial otherness itself.[18] Here the debate on the construction of identity in

signification is moved beyond the idea of 'positive' and 'negative' (which characterised a good deal of the polemics of the first generation of politicised black artists in Britain in the early 1980s) to a complex attention to 'otherness' as a positional concept. With this, by 1985-86, the discursive counter-hegemonic model of representation was to become increasingly identifiable with the idea of difference as articulation, ventriloquy and masquerade—notions that would eventually shape the influential idea of identity as performativity. Indeed, the most regarded and most visible art of this period takes performance-as-identity as the means by which the 'everyday' and the 'popular' can be negotiated, or recoded.

This severely compressed history of the theoretical turns of the 1980s obviously fails to do justice to the complex interrelationships between different practices and theoretical positions and the political effects and problematic identities of such practices and positions. But for our present purposes, at least, it makes clear the degree to which critical postmodern theory in Britain in the 1980s formed the vanguard of a wider process of socialisation: the 'secularisation' of art as a cultural practice and the institutional politicisation of culture. In fact what characterises these developments in the 1980s in Britain is the extent to which the anti-modernist critique of authorship, representation, and the art institution begins to form the basis for a new academy in higher education and in the museum. In a relatively short period of time, the occluded and marginalised debate on the 'popular' and the 'everyday' became the dominant, professional framework of address for advanced art as 'identity' politics and the new cultural theory entered the art schools and

Previous pages: Roddy Buchanan, Players who associate themselves with Italian Football by wearing Inter Milan and A.C. Milan shirts amid the dozens of local tops on display every night on the football parks of Glasgow, *1995-*

Left: Maureen Paley selecting James Brown, Turning the Tables, *1997*

universities. This has generated new forms of competence and skill, as the intellectual demands of knowing how to talk about art as a set of culturally grounded problems has widened how artists think about the cultural effects of their art. Pop Artists may have experienced a strong sense of their art as intimate with non-specialist forms of attention, but the notion of art as cultural practice was foreign to them. For art was yet to experience the full force of the technological mediation and its repressive envisioning of all things and all people with which Pop was enamoured. Today, though, the enculturalisation of art—the weakening of the boundaries between specialist forms of attention and dominant forms of visual communication—is now the common social and cognitive ground of artistic production, as the globalisation of capital has meant the gradual but insistent repositioning of the field of art's cognitive and aesthetic interests inside these structures.

Perceptions of art's negative function have greatly diminished. This has obviously transformed art's relationship to the issue of its autonomy. It is this issue of autonomy that is implicitly at stake in Hebdige's reading of Pop and all the polarised debate about the new cultural conditions which have accompanied the debate on postmodernism and the counter-hegemonic during the 1980s and the new art of the 1990s. For what is clearly at stake for Hebdige, and many other early contributors to the 1980s postmodern debate, is the possible democratising effects of these new cultural conditions. The integration of art's production into the field of photography and video, the sensitivity to the artwork as text rather than an auratic experience, the self-conscious play with different orders of representation—all standard postmodernist views by the mid-1980s—are evidence of a new 'openness' and social integration for art. As Hebdige says in concluding 'In Poor Taste':

> The final destination of Pop Art, Pop imagery and Pop representational techniques lies inside the gallery but rather in that return to the original material, that turning back towards the source which characterised so much of Pop Art's output in its classic phases. Its final destination lies, then, in the generation, regeneration not of Art with a capital "A" but of popular culture with a small 'pc'....[19]

For Hebdige, then, the success of Pop is down to the way in which it feeds back into popular culture as a shareable, demotic critical apparatus. That is, Pop is successful precisely because its reading practice confirms or replicates

Above: Mark Wallinger, A Real Work of Art, *1993-*

the reading practice of the popular spectator itself. Whereas the modernist or aesthetically trained spectator attempts to read the aesthetic object on its own terms, subordinating himself or herself to its demands, the popular reader takes what he or she needs or wants from a text or object at will.[20] It is no surprise, therefore, that Hebdige's reading of Pop has, in key respects, become the dominant reading of the art/popular culture axis in the new art in Britain in the 1990s. Although for different historical reasons (Hebdige's spectre is still that of modernism), there is a similar kind of disinterest in the issue of autonomy, on the grounds that because art's enculturalisation produces the need for a different kind of spectator, the issues of art's negation and continuing relationship to specialist forms of knowledge is irrelevant or elitist.

Indeed, in relation to the new art, we have a situation where the affirmative assimilation of artists within the media produces a reading on the part of both the artists and their popular critics that the new art is identifiable with popular culture itself, something that Hebdige skirts close to himself. Questions of 'critical distance' are taken to be not only elitist, but part of an avant-garde discourse that is no longer historically relevant, as was evident from the art and popular culture show, *Assuming Positions*, at the ICA in 1997. In this show, issues of social and cultural division, which underwrote so much of the debate on postmodernism, are taken to be academic. This is largely because the inclusion of art within the practices and forms of the popular is pursued without any sense of guilt, or moral worthiness about 'accessibility'. This has much to do of course, with the cultural advance of postmodernism, but also with the perception of postmodernism itself as part of the problem. For critical postmodernism was essentially an academic critique of entrenched hierarchies in the university and the museum, it therefore positioned the artist and spectator, by necessity, as a theorist of the pleasures of popular culture rather than as advocate or lover of such suspect pleasures. In short, postmodernism was in no position to enunciate the illicit pleasures of the popular, because those pleasures were always seen as a problem of ideology and its representation. Today, by contrast, there is a widespread alliance with the subordinate consumer of popular culture. If the majority of people experience subordination in their working lives, the argument goes, they do not need to have this reintroduced through their exposure to art.

From this perspective, what the new art is doing in its turn to the profane, perverse and trivial is to ventriloquise those forms of attention customarily

associated with the proletarian spectator of popular culture. As a result, this is where British Pop Art and the new art share a certain identity. For there is a comparable understanding that to take up a critical distance from the shared subjectivities of a common culture is intellectually dishonest hence, the over-eagerness to disrespect the theoretical categories of modernist and postmodernist art, and talk up art as a form of distraction and entertainment. I have argued recently that these forms of intervention have been important in shifting the leaden, professionalisation of critical postmodernism, opening up the debate on the popular to an acknowledgement of the pleasures and forms of attention of those who actually consume popular culture—the working class. In this respect, the pursuit of new forms of aesthetic informality have provided the major interest of the new art. This in turn has allowed non-specialist modes of attention to be incorporated into the debate on art and the popular in disruptive and vivid ways. Hence the importance of the concept of the philistine, for if anything the philistine is the revenge of the proletarian, non-specialist spectator on postmodernism's abstractly bodied theorist of pleasure. Moreover, this has allowed the particular national context of the new art to be given a voice. For what remains distinctive about art in Britain in the 1990s is its strong connection to the insurbodinate, proletarian energies of British popular culture generally.

Despite these forces, the new art cannot escape the contradictions of ventriloquism. For to endorse the 'popular' as artists, even as fans and participants, is to do no more than shift the boundaries of discrimination within the institutions of art. This tends to be forgotten in the rush to denounce the issues of autonomy and negativity, as if curators who turn themselves into a DJ one day and a studio artist the next resolve the cultural division between such activities. Dissonance is confused with dissidence, as it always is when artists mistake the disruption of professional codes and practices for the democratisation of art. But even so, there is a question concerning the transformation of the category of the popular in the new art which has to be answered: how is it possible for art today to conceive of its autonomy when perceptions of autonomy are no longer defined by their opposition to mass culture? What the new art reflects, in fact, is not so much the 'popularisation' of art and the artist, but the dis-identification of the artist as cultural outsider, which is a very different matter altogether. Thus, if there is less of a tendency

amongst non-specialist art audiences today to ask, 'is it art?', because of the technological enculturalisation of art, there is also a greater understanding that what artists do can be discussed in popular and non-specialist contexts without a loss of the work's formal integrity. In short with the global com-modification of art, the artist's primary socialisation is now through the media. In other words, the artist is someone who thinks of his or her identity as constructed in relation to the technological distribution of their art—even if this is an unhappy solution—and therefore is forced to adapt different kinds of voices to different kinds of contexts. The downside to this is the reciprocal fascination between the media and the artist with his or her own celebrity. This leads the artist into fear and self-mythologisation. The up side is that art and the artist are perceived as extensive with 'ordinary' experience. This leads to conversation.

The legacy of the 1980s postmodernist debate on high culture and popular culture, then, is instructive. One of the reasons why the new art looks the way it does is that art now operates in a space where both an older modernist concept of autonomy and postmodernist notions of utility and intervention (of 'unfixing' and 'deconstruction') appear to be in crisis. Postmodernism's critique of the categories and institutions of art is held to be as academicised and enfeebled as modernist distanciation from the tainted pleasures of mass culture. Artists have therefore refused to entrust their work to the abstract ideals of 1980s critical practice and the immanent critique of artistic form, turning instead to the existentially more 'secure' ground of their own enjoyment as cultural consumers. In this, the production of the 'popular' and the 'everyday' as counter-hegemonic categories or concepts, are taken to have prevented artists discovering what it was they took pleasure from in popular culture in the first place. In short, this generation of artists have insisted on recognising in the work of art the pleasures of their own experience as alienated consumers. Hence the functional importance of the concept of the philistine. For, above all else, philistine pleasures and interests are not necessarily emancipatory ones. The philistine is someone who loves or takes pleasure from his or her own self-estrangement. This is obviously why so much criticism of the new art has taken its informality for triviality, and its profanity and perversity for media-friendly subversion: for the new art is judged to be media friendly, precisely because in divesting the 'everyday' of its 1980s counter-

hegemonic agenda, it can live out the same kind of affirmative role as Pop Art in the 1960s.

That much of this art is available for this kind of affirmation there is no doubt. But such criticism misses a wider and more far-reaching point: that the turn in this art to the alienated pleasures of the 'everyday' reflects an increasing concern with the relations of art's distribution. What this art has achieved is a level of distribution and recognition outside of the professional art audience that even critical postmodernism could only dream of. This is because its interests and pleasures are judged by its non-specialist audience as being matters of a shared culture and not the exercise of acquired taste. This may amount to no more than a middle-class extension of art's audience— contrary to the fantasies of the populists—but nevertheless it marks out what is important about the new art's refusal to condescend to the pleasures of the popular: a recognition of the fundamental 'ordinariness of culture'.

Notes

1. Dick Hebdige, 'In Poor Taste: Notes on Pop', *Block*, no. 8, 1983, p. 56.

2. Ibid., p. 58.

3. Ibid., p. 67.

4. Ibid.

5. Hal Foster, ed., *The Anti-Aesthetic: Essays on Postmodern Culture*, Bay Press, San Francisco, 1983.

6. Stuart Hall, 'The Rediscovery of "Ideology"—Return of the Repressed', in Michael Gurevitch et al., *Culture, Society and the Media*, Methuen, London, 1982.

7. Ibid., p. 77 and 84.

8. Ibid., p. 80.

9. John Stezaker, 'Social Expression: Social Reality', *Meantime*, no. 1, April 1977, p. 35.

10. John Stezaker, *Fragments*, Photographers' Gallery, London, 1978, p. 52.

11. Rosetta Brooks, 'Everything you Want... and a Little Bit More', ZG, no. 7, 1983, unpaginated.

12. Laura Mulvey, 'Visual Pleasure and Narrative Cinema', in *Visual and Other Pleasures*, Indiana University Press, Bloomington, 1989.

13. Victor Burgin, 'Photography, Fantasy, Fiction', *Screen*, vol. 21, no. 1, Spring 1980; Burgin, ed., *Thinking Photography*, MacMillan, Basingstoke, 1982.

14. Burgin, 'Photography, Fantasy, Fiction', p. 80.

15. Burgin, *Thinking Photography*, p. 9.

16. Jacqueline Rose, 'Sexuality in the Field of Vision (1985), in *Sexuality in the Field of Vision*, Verso, London, 1986, p. 226.

17. Ibid., p. 228.

18. Homi Bhabha, 'The Other Question...', *Screen*, vol. 24, no. 6, November-December 1983.

19. Dick Hebdige, 'In Poor Taste', p. 68.

20. For a discussion of these issues, see John Fiske, 'Popular Discrimination', in *Modernity and Mass Culture*, Routledge, London 1991.

𝒜𝒹𝒹𝑒𝓃𝒹𝒶 　　　 −7 The carrier of the utopian trace, the digital networks, are themselves mirrored by biological analogies and models of cognitive thinking: in connectivist theories and in concepts such as memes.

The connectivists uphold a decentralised conception of the mind—heterogeneous entities operating across a meshwork, not the homogeneous structure of hierarchical thinking. A meme could be pictured as an 'idea gene'; it functions in a mind the same way a gene or virus functions in the body. Infectious and transmissible, the meme moves from mind to mind, propagating itself.[9]

The digital network is imaged as an extended intelligence, seen as an analogous evolution—endowed with a propagatory and preservatory role. But as the network's operation subject to the global monetary complexes requires ever more precise and absolute constructs of time and space, evolution in the form of Information Technology privileges transmissible reality. Transmissible reality which is marketable reality. A circularity which acts as a memetic filter as representation is relocated entirely within it. Outside it, a new spectacular dualism gels. The network as the *res cogitans*—and, beyond the res extensa. The network as *cogito* projects value, the *res extensa*; an inert receptacle for objectification. The endemic and the structural reformatted.

Projection 1

Through technology true communication become genuinely possible via new circuits and networks, and human experience flows across all artificially created borders.

Projection 2

Through technology experience itself is transcripted and transferable, and so participates in the systems of exchange.

　　　 +8 'A single experience that is never able to repeat itself is biologically irrelevant. Biological value lies only in learning suitable reactions to a situation that offers itself again and again, in many cases periodically, and always requires the same response if the organism is able to hold its ground'.[10]

In equal measure, the biological would be irrelevant to the single unrepeatable experience. Incapable of replication and without biological currency, it would be a non-meme, a blank meme, an absurd meme as a conceptual contradiction. The absurd meme which stays outside the genetic process by being the singular genesis. Beyond representation but because of that serving as a space for creating value, affinity.[11] The absurd is the asymbolic fabric which lies at the root of religion, its immanent etymological root: *religio*, the link, between souls and bodies, concepts and their materialisation. The absurd is equally the *yug*, the etymology of yoga, the harness between the material and immaterial, the perfected link. Neither natural, nor anti-natural, nor unnatural, it perceives that nothing is more distant from the natural than nature understood, nothing further from consciousness than consciousness represented.

Another Year of Alienation
On the Mythology of the
Artist-Run Initiative

Malcolm Dickson

To say that there is an imbalance in the relationship between the majority of artists and the exhibition mainstream is like acknowledging that there are the privileged, and those that are less so. Big deal! The source of friction and antagonism in the dichotomy of 'artists or administrators', however, is not just a facet of the culture of complaint, it is a paradigm of the struggle over meaning and of being able to represent oneself. Recognising this, however, is a critical issue.

In Glasgow, short-lived groupings of artists have emerged since the late 1980s (EventSpace, Womanhouse, Hertake, Breathe, to name but a few) for the purposes of exhibiting their work, which is often site-, or culturally-specific, in alternative venues. It was part of an expansive policy initiated by Glasgow Council when the city was nominated European City of Culture, and their commitment has continued despite central government cutbacks and minor controversy over grant allocations. However, the practice has fractured and mutated—the sense of a coherent whole and something to work towards has dwindled. The idea of a critical mass of Glasgow artists debating hot issues late into the night, rotating around each other's tenement flats and planning the next intervention into 'public space', is as unconvincing now as the phenomenon of alien abduction.

There are two more identifiable factors which influenced the 'renewal' of art forms in Glasgow. In the late 1980s, a challenge was mounted to the time-honoured dominance of painting. This included the establishment of the Environmental Art course at Glasgow School of Art, and external influences to that in the form of *Variant* magazine, Transmission Gallery, and the filtering through of time-based concerns from the Electronic Imaging Department at Duncan of Jordanstone College in Dundee. These structural forms contributed to the broader climate of self-determination, which is itself a prerequisite for the emergence of new organisations or tendencies.

The focus upon the 'artists' initiative' and the rhetoric of autonomy is very much symptomatic of its institutionalisation, where a hierarchy of spaces is allocated a slot regarding their proximity to, feeding into and replication of the cultural mainstream. The original impetus to establish the artist-run space was conceived as an ideological quest to destabilise the hegemony of complacent thinking, and create a contextual framework that made art more of a meaningful activity. The motivation now is more pragmatic and functional,

Frontispiece: Festival of Plagiarism, *Transmission, 1989*

Above: Simon Yuill, Be My Baby, *1996*

revolving around the potential of 'making it' and the 'demand' to exhibit work. The notion of an alternative does not have the critical import it previously embodied.

In an illuminating essay from *Roles and Reasons* published by AN, Ian Hunter of Projects Environment stated:

> Clearly there are now growing expectations as to what artist-led
> initiatives can deliver in terms of community and cultural practice
> and social and political activism across a broad range of arts
> development. However, some critics and artists active in the field
> are dissatisfied with the present achievements and critical orientation
> of artist-led initiatives, and uncomfortable with the claims being made
> for them as a universal strategy for institutional legibility and a securely
> funded future. It is possible to argue that, for all the excitement about
> the new critical territory won by artists and artist organised initiatives
> over the past few years, that the genre may already be in decline, critically
> and ideologically speaking, and showing signs of the premature onset
> of a mid-life crisis.[1]

Although such an observation is critically astute, the function of artist-led spaces is pragmatically grounded in the psychology of self-assertion and self-improvement—attributes commonly acquired after the de-education of art school. Whilst Transmission is seen to be the most significant gallery in the history and development of this sector in Scotland, and in Britain as a whole (not to belittle its international scope), there will at any one time be a number of parallel initiatives that begin the slow haul to recognition. In Scotland there are, or have been until recently, a few projects that reinvigorate

Right: Sophie McPherson,
installation at Independent Studio, 1997

Following image: Patrick Jameson,
Phat Tower 2, 1997

the originating impulses of the artists space: for example, Independent Studio, Generator, and e.space@Java.

The Independent Studio in Glasgow is comprised of studio space and a project room which is also available to non-members to exhibit work in progress and new projects. 'Our aim is to provide access and facilities to our members as well as providing an atmosphere conducive to creativity and progress. The aim is also for a web site, more contact with other studios which could lead to a national and international exchange programme'. It also benefits from the proximity of other art spaces in what has been embarrassingly referred to as Glasgow's Left Bank, being situated in the vicinity of Street Level Photoworks, Transmission, Glasgow Print Studio, Sharmanka Kinetic Theatre, Women's Art Library, Glasgow Film and Video Workshop, Project Ability, Trongate Studios and a multitude of other artists' studios called WASPS (Working Artists' Studio Provision, Scotland).

Also in Glasgow, for several months e.space@Java provided a combination of café, Internet facility and gallery:

> ... a centre where people with a range of different interests can interact.
> Our short history of shows reflects the aim of our future programme of
> seriously different exhibitions that continually transform the space and cover
> a spectrum of contemporary art practice. We aim to open up the context in
> which art takes place, and the forms in which it occurs.

Its vulnerability has been illustrated, however, by its being subsumed within the wider commercial imperatives of the Internet café. The exhibition space has now been suspended for the foreseeable future, with its galleries being transformed into office spaces where the unemployed and others undertake training courses. Until its recent demise, however, it offered a much-needed flexible and agenda-free space for local artists.

Dundee has come further to the fore of late, with the combination of the Electronic Imaging Department at its art school and the opening of Dundee Contemporary Arts. The establishment of a new artists' project entitled 'Generator', however, adds vigour to the infrastructure for artists' support that has not been seen since the Dundee Group of Artists in the late 1970s. Encouragingly pro-active, their objectives are to:
• Open and run a contemporary art space and gallery
• Support interdisciplinary collaborations
• Improve and enhance public education

- Create innovative venues for art and events
- Encourage talks and establish critical and international and national dialogue
- Provide various facilities at affordable prices.

There are other initiatives that do not require a building in which to exhibit projects. Elevator are a loose group of Scottish-based artists from Edinburgh, Glasgow and Dundee who aim to explore 'the use of new communication technologies both as artistic media in their own right and as a platform for the development of works based around issues of human contact and the transformations of personal presence within communication.' Their inaugural web site project was critically applauded for its innovation with multimedia art on the Internet.

Northern Ireland's Catalyst Arts are perhaps the closest culturally to Glasgow and are programmatically one of the more interesting cultural excursions in the area. Established to provide a platform for local artists and work not seen elsewhere, it set its sights on placing its activity within an international context. The varied programme is repeatedly innovative, expressing its objectives:

> Being an artist-run space means initiating exchange; exercising cross
> and interdisciplinary approaches to making art; developing networks;
> through curation, putting creative ideas and arguments into action;
> challenging formal structures with will and inventiveness; basically acting
> as curators and administrators as we would artists.

Another reason for the existence of the artist-run venture is that often existing venues cannot meet the demand of artists, and most do not try to be more open to possible collaborations and the input of artists. An attraction of the 'artist-run' is that it can be reclaimed as an ideological space, a temporary autonomous zone, setting some terms for discourse and practice.

Writing on the first ten years of Het Appolohuis in Eindhoven, Holland, Paul Panhuysen noted that 'The justification for a circuit presenting art and organised by artists lies in the fact that art has a fundamentally different meaning for artists than that for collectors or art historians...'. The exhibition mainstream is no more exclusive than artists' groups, except that in the social hierarchy of the reproduction of capital, the curator/administrator represents the benign boss class.

Grant Kester, writing of the 'curator class' or the Professional Managerial Class, describes in the following passage how

> ... we can understand artist/administrators as a segment of the PMC.
> They are the managers of a particular form of cultural capital that is
> generated at the intersection of two discourses—the discourse of fine
> art, with its demand for freedom and autonomy, and the discourse
> of public funding, which imposes conditions of accountability and
> which requires them to take up a position in relation to the 'public'.

Kester's assessment of the American model of the artist-run space, whilst
specific to the cultural conditions and art bureaucracy in that country, can be
related to the situation in Glasgow:

> The objective was self-determination. Artists took this rhetoric,
> originally intended to address disenfranchisement from political
> decision-making processes, and applied it to the microcosm of an
> art world that had effectively placed artists in a passive and victimised
> role, identifying that condition as a political one. As an alternative to
> such a condition, artists proposed to create their own ground for
> displaying their works both for their peers and any interested audience.

There is a lineage in recent art activity in Glasgow that perhaps marks this
shift. *Windfall*, in 1991, was a large exhibition involving Glasgow artists and
several from other countries. It represented the consolidation of the site-
specific, and a celebration of international collaboration between artists. It
heralded in some respects the parting of the ways for many artists in their
different directions with the ascendancy of a small tightly knit group into the
orthodox system, mainly through the endeavours of some of the main artist
movers and curators whose own reputations had likewise been elevated. The
repercussions—positive and negative, as far as this article is concerned—still
remain. Kester again:

> the alternative sector, far from rejecting the art market, would come
> to function as a highly effective farm team system for the commercial
> sector, with selected artists being called up to exhibit in the big leagues.
> If the alternative space movement represented an avant garde it was a
> singularly institutionalised avant garde.

I have been waiting for the bubble to burst for a long time, and I'm still
waiting. I have been grasping at the hope that there are some critical
foundations in what presents itself as the art world. But every time I pick up
a magazine and read about The Turner Prize, *Young Contemporaries*, the

Above: Patrick Jameson and Andrew Whitaker, Tower Blocks, *1997*

British Art Show, and the young British artist—all part of that necessary illusion—it slips from my fingers and evaporates with a sigh of despondency. Not that they are unworthy in themselves, but, taking on a profile far out of proportion to their significance, they eclipse all other issues.

Artist-run spaces still signal new developments in art, but for curators and critics they have become the postmodern pick'n'mix shop. It is easy in this situation to see how a 'scene' becomes self-replicating, a serpent eating its own tail. Of course, this is what is admirable about Transmission—it can look after its members well, with a number of big-name artists whose careers gravitated out from that centre. The opportunity of success must be seen as an idealism that also drives the passions towards the goal. Artists in the limelight at the moment—Douglas Gordon, Christine Borland, Ross Sinclair, Jackie Donachie, Martin Boyce, Claire Barclay (who all studied in the Environmental Art Course), plus Nathan Coley and Simon Starling—were conscious of the need to break with a perceived conservative tradition. How an original 'radicality' soon petrifies into a new stasis is the subject of much informal discussion on the art streets of Glasgow.

In 1996, Street Level Photoworks organised the symposium, 'The Centre is Here'. Influenced by the 1994 Littoral conference in Salford, the title was paraphrased from a quote by the Scottish artist Alastair MacLennan now residing in Belfast, when he said that 'the centre is wherever you happen to be'. That seemed to underline the two issues of importance to the Street Level symposium: working outside the metropolis or centres of art world activity, and initiating things beyond the *dominant* exhibition structures.

In correspondence preceding his talk at the event, Eoghan McTigue of Catalyst Arts observed that:

> The word centre implies that there is a periphery, that there is an 'inside' and an 'outside', a 'them' and an 'us'. I don't know if this applies anymore. I don't know if artist-run projects or projects that happen outside of the gallery system can ever step outside the set of relationships that are present already. The notion of a boundary between an inside, a gallery, and an outside has collapsed into a symbolic relationship, where one depends upon and feeds the other. We are in a situation now where the artist-initiated project is just as much an institution as the gallery. The power of the gallery to recoup and translate under its own terms of reference that which is external to it has already been demonstrated, equally it is evident that there are artists that have built their reputations within the established galleries by initiating projects external to those institutions.

It may seem crude to generalise now about the centre and the periphery, the provinces and the metropolis, or England's dominance over Scotland and Ireland, because by the mere fact of mentioning them their construction is mentally and structurally reinforced. It may be inappropriate now to polarise culture into two separate perspectives: that of the artist and the 'other' of the administrator. There are many positions in-between, all relying upon one another, even if they are fought on positions of power and subordination. Not all of these issues, causes and effects have disappeared. They are also relative: the relationship between Edinburgh and Glasgow to Stirling, for example, might perhaps be said to epitomise an earlier relationship between London and Glasgow.

'The Centre is Here' attempted to reassert the creative self-determination of artists' projects, of making the marginal more central, in geographic and artistic ways: of affecting the agenda and who constructs it. In the course of the last several years, many artists, rather than see their geographical position as a limiting factor, or their exclusion from the dominant exhibition structure as limiting, have turned these supposed drawbacks to their advantage. They have done so by shifting the balance of power away from the metropolis and by setting up their own structures: independent spaces, new types of organisation and collaborations, magazines, studio groups and symposia.

The flip side of such positive activity is that we are currently in an era of flattening out—both of criticism and of engaged art. The positive cynics are so far out on a limb, they are in danger of cutting off the branch to spite the tree. Whilst there is a welcome proliferation of viewing opportunities,

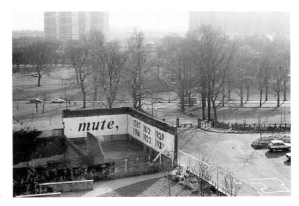

Right: Douglas Gordon, Mute, 1990

with more work on show, it is more thinly spread. Publicity unashamedly masquerades as criticism to the extent that you even have whole magazines devoted to the promotion of narrow groups of artists which are perceived by those outside of them as self-congratulatory micro-cultures. The personal is promotional. Furthermore, positive developments in Scotland can take on a peculiar, over-ideal hue when seen from outside:

> Scottish artists returning from abroad, frequently complain of the romantic, idealistic picture many seem to have of artistic life in Scotland. Londoners in particular seem to need to believe in Scotland (Glasgow specifically) as the home of egalitarian, socialist co-operatives where everyone supports and nurtures in a pseudo-cultural wonderland. The reality, of course, is infinitely more complicated and contradictory. The idea that the lack of private contemporary galleries in Scotland is responsible for the present flowering of artistic production, glosses over the competing and conflicting pressures that exclusive public funding generates.[2]

The crisis of value in the visual arts and its defensive self-confidence is at odds with the fierce assertions of Scottish literature (two new collections are a case in point: *Ahead of its Time* edited by Duncan McLean, and *Contemporary Scottish Fiction* edited by Peter Kravitz). There are complex historical reasons for the mentality of inferiority located in negative perceptions of Scottish culture, as Craig Beveridge and Ronald Turnbull have indicated in *The Eclipse of Scottish Culture*.[3] The Scottish diaspora has further combined with cultural colonisation to undermine a position of strength drawn from rich philosophical and intellectual traditions. The vulnerability of the visual arts lies in its inherently middle-class values that still feign transcendence from critical realism:

> The Scottish art scene occupies a particularly precarious position at present. On the one hand it's continuing to successfully expand, with home grown and Scottish based artists consistently attracting national and international attention, while simultaneously, these same artists operate in cities hovering on the threshold of economic, social and political collapse.[4]

The challenge is in identifying gaps to 'recover alternative images and discourses' and locate opportunities to engage with the mode and the means of image production and distribution. The function of the arts contributing to community development does not have the critical import it deserves—not yet anyway,

but there are the sources and the desire for a more intensified creation of communication infrastructures in small, local enclaves that can contribute to a wider spread structure.

The realm of 'new media' offers a great opportunity to push the debate about art practice to new levels and to cover the less centralised areas of the pure and anodyne concerns of the art world. In Scotland, the development of these areas has been impeded by the lack of strategic support that could have legitimised the video art aesthetic, for example. The irony here is that the current practice of video projection is now firmly placed within an institutional context with no lineage being traced through its organic roots or discussion involving existing proponents.

The authority of galleries plays a part here in the interpretation of any history, a case in point being a one-day forum in June 1997 entitled *Video Visions* at Edinburgh's Fruitmarket Gallery. Whilst the event acknowledged the existence of the experimental moving image, it also demonstrated the paternalism and self-censorship at work in the Scottish mainstream by completely ignoring any Scottish input. The individuals giving presentations, largely from London and Oxford, are credible players in the field, but the influence of the Scottish presence desperately requires wider exposure and discussion, and subsequently its absence puts into question the motivations of the organisers. I welcome the stamp of legitimacy on the back of a Bill Viola exhibition, but only in recognition of the particular context and place in which it is taking place.

You cannot have polemics without a vision or a practice. The history of cultural practices has to be seen in accumulative terms with the traces of the forerunners in evidence through institutional settings and with the necessity for research and new ideas and problem solving built-in. It is this that will produce a more provocative and futuristic challenge to what has gone before.

Notes

1. Ian Hunter, *Roles and Reasons: The Scope and Value of Artist-Led Organisations,* edited by Susan Jones, published by AN, Sunderland, 1997.

2. John Beagles, 'Under the Central Belt', *Variant,* vol. 2, no. 2, Spring 1997, p. 12.

3. Craig Beveridge and Ronald Turnbull, *The Eclipse of Scottish Culture,* Polygon, Edinburgh, 1989.

4. Beagles, 'Under the Central Belt', p. 13.

94:95

After a Fashion: Regress as Progress in Contemporary British Art

Peter Suchin

In the last few years, the notion of the Britishness of British art has undergone some intriguing vicissitudes. A decade ago, Matthew Collings and Stuart Morgan, in a discussion published in *Artscribe*, proposed that no such thing as a uniquely British manner of art practice existed.[1] Charles Harrison continued the theme in the following issue, in a long review article examining the Royal Academy blockbuster show, *British Art in the Twentieth Century*.[2] Harrison was more than a little critical of what he referred to as the exhibition's 'dextrous turning of art's complex resources and references to a single expressive end: the celebration of one universal culture, one journalistically exciting human condition...'. This, Harrison concluded, was 'provincialism of a deep and insidious kind'.[3]

Carried in the same number of *Artscribe* as Harrison's review was a notice for a series of exhibitions by Terry Atkinson, entitled, one would think ironically, 'Brit Art'.[4] The irony is evident in that Atkinson's deliberately disaffirmative work concerned England's occupation of Northern Ireland. Atkinson's Brit Art had nothing to do with what now goes by that name. Today, the mainstream marketing of Britishness continues, but certainly without irony. A recent copy of *Vanity Fair* displayed on its cover the clichéd claim that 'London swings again', and provided its readers with a chart purporting to map the comparisons between 'Swinging London' and 'Swinging London Mark II'.[5] The tone of the London section was nauseatingly chummy, in keeping, it would seem, with most other media accounts of the capital's allegedly replenished 'buzz'.

In an essay that goes some way towards disentangling several prevalent notions about recent London-based art, not least that Brit Art forms a coherent and critical avant-garde, Mark Harris suggests that the belief that there is something intrinsically British about the work of this alleged vanguard is little but a linguistic construct:

> The implication that this celebrated nationalism might be a retreat
> from a trans-national style, into what is locally potent, is hardly tenable
> given this participation in the conventions of avant-gardism, now clearly
> the orthodoxy of art institutions. Along with certain other characteristics,
> this aspect reveals a focus common to much international contemporary
> art suggesting a continuing impossibility for regionalism and the subsequent
> irrelevance of this acclamation of Britishness.[6]

Several other commentators share Harris' view that Brit Art is, in large measure, an entity fabricated by journalists, galleries and other related institutions. Diverse aspects of this orthodoxy are, it might be argued, increasingly being questioned. Charlotte Raven, writing in *The Guardian*, appears to be uttering a clutch of heresies in a recent article disputing the supposedly-hunky-dory status of the present cultural climate. She observes that:

> The current London art scene... is neither aesthetically satisfying,
> nor conceptually exciting... if someone like Tracy [sic] Emin can emerge
> as the latest sensation, it's a sign that we've stopped asking any questions.
> It's surely a happy coincidence that we have become undemanding at
> the moment when there's least on offer.[7]

Also in *The Guardian*, Adrian Searle, commenting on the Institute of Contemporary Art's exhibition, *Assuming Positions*, another Brit Art-related display, notes:

> This must be one of the most inert pieces of programming I've seen
> in a long time. No one I've spoken to has a good word to say about the
> show.... The ICA strains to be relevant, radical and hip. But this is just
> another desperate stumble across the frontiers between art and non-art,
> fashion, pop and pap.[8]

It is curious to see this shift in attitude manifesting itself. However, certain interested factions continue to propose that a return to the 'golden age' of the 1960s is taking place. The very possibility or impossibility of an 'exact' repetition of whole periods of time is never, of course, argued

Frontispiece: Carina Weidle, Dog, *1992*

Right: Marty St James and Ann Wilson,
title unknown, 1986

through.[9] How could it be that the present is a reassertion of the 1960s? The idea is clearly absurd. What we do have is a kind of coercion in the form of a reiteration of the bland idea of a return, carried out through the mass-marketing of clothes, music, and various other commodities with a 'Sixties' look but also, importantly, by an emphatic verbal and textual pressing home of the claim that the British economy and culture has revitalised itself.[10]

This repetition has, to be sure, its art-world examples. The present incorporation of the 'everyday' and the 'popular' into the frame of art clearly mimics some of Pop art's most accepted contingencies. When Hal Foster discusses what for some has already become a kind of antiquity, the New York art world of the 1980s, he could easily be referring to the current British context: 'More and more, art is directed by a cynical mechanism akin to that which governs fashion, and the result is an ever-stylish neo-pop whose dimension is the popular past'.[11] In the 1990s, the erstwhile radical practices of the 1960s return in simulacral form. Anya Gallaccio's flowers and rotting fruit echo strands of Arte Povera, just as Gary Hume presents us with a flaccid rehash of Warhol. Ian Davenport's process-based painting, with its use of drips, chance and the artist's apparent indifference to actual results, mirrors key features of conceptual art's realignment of conventional artistic mores. Likewise Tracey Emin's 'expressionist' self-portraits return us to an already once-repeated painterly trait, but without recognition, obviously, of Benjamin Buchloh's powerful critique of such mannered inanity.[12]

The above are but the most apparent of examples, and one could extend this list considerably. Such cultural introspection has its defenders.

98:99

Left: Simon Patterson,
J.P. 233 in CSO Blue, 1992

Opposite: Richard Wilson,
One Piece at a Time, 1987

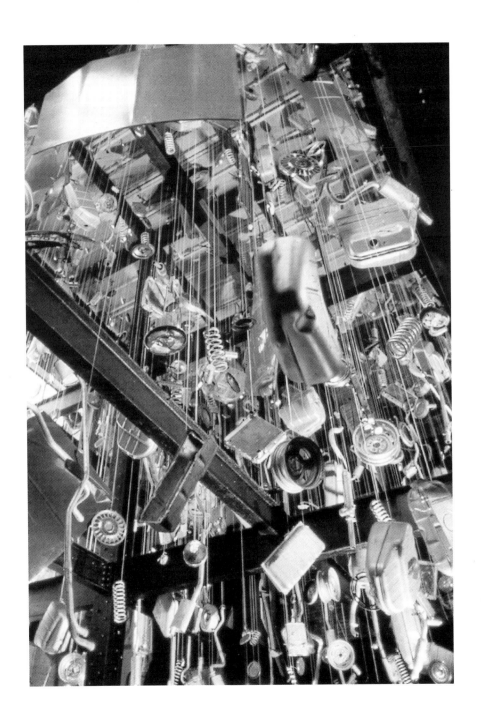

Liam Gillick has talked about how, in the 1980s, the practices of the 1960s and 1970s were considered exciting: 'Certain conceptual and minimal work seemed... quite radical, interesting and worth reconsidering'.[13] Similarly, Michael Archer, whilst pointing out the parallels between work made thirty or forty years ago and that produced much more recently, argues that:

> What is being made now is well beyond the neo-conceptualism of
> the 80s. It is not a working through of the implications of earlier
> questions. Certain things have been internalised, accepted. This is
> just how you make art now and that familiarity, of course, opens up an
> entirely new area of enquiry. Gallaccio's work is nothing like Ruscha's,
> Floyer's is nothing like Wegman's, and so on. The ability to recognise and
> the requirement to work at understanding in what the differences consist
> is... the most significant legacy of conceptualism. To talk down the worth
> of today's work because of an apparent resemblance to earlier production
> is not to have absorbed the lesson.[14]

Although Archer's argument has some reflexive complexity, its author does not clarify what exactly such 'differences' between the old and the new work might be. Elsewhere, he attempts to defend the work of contemporary practitioners from Harris' accusations to the effect that much of Brit Art is shallow and apolitical, attending to ostensibly important themes in a merely superficial manner. Referring to Damien Hirst, Harris proposes that 'it remains to be proved what his work reveals of death other than its idle referencing', going on to comment that from a generation of artists widely considered to be making radical art 'you'd expect to see occasional instances of deep engagement'. Had the possibility, Harris asks, of 'a more profound collision of aesthetic and

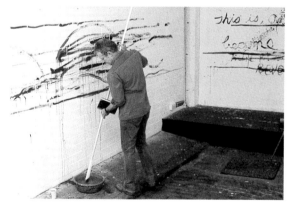

Right: Stuart Brisley, Red Army II,
1987

political radicality' been 'ironed flat by 16 years of conservative rule?'[15] Archer disputes Harris' claims, though without really countering his accusation of shallowness. 'These people', Archer emphasises, 'are making art, not theory'.[16]

While it would be absurd to dismiss all art recently produced in Britain as merely derivative, Harris does have a point. Much Brit Art is too much like work made some years before it to be of much interest in its own right, save as a pointer to the earlier work. 'Much as I find Hirst an entertaining character', writes David Lee, 'there is nothing in his work which... has that... re-call factor which makes the finest works of art rewarding on visit after visit'.[17] He continues:

> I should like those who believe that Hirst is a great artist to explain
> to me why I should go to the work of an amiable, badly educated
> innocent... for the quality of his 'ideas', his 'concepts' when I might
> go to Wollheim or Berger? Is it possible that an artist for whom profundity
> is apparently synonymous with undergraduate platitudes and the
> repeating of Big philosophical questions (so inimically expressed in
> the language of the streets: 'life and death and all that stuff'), is going
> to be enduringly attractive to anyone other than those of his peers
> nurtured on the same diet of what passed for teaching and examination
> in the 1970s and 80s?[18]

A major factor in the development of Brit Art is that somewhat nebulous network of institutions, the art schools. Michael Craig-Martin, responding to the question, 'Is there a crisis in Britain's art schools?', rightly answers in the affirmative, referring to the recent restructuring that has taken place throughout the country.[19] The results of the *Coldstream Report* (published in the early 1960s)

Left: Jon Bewley, True Confessions,
1982

were, he says, 'a brilliant solution... the envy of colleges throughout Europe...'. With Coldstream, teaching had become 'primarily the responsibility of part-time staff, practising artists free from administrative responsibility'. Such an approach has been maintained at Goldsmiths College in London (where Craig-Martin teaches), a school very much linked with the spectacle of Brit Art.

Goldsmiths' MA in Fine Art, in particular, stresses the relation of critical theory to artistic practice, a model emulated by many other British MA courses. 'Goldsmiths is not a new phenomenon', Craig-Martin observes, 'it is, in fact, more closely related to art schools of twenty-five years ago than it is to most other schools today'.

Dave Beech and John Roberts have voiced the view that the most recent wave of young British artists are reacting against an institutionalisation of critical theory.[20] Such theory-related work as is encouraged by the aforementioned MA courses is itself an entrenchment of an approach taken by artists in the 1980s, and which formed a penetrating attack upon the then current conventions of fine art practice. The kind of artists Beech and Roberts have in mind—their examples include Victor Burgin, Mary Kelly and Hans Haacke— were at least as much engaged with theory as they were with the making of actual art objects. With the incorporation of such work into the 'academy', the only critical move left to artists keen to refuse the (already recuperated) roles on offer is, according to Beech and Roberts, a deliberate anti-theoretical position, employing what Roberts has described as 'the thinking stupidity of the philistine who sees the rejection of the dominant discourses of art as a matter of ethical positioning'.[21] (Here Roberts is discussing, amongst others, the group of artists collectively known as BANK).

Beech and Roberts' theorising of the philistine conveys a weighty layer of critical authority to practices within the contemporary British art scene which might otherwise look as artless as they actually are. BANK's carefully disaffirmative framing of the everyday within the studied disarray of their spectacular installations is nothing if not critically informed. Tracey Emin, on the other hand, does not seem to be merely playing dumb when she reveals to Stuart Morgan her passionate interest in the mumbo-jumbo world of astral projection and levitation, nor when she naively says that she knows she will 'never be part of society'. 'That's what's lovely about being an artist: I don't have to.'[22] This is art school nonsense of the sort that the importation of theory into art education was intended to dispel.

Above: Helen Chadwick, Blood Hyphen, *1988*

Of course, fine art education, even with its complementary studies supplements and well-meaning artist-tutors, hardly ever manages to completely smash the spell of romantically inflected contentment that art students hold regarding their all-too-authentic ignorance. There are several reasons for this. In the first place, the ideology of the artist as the bearer of an alienated but esoteric persona, a subject somehow 'different' to the rest of the pack, is still extremely powerful in our culture. At primary and secondary levels of education, those pupils who are considered to be academically inept are pushed towards the art room, and, very often, the attitude towards 'theory' amongst art school staff is equally absurd.[23] This is even the case with MA courses in Fine Art, where theory is sometimes viewed by the students themselves as a restraint upon self-expression, a necessary evil to be confronted in order to obtain a higher degree. Even when there is an enthusiastic interest in theory, it can be badly taught, its relevance to individual practices left unclarified.[24]

Furthermore, the carrying out in recent years of spurious improvements, purportedly as part of a democratisation of higher education, has meant a lowering of standards with respect to the abilities of students accepted onto degree courses. A situation in which colleges can maintain old funding levels only through an increase in student numbers has led to an 'open door' policy. Some colleges have been allowed to set up new degree courses for which they have neither adequate financial resources nor appropriately informed staff, and even within long-established fine art departments the absence of sufficient studio facilities, and, again, of appropriate staffing has meant that the 'dumbing down' discussed by, amongst others, Beech and

Left: Matchbox Purveyors,
Two Dimensional, 1979

Roberts, is a far less duplicitous pose than some would have us believe. Over-paid professors with nothing to profess, and ranks of managers for whom the avoidance of responsibility has become a fine art are thick on the ground, whilst impecunious students take up poorly paid part-time jobs in order to pay fees for 'full-time' courses they do not have the free time to attend. Such a situation cannot have contributed to the mini-renaissance that is erroneously said to constitute Brit Art. What *is* common to both art education and to Brit Art is the pernicious and unsubstantiated image of brilliance each employs to obscure the actual reality of decline. One might, with Kierkegaard, suggest that 'ours is the age of advertisement and publicity. Nothing ever happens but there is immediate publicity everywhere'.[25]

One should not neglect the element of fashionableness involved in fine art, a field which must to many today appear to be a site of easy success. The categories of fine art and pop seem increasingly indistinguishable. While this might be thought to be a good and democratic thing, it is often forgotten that the pop world is a multi-million pound capitalist industry, not a neutral, 'natural' ideologically untainted space. Richard Gilman's snapshot account of fashion is to the point when thinking about today's art-pop scene:

> Caught up in a fashion, you experience an inability to determine—
> should you make the attempt—its true relation to yourself, since
> fashion is, by definition, what has been set in motion and maintained
> by others.... Fashion is also by definition the ephemeral masquerading
> as the permanent, the arbitrary as the inevitable. Fashion chooses
> rather than is chosen and imposes 'truth' instead of allowing it to
> be determined.[26]

Amongst the most highly visible of art-world fashions today is that of the artist-led organisation. These, too, give contemporary British art the look of a lively mini-democracy. Control of artworks and their presentation would appear, in this context, to be in the hands of artists rather than profit-motivated galleries. Whilst in principle this organisational strategy is commendable, one wonders just how 'radical' such ventures actually are. That artists curate their own shows is one way of avoiding the problems thrown up in dealings with officially-sanctioned 'experts' but so-called alternative presentations too often, in Julian Stallabrass' words, 'claim to be unique but... say much the same thing: that they are "alternative".'[27] Such blunt signification parallels the 'idle referencing'

mentioned by Harris, wherein something of considerable import is hinted at within a given artwork but never actually delivered. Harris also has something to say about alternative shows, which he sees as 'incredibly opportunistic; the feel of the casually installed, of the rough edge, acquires seductive commercial appeal... ultimately serving the exchange-value of the artist's career... If an "alternative" hasn't the means to supplant its other then it is only a part of that other'.[28]

This lack of critical distance between the orthodox and the purportedly alternative needs to be borne in mind when considering Brit Art's hyped sense of difference and novelty. The supposedly transgressive nature of young British art has done nothing to prevent its recuperation within the mainstream museum, as the exhibitions *Life/Live* and *Sensation* clearly indicate.[29] *Life/Live* made much of the ideology of the artist-run organisation, zooming in on Britain's quirky, delirious, febrile 'scene' of counter-mainstream spaces and 'street credible' strategies of attraction and display. *Sensation* was, surely, the final nail in the coffin of the claim that Brit Art represents the authentically scathing gaze of disaffection or dissent. 'Lack of talent and originality', writes Searle, 'have proved no impediment to the continuance of what, now, looks like an academy of the hapless'.[30] Brit Art's regimented celebration of the puerile, together with its oxymoronic embrace of the obviously shocking, long guaranteed its place in the Academy. As an officially sanctioned avant-garde it could have no other destination or intent.

Life/Live was, as a celebratory exercise, a smoke-screen hiding as much about art in the UK as it revealed. It certainly did not point up the negative

Right: Stefan Gec, Trace Elements, *1990*

aspects of artist-led organisations. Participating in artist-led ventures has become an unexamined convention, the unspoken 'guarantee' of professional artistic status. But whilst those artist-led organisations that do run efficiently administered galleries and projects are not to be mocked, achievement in this field cannot be the proof of artistic success, though the two are often confused. At a time when Britain (particularly London) is represented as 'cool' or 'hip', being seen in the most fashionable gallery or club contexts takes on an exaggerated importance. Copying the currently prevalent social codes is, in any case, easier than entering into any kind of deep involvement with the practice of making art.

Whilst this reading of the 'artist-led' tends towards the negative, there are, for sure, exceptions to the rule. One of the most important of these, Locus+, occupied a prominent place within *Life/Live*. Formerly operating as the Basement Group (1979-83) and as Projects UK (1983-92), this organisation has consistently emphasised the relationship between art and the everyday in a manner that is only now taking hold within the would-be alternative scene. Based, not in London, but in the North East of England, yet collaborating with artists of many nationalities, Locus+'s artistically informed curatorial practice combines a responsibility to their artist-clients with an acute awareness of the demands involved in presenting work within the public domain. Conventional curation, it might be argued, encourages predetermined patterns of practice and response, whilst many artist-run ventures fail to adequately address the question of how works of art are publicly received. The latter agencies are frequently, as Harris has observed, much closer to mainstream practices than they would have us believe. Without blowing the tired trumpet of the 'alternative', Locus+ side-steps both the establishment's commodification of culture and the mediocrity of much that purports to be artist-led. Their example shows that the promotion and support of artists outside the orthodox gallery context can be practically addressed without compromising either one's own curatorial independence or the integrity of the artist's work.

Now that there is no longer any doubt about Brit Art's canonical status within high culture, its juvenile pretensions and its trite and predictable referencing deserve nothing less than the most rigorous of critiques. Future critics may well regard the frenzy over 'young British art' as little more than an immense spectacle, a vast but transient distraction, impressing on all and sundry its contingent if pernicious allure.

Notes

1. Matthew Collings and Stuart Morgan, 'True Brit: An Enquiry into National Character', *Artscribe*, no. 61, January-February 1987.

2. Charles Harrison, 'The Modern, the British and the Provincial', *Artscribe*, no. 62, March-April 1987.

3. Ibid., pp. 34,35. The writings of Peter Fuller exemplify the reductive nationalism to which Harrison refers. See, for example, Fuller's 'Against Internationalism', *Art Monthly*, no. 100, October 1986.

4. *Artscribe*, no. 62 March-April 1987, p. 2. See also Atkinson's exhibition catalogue, *Brit Art*, Gimpel Fils, London 1987. For a discussion of Atkinson's work and his ideas on art education see Peter Suchin, 'Ghosting and Greasing: Terry Atkinson's "Disaffirmative" Art', in Nigel Whiteley, ed., *De-Traditionalisation and Art: Aesthetic, Authority, Authenticity*, Middlesex University Press (forthcoming 1998). Michael Archer notes that Atkinson's work of this period echoes the sentiments of Marx's famous observation (at the beginning of his 'Eighteenth Brumaire' essay) about the repetition of history as farce, a point worth reiterating in the context of the present resurgence of forms of practice initiated in the 1960s and 1970s. See Archer's 'Brit Art', *Artscribe*, no. 63, May 1987.

5. *Vanity Fair*, no. 439, March 1997, cover and pp. 94-5. The 'swinging London' theme is also employed in Kate Bernard, 'Brave Art', *Harpers & Queen*, January 1996, p. 80, and elsewhere.

6. Mark Harris, 'Putting on the Style', *Art Monthly*, no. 183, February 1996, pp. 5-6.

7. Charlotte Raven, 'Does No One Hear a Bum Note?', *The Guardian*, 5 August 1997, section 2, p. 8.

8. Adrian Searle, 'Is this the Cutting Edge?', *The Guardian*, 22 July 1997, section 2, p. 10.

9. For a discussion of Walter Benjamin's analysis of the repetition involved in fashion, with particular reference to recent art-world trends, see Peter Suchin, 'Somewhere Near the Northern Edge: The Sense and Nonsense of the Centre', in Brian Ord, ed., *Artlanta*, Hatton Gallery, Newcastle-upon-Tyne 1996.

10. See Raven, op. cit. The 'return of the 1960s' theme is perhaps most easily accepted by people who are too young to recall the actual period, which was itself highly geared to the promotion of the young producer and consumer of culture.

11. Hal Foster, *Recodings*, Bay Press, San Francisco, 1985, p. 23.

12. See Benjamin H. D. Buchloh, 'Figures of Authority, Ciphers of Regression', *October*, no. 16, Spring 1981. The concern with the authentic in the work of Emin and others is a classic example of a category prevalent within art schools. It has been subjected to a lengthy critique in Terry Atkinson, 'Phantoms of the Studio', *The Oxford Art Journal*, vol. 13, no. 1, 1990.

13. Liam Gillick in 'Discussion', in Andrew Renton and Liam Gillick, eds., *Technique Anglaise*, Thames and Hudson, London, 1991, p. 8.

14. Michael Archer, 'Reconsidering Conceptual Art', *Art Monthly*, no. 193, February 1996, p. 16.

15. Harris, op. cit., p. 16.

16. Michael Archer, 'No Politics Please, We're British?', *Art Monthly*, no. 194, March 1996, p. 14.

17. David Lee, 'Damien Hirst', *Art Review*, vol. xlvii, June 1995, p. 10.

18. Ibid., p. 10. Hirst is already being read as concerning himself with the 'timeless' theme of the sublime. See Laura Wixley Brooks, 'Damien Hirst and the Sensibility of Shock', *Art & Design* (Profile no. 40, 'The Contemporary Sublime'), vol. 10, nos. 1/2, 1995. The reference to 'undergraduate platitudes' is apposite, and might well be applied more widely. Referring to his own youthful achievements Hirst himself observes that 'if you can do the art world at 32, it means there's something wrong with the art world, not that you're a genius'. See Steve Beard, 'Nobody's Fool' (interview with Damien Hirst), *The Big Issue*, no. 248, 1-7 September 1997, p. 12. Hirst makes a similar point in an interview conducted by Mark Sanders, 'Pop Art: Revolution for Your Breakfast', *Dazed & Confused*, no. 34, September 1997, p. 48. Noting Hirst's closeness to the fast turnover practices of advertising, Michael Corris suggests that 'London's infatuation with Hirst would indeed waver were it a less clubbish and more robust contemporary art milieu'. Michael Corris, 'Damien Hirst and the Ends of British Art', *Art/Text*, no. 58, August-October 1997, p. 69.

19. Roger Bevan, 'What is—or was—the Goldsmiths Phenomenon?' (interview with Michael Craig-Martin), *The Art Newspaper*, no. 48, May 1995, p. 21. Craig-Martin's links with the Waddington and Karsten Schubert galleries, and his connections with the Tate Gallery, hardly seem irrelevant to any assessment of the success of some of his former students.

20. See, for example, Dave Beech, 'Chill Out', *everything*, no. 20, 1996 as well as his 'Getting Carried Away', *Variant*, vol. 2, no. 1, Winter 1996; John Roberts, 'Mad for It!', *Third Text*, no. 35, Summer 1997, and also Roberts' 'Notes on 90s Art', *Art Monthly*, no. 200, October 1996; see also Beech and Roberts, 'Spectres of the Aesthetic', *New Left Review*, no. 218, July-August 1996. On the 'young British artist' nomenclature and myth, see Simon Ford, 'Myth Making', *Art Monthly*, no. 194, March 1996, a version of which is included in the present volume.

21. Roberts, 'Mad for It!', p. 35. Whilst Beech and Roberts report on the deliberately anti-theoretical stance of some of the artists associated with Brit Art, it is hard to see how such artists' rejection of theory is not itself a 'theoretical' position, whether knowingly or not. The refusal of theory is an already well-documented art school convention. On this see Terry Atkinson, 'Phantoms of the Studio'.

22. Stuart Morgan, 'The Story of I' (interview with Tracey Emin), *frieze*, no. 34, May 1997, pp. 56, 59.

23. On this point see Peter Suchin, 'The Treasure of the Perplexed Ignorance as "Bliss" in Fine Art Education', *Art Monthly*, no. 98, July-August 1986.

24. Whilst I feel that art schools should, as a particular kind of educational establishment, be defended, it cannot be seriously denied that there are problems. For a less pessimistic account, see Peter Suchin, 'Imperative Pleasures', in *Round Midnight 5* (supplement distributed with *Artists' Newsletter*, April 1997).

25. Søren Kierkegaard, *The Present Age* (1846), Harper Torchbooks, New York, 1962, p. 35.

26. Richard Gilman, *Decadence,* Farrar, Straus and Giroux, New York, 1979, p. 164. It would perhaps be instructive to compare some of Gilman's (and others') considerations of decadence, both as an idea and an actuality, with art practice as it stands at the end of the present century.

27. Julian Stallabrass, 'Artist-Curators and the New British Art', *Art & Design* (Profile no. 52, 'Curating'), vol. 12, nos. 1-2, 10, 1997, p. 80. On artist-curators see also John Beagles et al., 'Your Place or Mine?', *Variant*, vol. 2, no. 3, Summer 1997.

28. Mark Harris, 'Trading Up or Selling Out', *Art Monthly*, no. 203, February 1997, p. 2.

29. *Life/Live*, focusing upon contemporary art practice in the UK, opened in October 1996 at the Musee d'Art Moderne de la Ville de Paris, moving to Portugal in early 1997. Volume 2 of the accompanying catalogue is a descriptive list of some fifty artist-run spaces and organisations. See *Life/Live*, Musee d'Art Moderne de la Ville de Paris, 1996. *Sensation* occupied the Royal Academy galleries during the last quarter of 1997. Coming ten years after *British Art in the Twentieth Century, Sensation* can be seen as a kind of supplement to the former show. One is reminded of the promotion within Europe during the late 1950s of Abstract Expressionism, together with its subsequent installation in New York's Museum of Modern Art. The RA's overtly commercial approach to the presentation of *Sensation* was criticised even before the exhibition opened. See Andy Beckett, 'Shock Art to Shop Art', *The Guardian*, 28 August 1997.

30. Adrian Searle, 'Roberta, you and Bob too', *The Guardian*, 9 September 1997, section 2, p. 11. Whilst discussions of the academicisation (and therefore preservation) of recent British art are worth quoting in the present context, the vanishing into virtual obscurity of individual artists (a key component of the motor of fashion) is also worth noting. As John Stezaker recently observed, 'Some of the earliest figures that have been associated with so-called young British art are already half-forgotten figures, two years later. It's extraordinary, the movement; I don't think I'm just being conservative and old fashioned when I say that this is a very, very severe limitation in terms of the role that it gives to artists... perhaps the merger with the strategies of media culture [is] so indistinct now that they're interchangeable which is a very frightening thought.'. John Roberts, 'Interview with John Stezaker', in Roberts, ed., *The Impossible Document: Photography and Conceptual Art in Britain* 1966-1976, Camerawork, London, 1997, p. 162.

𝒜𝒹𝒹𝑒𝓃𝒹𝒶 −9 The absurd meme obstructs the naturalisation of values, refuses to surrender the aura of unique experience without which experience itself would be entirely subject to the nexuses of communication processes. The absurd is the obstacle to the transference of the aura, its disappearance from the individual object; the aura based on distance which once safeguarded the authenticity of the object, its singularity in time and space. Its loss now proceeds from the object to the subject; a procedural progression which effects a severance of connectivity on another plane, between means and ends. Within the networks, a threshold is crossed on the plane of morality to allow a new dimension of moral plasticity:

> there is a two-fold development... a transmutation of values and the game with the resulting amorality, a game that as it proceeds becomes more romantic, and more and more pathetic. With this game one enters the domain of hyper-morality. You play the game with amorality: you do not discard morality—rather you retain it, but purely as one of the rules, as one of the conventions which are completely perverse but nevertheless necessary if the game is to proceed at all.[12]

+10 On the plane of the de-aurified subject. Memetic replication occurs at the level of simulation; simulation copies not reality, but simulation. Perfect replicas of desires and fears. The externalisation of the subject is essential to maximise the flow of desire. Desire flows in mass, in proxy. It has become transgenic; it belongs no longer to a sole species. Its allegiance is not to the body but to the maintenance of its circulation. As bodies turn into things and activities become self-defining, the state of involuntariness evokes the inevitable law trailing blind contingency that Heraclitus called *enantiodromia* (a running towards the opposite). The *enantiodromia* takes the form of an 'autogenerated encapsulation': viral figures of autism which repeat through successive circles of objectification, through the individual, to the collective, the material, the virtual, the natural and the cultural. A symbiotic psychosis, an inability to form mutually beneficial interdependence.[13]

The *enantiodromia* is communication stuck in its mirror phase; at each level, it recognises only itself. Representation mediates all ethics, difference is negotiated through the perceptible. The subject, forced to externalise as a means of survival, survives through the projection of difference. The destiny of difference so reaches its own viral plane with the proliferation of others saturating every discourse, the plague of difference.

112:113

What are you Looking At? Moi?

Heidi Reitmaier

In 1979, at the Slade School of Art, Catherine Elwes spent three days in a glass-fronted white room, menstruating. Silent and writing on the glass with a felt-tipped marker, she answered questions put to her. *Menstruation II*: a work that sought to reconstitute 'menstruation as a metaphorical framework in which it becomes the medium for the expression of ideas and experiences by giving it the authority of cultural form and placing it within an art context'. Nine years later, in the now notoriously paradigm-establishing exhibition *Freeze*, in the Docklands area of London, Sarah Lucas hung a brick from a brick wall. Both of these were performative gestures, though something more than time separates them.

In the context of their preceding works (Elwes' performance, her writing and her films and Lucas' photographs and found-object sculptures), both of these pieces make some literal and metaphorical references to the body; they query traditional assertions about the role and place of the artist and, in their contemporary contexts, challenge respectively prevailing notions of the feminine.

Some might argue that Elwes' works are literally intended as political gestures aimed at the institutions and establishments that ostracise and oppress women, women artists and their work. Like most fine art institutions in the 1970s, the Slade, where the artist studied, suffered its share of misogynist contempt and tutorial espousals of formalist, expressionist aesthetic ideologies. *Menstruation II* could have been seen as not being concerned with Art at all, except to use an umbrellaed understanding of it as a punch-bag—and more to do with personal vendettas and a politics of gender.[1] It is easy for some to dismiss this work as having little to do with Art then, and a lot to do with politics. Hmmm. Lucas on the other hand, it could be argued—and it is by some—is not involved in any such investigation. There is rarely much pretence, on her part, that she is. Her works are understood more generally as brashly cunning, witty interventions addressing not only the current visual art scene and its cadres, but more particularly the traditions of sculpture. Lucas, it is regularly stressed in the mainstream, asks some serious questions about Art *per se*.

It is historically fairly safe to generalise and say that the curatorial projects and events, the work produced by Elwes, Mary Kelly, Carolee Schneemann, Hannah Wilke, Susan Hiller amongst others, throughout the 1980s specifically addressed the various aspects of the feminine, femininity and woman-ness

...ally known mine, which you may think ... is re... ... on to these voices of ...
"Why are you doing it here?" you not quiet "My ans...
... of us who can pollute your pre... expose me to go
... to spit and shit in peace) you ...

I go to bleed?___ I have made this space for that
bleed on the bag?" you may ask ... For four days??
... I bored? NO I'm not bored — Have I eaten? Y...
... ... I been here? About a day. Does it work?
...up at you like an animal in a cage? Ye... ...
... just wonder about what they are doing and wh...
... they are reacting to me — but its getting eas...
... to work while being watched. You're being ...
... it now. 3.37 Reached boredom. Bris...
... the purpose of the work? — The principal purpose of th...
something public which is normally kept hidden ...
... instrumental in conditioning my view of myself — as — I wish
... to reverse this process. ③/⑤ these little scrawls ... pieces of paper do they
... help or do they hinder? — for me they detract — They are ... mental raw material

... which communicable ideas are drawn. The residue is of value to me
personally, but has been sifted out of the work. However it is as much a part of
the process of this piece as the blood it also some trace of it must remain. In
the last menstrual piece the "verbal flow" was unprocessed — which weakened the
work from the p.o.v. of the observer ④ the blanket — what is it there for? does it help
in any way (the purpose) does it hinder? none it hinders — It is there to keep me
warm. Any added discomforts would detract from the experience of menstruation.
But its fine — I'm not cold. ⑤ The fact that you easily communicate
(by speech) does it help or not? no it doesn't Tuesday 15th May. Cate: No it
does not help the image — but it helps me — a conflict of loyalties? ⑥ The
fact that you are so diligently active writing — does it help the image?
No it does not Cate: I write when I need to. As you point out:
"The text would seem to be the communication form ..." My need
to communicate appeals to be insatiable instrument. and
in this situation I allow only consid... / thought
to be communicated. My conversation lack... ... / given
the opportunity. I would talk in... to keep up with
the pace of my usual conversational to write twice as
fast/a twice as long — hence the writing. If it upsets
the image — its a necessary evil...

⑦ Why is the clock so important as an image can be there, but needs
being covered in some way to reduce its visual prominence: The clock's visual
prominence is now much reduced by the surrounding writing. As an image its
importance lies in its capacity to suggest the temporal constraints of the
work. ie. the blood follows its own time-table (... the intervention of pregnancy
or oestrogen) It determines the timing of the work & its duration. The
cyclic nature of menstruation is regulated by a fairly constant temporal
pattern. All this functions within the larger ... scale of a lifetime. For me
the clock carries these meanings ⑧ Is the cushion in the best place to reveal
evidence of the transference of blood from you to it — and on it becomes symbolic:
No it does not Cate: I'm sorry Stuart. I do not understand this question.
⑨ Concentration by you on what you are both consciously and
in a way accidentally — needs concentration ⑩ It is far ahead of
the last menstrual work Cate: Thank you Stuart. Does this mean
that I am, at last, worthy of the prize?

Frontispiece: Fran Cottell, A Meeting Outside of Time, *1988*

Previous: Catherine Elwes, Menstruation II, *1979*

Above: Sarah Lucas, Black and White Bunny, *1997*

and opened up the space for work like Lucas' to be made. The type of explorations undertaken then, and still undertaken by these women, whilst consistently nominated as marginal, introduced to the cultural consciousness novel forms of materials and methods of articulation of the body and sexuality. Even, more than this, it established a visual rhetoric of image-making and a certain form of status for women artists.

It is perhaps too easy to see why the work of Lucas and some of her peers (I am thinking here of Tracey Emin, Karen Kilimnik and Sue Williams, for instance), which is riddled with references to gender and sexuality, is so comfortably assimilated, discussed and boldly categorised, in such events as the transatlantic *Bad Girls* exhibitions, in terms of these earlier practices.[2] Work like that of Elwes and others is set up as the logical predecessor to *any* current practice that deals with gender—be it framed as feminist or not. If the 1980s feminists were not fighting for what Lucas has achieved, runs the new thinking, the ability to be bold, brash and swaggeringly boyish, then what could it all have been about?

Presently, we have Lucas as the deviant, able lass who says what she wants when she wants. The victory for twenty-five years of feminism is made in her image. But by whom? In the mainstream national and international art media, it is Lucas that consistently surfaces as the individual who heroically claims her identity in her work—like Tankgirl. However, not only is the focusing on and highlighting of Lucas a bit disconcerting (she would have to be some kind of artist to live up to all that is claimed for her), not only is the way she has been selected and constructed all too uncannily familiar, but someone, somewhere along the line has got it all backwards. For all that she has been presented as the hard-stare of British femininity, it's starting to look as if she is a personality concerned much more with the personae and practices of Fine Art. The bluster about her phallus-wilting self-sufficiency might be masking the fact that she is a traditional artist, with rather traditionally formal and traditionally avant-garde concerns. This is worth investigating a little to see how the political and cultural poignancy of work by other contemporary women artists (Kerry Stewart and Cathy de Monchaux, for instance) has been shadowed by the manufactured image of Lucas and by the assimilation, in the mainstream at least, of her work.

Where does Lucas come from? As far as her public persona is concerned, she originates in her own work. Try this, Gordon Burn on *Bitch*: 'the stereotypical stroke-book image of a woman bending forward, offering herself; a pastiche of male fantasy that, as reclaimed by Lucas, is simultaneously crude, repellent, engaging and funny'.[3] Not only do the readings of Lucas' work get mixed in with a persona and a biography of the artist Sarah Lucas, but the figure of Lucas, already a heroically mythical one, is just a playing through of a variety of masculine tropes. This deference towards masculinity certainly is not what Catherine Elwes was up to. Burn, further, relays the comments of a friend of Lucas who says that the artist has found 'a completely genuine way of being and her femininity shines through it. There's no artifice involved, which is very liberating for women. No tricks or games with hair and breasts and high heels, and yet she's totally like a woman in every way'.[4] So Sarah Lucas is supposed to have finally attained the cultural transparency of a man. No artifice here, just a genuine, straight-forward, no pissin' about bloke. Please.

There is more. John Roberts and his tragic claims concerning gender and the 'Philistine':

> In fact, the increased tolerance amongst women artists for the profane and illicit is perhaps where the voice of the dissonant philistine is at its strongest at the moment. Talking dirty—literally—and showing your bottom for the sheer delight of it has become a proletarian-philistine reflex against 80s feminist propriety about the body. Reinstating the word 'cunt' as a mark of linguistic pride and embracing the overtly pornographic and confessional, have become a means of releasing women's sexuality from the comforts of a 'progressive eroticism' into an angry voluptuousness.[5]

(I am here tempted to re-cite Laura Mulvey on Allen Jones—'You don't know what is happening, do you ...'.[6]) For all the work put in by women artists over the past twenty-five years or so in attempting to redefine the image of femininity, we still see the astonishing arrogance of writers like Roberts and Burns rubber-stamping acceptable degrees of transgression. Not only that, but reading these contemporary deployments as pseudo-appropriations or methods of assertion marks the feminist as a humorous rebel, and reduces the work to trite clichés which demand attention only because of how loud one is shouting rather than what one is shouting about. Lucas' demeanour is a complex play of identifications, defences and self-deprecations, but also it is quite simply

Above: Allen Jones, Chair, *1969*

an adoption of a stylistic guise as a visa, a distraction. It's a difficult game and, due to circumstances, Lucas may not have played it too well. These circumstances are open to description.

Recently, at Deitch Projects in Soho, New York, a male Japanese artist Noritoshi Hirakawa requested that visitors donate their white underwear and hang it up in the gallery on drying-trees as an element of his installation-in-progress.[7] His reasoning—there are no boundaries or distinctions in underwear, they are the one 'universal' signifier. Yet there are differences. It is one thing to assume that underwear is not riddled with signs of class, race, gender, health and the like, but, it is quite another not to recognise that mostly all the underwear donated was done so by young, healthy, white women (or should I say girls). Flashing your knickers is a well-established, fairly provocative and exhibitionist thing to do; neither lamentable or praiseworthy. I am just saying that this sort of in-your-face sexual cheek is not the sole preserve of certain British women artists, even if someone like Waldemar Januszczak does make claims for the originality of such gestures. He says that Lucas 'joined by Tracey Emin, Gillian Wearing and Georgina Starr have all had significant shows and made noisy contributions to the broadcasting of a loud new voice in British art: urban, cocky, female, fearless'.[8] Yet, any issue of *minx* will concur, it is titillation, teasing sexual ridicule. And it is not the same as simply sticking your arse out of the window.

Januszczak says new voice? One could argue, probably in a vulgar manner, that there is a simple denaturing of the radical character of the forms of practice that came before. Eating a sausage on video and writing obscenities for sexual parts and sexual practices (both performed by Sarah Lucas in 1990) is not that disturbing to contemporary consciousness when you consider first that the porn-flicks of the 1970s are now being collected and reprinted as connoisseurs' classics and, secondly, that decades ago, artists, like Carolee Schnneeman performed 'cocky, female and fearless' work. In *Interior Scroll* of 1975, naked, Schneemann pulled a scrolled script from her vagina. She read from it a story about a male film-maker acquaintance who had no difficulty in physically objectifying her as a dancer, though rather more difficulty in understanding her as a Fine Art practitioner. That is 'in-your-face'. Lucas' grebo aesthetic is no more aggressively subversive than the art-direction of any teen or style magazine. The Fine Art context may make it grittier, more marginal

Above: Sarah Lucas, Round About My Size, *1997*

and more 'real'. But what gang of wimpish aesthetes could be terrified of Sarah Lucas' boots and the world-modifying impact of her grubby Wranglers and crumpled Marlboros? That's the point: these boys aren't terrified of Lucas, or for that matter any other of the girlie baddies, at least not in the ways that they speak about them and their work. Gregor Muir to Cerith Wyn Evans, sitting next to him: 'I can smell her minge from here'.[9] Carolee Schneemann, on the other hand, might well have put the wind up a pair like this.

In no way do I mean to dismiss this contemporary work and say that everything was so much better in a dreamed-of 1970s and 1980s. Quite the opposite, in fact. What irritates is the way that Lucas has first of all been represented as a particular kind of person and then foisted on all and sundry as the *fait accompli* of feminism, feminist art and feminist art criticism. With a particular view of Lucas as the figurehead of feminism, the politics of gender and the project of feminism loses out. Why on earth should a gang of male artists and critics find themselves in a position to grant licence concerning just what an icon for women, or a particular woman, should be? Why should they be allowed the dominating say in what Lucas' taciturn dress codes mean? More to the point, and it is hardly ironic here, Sarah Lucas loses out. What happens to the subversive sophistication of her play with the traditional concerns of, again predominantly male, avant-garde sculpture and photographic self-portraiture when caught within the stifling embrace of the boys' desire for tomboys?

Licence and Genius

You have probably heard all of this before, but when it comes to discussing the significance of Sarah Lucas' work in the context of that by other contemporary women artists, the lads' reactions to the shapeliness of a leg or the coarseness of a public utterance does not have to occupy centre stage.

The issue of a rich and largely unbroken tradition of Duchampian avant-gardism, one that has obviously slipped from the collective mind of popular arts writers, is worth pursuing. Maybe Lucas' affectation of a masculinised front is a subtle assemblage of found motifs, or maybe it is not. But the ritual embellishment and situation of popular obscenity that turns up in work by Mike Kelly and Mike MacCarthy, as well as in the work of Beth B. and Sue Williams, could lend the view some credence. Could one say that a current,

justifying interest in the work of the male artists of the 1970s and 1980s (Woodrow, the Art and Language group, etc., and these artists' toyings with Duchamp) is caught up in a form of paternal nostalgia? Further, that the lingering folk memory of the activities of women artists of the period has had a nostalgic glow cast over it? Women in the 1970s showed spunk but it has been forgotten quite how genuinely unnerving their actions were to a masculine artistic perspective. They were unnerving to the degree that some people were literally left speechless. Elwes' work could not even be spoken of in terms of Art—only in terms of political intervention.

Molly Nesbit, in her essay 'The Language of Industry', has argued that there is implicit blindness in Marcel Duchamp's work to the sophistication of women's engagements with the conventions of fine art practice.[10] A clever man and well-versed in the manipulation of the prejudices about and weak spots for the professional antics of an avant-garde artist, Duchamp failed to grasp the fact that almost by its very nature, a female artist's use of something apparently universal and harmless as line-drawing is completely tied up in institutional male prerogatives. Those disinterested sciences, those engineering and anatomy courses that developed line-drawing as a speculative and information-gathering technique were established by and for men. For Nesbit this has been useful in the analysis of Duchamp's glass works where the line is supposed to be so radically subversive. Arguments have been made that even in the act of picking up a pencil or squaring up a sheet of paper, a woman artist is subverting convention. It is just that for some, it is difficult to see quite how that could be. However, the performance of the artist's personality has a similarly, invisibly-secured perimeter—it is just as sewn up with dreams of heroically self-possessed, arrogant genius. Behaving as an artist means performing to a particular audience. That audience behaves as a male audience, and hisses or applauds the work accordingly.

The current sentimental reflection on a period of artistic aggression that has brought Duchamp to light might be the place where a rescue of Lucas from the greedy eyes of the arts pages could be effected. Her various experiments with plumbing, fish and spitting in the street might turn out to be sniggering revisions of male art-writers' predilections and deifications. The unnerving aspect of *her* artistic forays might be overwritten by a garrulousness about her personality. On the other hand, they might remain easy-going supplications,

and if so, what of other contemporary women artists whose gestures towards masculinity have not come quite so starkly into the mainstream consciousness? What of work that generates much awkwardness when attempts are made to characterise it?

Kerry Stewart's recent video work of primal beasts off humping in a clearing shows a girlie involvement with patterns of desire.[11] First, there seems to be a separation of sexuality from any identifiable individual, a reverence towards almost abstract metaphysical rutting. Yet, this is set up to cast an eye over male attitudes towards simple-minded universalisation. The way this piece is staged is in terms of the visual rhetoric of a current romantic nostalgia for horror-kitsch that has formed the centre-piece to so many recent exhibitions in London. What is unsettling is the way that Stewart shows a fondness for these monsters. What is disturbing is the way that the conventions regarding the role of women in horror yarns is side-stepped. The elision, in Stewart's tableau, of the terrified woman removes an important aspect of the easily assimilable structure of the horror story. It is likely, though far from certain, that these monsters are heterosexual. Either way their cheery copulations disturb. Then, much to Stewart's credit, there seems to be a neat rise taken out of Freudian views of a mysterious female sexuality. One of the great controlling gestures in conversations about women's sexuality is that it is possessed of something unknown. Women are out of control. The image of Stewart letting her, unfortunately for Freud, all-too familiar sexuality off the leash is a compelling one.

Cathy de Monchaux's subversions of spheres of male artistic technical facility

Right and opposite:
Cathy de Monchaux,
Cruising Disaster, *1996*

are rather different in their nature.[12] Her most recent work quite decisively moves away from a crude metaphoric play. Unlike much current work dealing with questions of femininity and sexuality, de Monchaux toys not just with recognisable tropes but also gendered demarcations of space. In much of her baroque sculpture there are obvious feminine references. Initially, the sculptures look to be concerned only with vaginas, wombs—girlie places. Yet in the technical detail there is a conjuring of male craft and of a proficiency in the planning and high-tolerance handling of materials like steel and leather. The constructional details, so much a part of the overall imagery, specifically suggest certain gender and historical reversals. They bring to the fore the hierarchy between the male artisan and the female crafts-person.

Instead of disgorging linear or quite literal expositions of what it means to be a woman, to be a sculptor or to be a woman making sculpture, de Monchaux examines a plethora of contradictions and ambiguities implicit within her own personal anxiety, the traditions of sculpture, of form, of space, of decoration, of design and of gender. These, all riddled with their own historically specific meanings, prompt a series of contradictions within the work. In pieces such as *Cruising Disaster*, she constructs an elaborate rusted steel brace where fleshy pink knots of leather burst from pod-like bases. Is this the weapon of impalement or a display of erotica? Or is it both? Sublimely quirky, cheerily austere and disarming, de Monchaux has created an array of actively-slipping sculptural signifiers. Hard to pin down, they will purposefully disallow the reduction of the female and contemporary artistic femininity to an essential Bad Girl stance.

The nature of her work and the manner in which she contextualises herself and her objects, make de Monchaux herself a very slippery subject. Her own particular reticence about regarding herself as a feminist visual artist never comes across as an affected commercial posturing designed to avoid heated and focused debate. She sees herself as a feminist, as a woman. Yet, her self description, in terms of the visual art world, is as a sculptor; someone who works in the tradition of, let's say, Auguste Rodin or Richard Serra; someone who is concerned with formal details of line, massing and negative space, materials and someone who is trained in the effective use of symbolic imagery. This stance is lent significance again in view of a misapprehension of both what it meant and what it now means to have been a woman artist in Britain in the 1970s and 1980s, what it means to be political in the 1990s, and what it means to make radical, subversive and cunningly articulate work. It is not possible to dismiss de Monchaux's work on grounds other than ones that address the tradition of sculpture, and yet it is impossible to ignore her overt queries about the role and position of women in everyday life and women sculptors within the history of art. De Monchaux has demonstrated an astute strategy, one that not only subverts male artistic technical competence but subverts a traditionally male canon of works and symbols with humour, patience and infinite subtlety rather than titillation, violence or shock. There is little room here, to trivialise.

There is little doubt that some women artists now enter the field of practical artistic endeavour as politicians first and foremost. There is plenty of theoretical justification for their doing so, but if their actions now only

Right: Elizabeth Price, G.U.N., 1993

knowingly occur in an intellectual environment where mainstream criticism has made the necessary adjustments to nostalgically cloud their memories of the interventions of Elwes and Schneemann, then some purpose is already lost. De Monchaux has caught the boys on the hop, not only in rejecting the decision to underpin her work by some rhetorically facile political ambition. You must talk about her practice as Art—that is the key insistence of the work—but it is going to be difficult for the art press to ever refashion de Monchaux as a friendly, dismissible feminist. She is an awkward entry in anyone's elementary history books. Some girls just won't be tamed.

Notes

1. To understand more thoroughly the context of *Menstruation II*, it is best to quote the artist:

'In the late 1970s a second wave of body art was manifesting in both Britain and America. Here male artists like Stuart Brisley were reinventing the cathartic practices of the Viennese Aktionists whose performances in the 1960s involved the ritual disembowelment of animals, body mutilation and the use of the female body as an object of every kind of physical humiliation. The Italian critic Lea Virgine saw much of this work as profoundly misogynist, the blood letting and moaning being an attempt to colonise the drama and creativity of menstruation and childbirth. In the late 1970s, the Slade was indeed a hotbed of Viennese-influenced performance art with Stuart Brisley and Kevin Atherton goading the students into ever more extremes of physical endurance. I'm not sure that my response was a 'personal vendetta'... but I did find the angst-ridden masochistic male art around me both theatrical and a parody of what happened to me 'naturally' each month. But there was another influence at work here, a far more important one, and that was feminist art. Although the somewhat academic feminism of artists like Mary Kelly dealt with motherhood and indeed the excrement, the bodily manifestation of infancy, I was more drawn to the ideas of radical feminists like Judy Chicago in the States and Monica Sjoo in this country. They combined the notion of the personal being political with the task of reclaiming women's bodies and their functions from the object position of model and muse to the subject position of creative artist. If Duchamp liberated the everyday object to the creative imagination, feminists liberated the female body and by extension those aspects and functions of the male body that bring it perilously close to the condition of 'otherness' that is female... *Menstruation II* could be said to exist within a performance tradition concerned with the body and its functions, but extended it by applying a feminist concern with the tabooed aspects of 'the curse' and returning menstruation to its original function as a source of creative energy (see The *Wise Wound* by Penelope Shuttle for a history and social analysis of menstruation).'
(Extract from a letter to the authors from Catherine Elwes, September 12, 1997.)

What interests me is the way the work, even in this type of 'avant-garde' environment, might have been construed as being about the 'wrong' kind of politics, or too much about the personal. Even though reference to the latter was a political gesture for Elwes, it most certainly

offered ammunition for many commentators who considered this type of work reductive or dismissive of more essential, relevant and weighty universal art themes, focusing on what they considered less important or even trite. The work did not use 'shock' tactics as we understand them in relation to the work of the yBa crowd, but Elwes points out that even though 'quieter' than most of the often 'violent and ear-splitting' practice of the time, *Menstruation II* was seen by many as an 'extremely aggressive piece'.

2. Three exhibitions were organised under the theme and title 'Bad Girls'. They ran consecutively on both sides of the Atlantic. *Bad Girls, UK*; Institute of Contemporary Arts, London, October 7 – December 5, 1993; CCA, Glasgow, January 29 – March 12, 1994; *Bad Girls, Los Angeles*, Wright Art Gallery, UCLA, January 25 – March 20, 1994; *Bad Girls, New York*, The New Museum Part I: January 14 – February 27, 1994; Part II: March 5 – April 10, 1994. There was a mixed critical response to these shows which attempted to co-opt a 'bad boy' stance and to frame diverse practices under this theme.

3. 'Sister Sarah', *The Guardian Weekend*, November 23, 1996.

4. Ibid.

5. John Roberts, 'Mad For It! Philistinism, the Everyday and the New British Art', *Third Text*, Summer 1996, pp. 29-42 (citation from pp. 36-8).

6. Laura Mulvey, 'You don't know what is happening, do you, Mr Jones?', in *Framing Feminism*, Pandora Press, London, 1987.

7. Noritoshi Hirakawa's Garden of Nirvana was at the Deitch projects space in New York from 10 May to 7 June 1997.

8. Waldemar Januszczak, 'Maybe it's because She's a Londoner', *The Sunday Times*, Section II, 25 May 1997, pp.8- 9.

9. '*Two Melons and a Stinking Fish*': A Documentary on Sarah Lucas, an Illuminations Production, aired 17 October 1996 on Channel 4.

10. Molly Nesbit, 'The Language of Industry', in *The Definitively Unfinished Marcel Duchamp*, ed., Thierry de Duve, The MIT Press, Cambridge, Mass., 1991, pp. 351-83.

11. Stewart exhibited along with Ana Genovés and Rachel Lowther in an untitled exhibition at The Approach, London, 12 June to 13 July 1997.

12. This is evident in her most recent work exhibited in her solo exhibition at the Whitechapel Gallery, London, 30 May to 27 July 1997. This show toured to Galerie Rudolfinum, Prague, 9 October to 30 November 1997.

𝒜𝖉𝖉𝖊𝖓𝖉𝖆 −11 'Language is an effect of articulation, and so are bodies. Nature may be speechless, without language in the human sense; but nature is highly articulate. Discourse is only one mode of articulation. An articulated world has an undecidable number of modes and sites where connections can be made.'[14]

As the *res extensa* is incapable of language, the *cogito's* projection of it as a site of objectification is perceived to be true. The projection of all difference also operates on this level. It can only be contradicted if the contradiction takes place on the same plane of articulation—that is, discourse. Otherwise the projection is always self-confirming and thereof materially productive.

Descartes, progenitor of the first *cogito*, also speculated that monkeys could talk but remained quiet in case they were put to work.

+12 Plague being waged at the memetic level. (A meme is not viral; it does not destroy data or information. Its locus is meaning and it operates only on this plane. The plague is St. Augustine's silent rage; the syndrome remains invisible.)

The plague is selective, it is a seizure on the plane of connectivity, a virtual apoplexy to enable the material to articulate desire anew. The plague is a surgical strike, renegotiating means and ends, grafting and transplanting desire to effect new forms of sustainable subjectivity. It only affects the channels responsive to meaning as value, keeping its operation tightly within the ambit of the involuntary and the voluntary:

> ... only two organs are affected by the plague, the brain
> and the lungs, both dependent on consciousness or the
> will. We can stop breathing or thinking. We can speed up,
> slow down or accent our thought. We can regulate the
> subconscious interplay of the mind. We cannot control the
> filtering of the fluids by the liver, the redistribution of blood
> within the anatomy, by the heart and arteries, control digestion,
> stop or speed up the elimination of substances in the intestines.[15]

Proposition 1
How can one experience something that could not be the object of representation?
Proposition 2
How can one articulate something that can not be a subject of communication?

The Myth of the Young British Artist

Simon Ford

The myth of the young British artist (yBa) is now well established. To examine it, this essay does not provide a critique of particular artists or works; the power of the myth resides elsewhere, in discourse, where it informs and connects both articulate and inarticulate statements. First, though, we must be clear about what we mean by myth and in particular its relationship to ideology. Terry Eagleton in *Ideology* (1991) has described myths as 'pre-historical or dehistoricising' whereas ideologies are 'specific, pragmatic forms of discourse'. Myths, he claims, are usually 'imbued with an aura of specialness: they are privileged, exemplary, larger-than-life phenomena which distil in peculiarly pure form some collective meaning or fantasy' and 'that whereas myths are typically narratives, ideology does not invariably assume such a form'. As will become apparent, the myth of the yBa contains both mythical and ideological characteristics: it is mythical in that it is narrative in nature and ideological in its specific function within contemporary culture.

The Myth of Origin

Once upon a time in 1988, a group of art students from Goldsmiths College decided to put on a show, and that show was called *Freeze*. Because of its narrative form, every myth requires its 'creation myth', the point of origin from which everything followed. *Freeze* is deemed important because it was an exhibition organised by art students, in a soon-to-be-redeveloped industrial space in Docklands, London. Stuart Morgan described in *Artscribe* (January 1989) how Hirst:

> came across an empty police-station, with two large rooms and a glass roof... [Hirst] raised funds from sponsors, refurbished the building, selected the work, commissioned a catalogue, supervised the installation, organised an opening party.... One of the painters was approached by a New York gallery, while he and two others were snaffled up by London dealers.

Freeze was instantly cited as being of paradigmatic importance even though artists had been using such 'alternative' spaces regularly since at least the late 1960s. Deanna Petherbridge had suggested in *Art Monthly* (April 1988) that art beyond the gallery 'was fast being appropriated by curators acting as entrepreneurs in the field'. That this was a well-established practice was

made clear by Goldsmiths' lecturer, Michael Craig-Martin, when in a March 1988 article (that is, before *Freeze*) for *Art Monthly* he noted how Conceptual Art 'made possible a new type of gallery. Single rooms in office buildings, small shop fronts, enormous spaces in old industrial buildings were opened as galleries.'. *Freeze* was simply a recurrence of the founding myth of modern art: the *Salon des Refusés* of 1863. This exhibition, organised by artists rejected from the Salon, indicated the growing entrepreneurialism amongst artists and dealers, and helped to establish the myth of the modern artist as independent, individualistic and in constant conflict with state- and establishment-sanctioned culture. With the critical and financial success of *Freeze*, this type of exhibition became legitimised. Developers with property awaiting redevelopment were soon kept busy handling enquires from artist-entrepreneurs wishing to 'borrow' their space for a temporary extravaganza. These artist-run shows did not mean, though, as James Roberts in *General Release* (1995) suggested, that artists were now in control of their 'own working structures'. Rather, these shows were easily assimilated into the prevailing dealer and gallery system which welcomed them as a form of research and development of new products and personalities.

This emphasis on temporary exhibitions, short-lived commercial enterprises, art consultancies, and parties corresponds to a shift towards a culture of the service industry, where what is sold is less likely to be objects than something intangible, such as an aesthetic experience. The growth in the numbers employed in these industries, including the various media and culture industries, has also provided an expanding audience for contemporary art. One of the earliest attempts to codify the yBa took place in *Artscribe* in November 1990 when Adrian Searle wrote that:

> when faced by an extraordinarily self-possessed, ambitious, professionally acute group of young artists whose work largely conforms to already approved radical taste and conventions yet manages to invest it with confrontational edge and a kind of obdurate, dumb perversity, dealers and critics pick it up.

As this already fully formed mythical reading of the yBa attests, commentary on the myth of the yBa becomes part of the myth of the yBa.

In *Technique Anglaise* (1991) Andrew Renton said that a 'certain kind of irresponsibility seems to me to be a very key concept that brings all these people together aesthetically. Although such a body of work should be difficult

to categorise, the seemingly effortless way in which it is categorised is not surprising; myth suppresses heterogeneity by co-option. The yBa is confident, ambitious, irresponsible, accessible and heterogeneous. One strategy for countering the myth would be to provide social and financial information about the relationships between artists, curators, editors, dealers, and collectors involved with the yBa. This project was offered, but ultimately dismissed, by Liam Gillick in *Art & Design Magazine* in 1995:

> It is tempting to stick to precisely remembered details... But who cares?
> He who pays the printer sets the colophon... The point is that a strange
> mix of self-determination and generalised commentary has provided a
> peculiar situation here, one that affects the way that work is made and
> the way in which it is read.

The manufacture and nurturing of the myth is more 'productive' than the brass tacks of facts, figures, and social relationships.

The emergence of the yBa has also been 'explained' by genetics, inevitability, and even, tautologically, by the self-selection of the yBa's themselves. Karsten Schubert in *Technique Anglaise* describes the yBa as a 'genetic accident': 'We had, by chance, a bunch of incredibly brilliant people emerging simultaneously and influencing each other.'. In a further passage, Andrew Renton justifies the selection of artists for the book: 'There is, to me, something inevitable about this grouping... The artists wrote the list in a way... we are trying to suggest that there is something that emerges of its own accord.'. Extreme 'naturalism' which transforms history into nature is a fundamental principal of myth. It was, however, Charles Saatchi's five *Young British Artists* shows (starting in 1992) that cemented the label and defined the movement's parameters. It was possibly the first movement to be created by a collector. The formation of the movement was essential for the establishment of the yBa's reputation. According to New York based dealer Gavin Brown in *Vogue* (June 1995), 'It takes a movement and a dialogue to take the work to a more intense level, and that's what's happening now.'. If the yBa did not exist s/he would have been invented.

Britishness and the British Council

A major claim made for the yBa's work is that it parodies a notion of tabloid 'Britishness'. Although the work refers to, and derives much of its

celebrity status from popular culture, the intended audience for these works is well-defined. The style of the popular and the vernacular is quoted but only in order to be converted via pastiche to rejuvenate a moribund high culture. This high culture depends on its difference from popular culture to justify its existence, for as Michael Archer states in *États spécifiques* (1992): 'The artists, though, are never in any doubt that what they are doing is making art.'. The grouping of the yBa deriving from *Freeze, Technique Anglaise* and the Saatchi shows has been subtly redefined through group exhibitions, many of them partly funded by the British Council. These include *États spécifiques: 11 artistes anglaises* (1992), *General Release* (1995), and *Corpus Delicti* (1995). The question as to whether the myth of the yBa is nationalistic does not exhaust itself with an examination of individual works; how the work is used and promoted abroad should also be taken into account. By appealing to national pride, the myth of the yBa seeks to instil in its audience a sense of national identity, and this is where myth fades into ideology. The yBa's have been used as cultural ambassadors representing and defining 'British' culture abroad. They are promoted as entrepreneurial, opportunist, confident, resourceful, independent, and non-political, representing Britain in full 'enterprise culture' bloom. For Stuart Brisley, in *The Guardian*, art today:

> has a particular energy because we have been moving from the welfare state to the free market. It doesn't suffer from the constraints of state patronage. There is an atmosphere of libertarianism and a release from social responsibilities.

Art not only reflects, it also provides ideological support and justification for the acceptance of such shifts. The yBa is called upon to justify increasing social division through a recourse to the values of self-reliance and a rejuvenated entrepreneurialism.

The myth of the independence of the yBa from state funding is vitally important for those wishing to promote a privatised culture run as a 'free' market. Hans-Ulrich Obrist in *Vogue* said that:

> in Europe, young contemporary art is dependent on state-financed institutions. If museums don't organise these exhibitions, nobody does. In Britain, there is much less support for contemporary art from public money, but the artists don't sit around complaining—they do it themselves.

The state, however, is very much behind the yBa and, although public funding for the arts continues to be cut, the yBa economy is still based upon state education, public arts funding and the welfare state. This contradiction between the yBa's promotion of the free market and its dependence on state support is apparent in the following passage from John Harlow in *The Sunday Times*:

> Ironically for a leftish-leaning industry, the single most dominant cause of the explosion is Thatcherism. They are Margaret's children deeply motivated, multi-skilled risk-takers... The blue touch-paper was the introduction of the enterprise allowance in 1983, which was underwriting 10,000 artists a year before it was scrapped.

Kate Bernard wrote in *Harpers & Queen* (January 1996) that 'London is swinging again. Britain is at the cutting edge of contemporary art world-wide'. As befits a myth, the yBa has its mythical precedents, the swinging Sixties and punk. Neville Wakefield has taken this to absurd lengths, especially in an article for the Winter 1995 issue of *Tate Magazine*:

> Somewhere between these parallel legacies of the 1960s—the aesthetics of Pop and the provocational strategies of Situationism relearned through punk—lie the general impulses of recent British art.

Wakefield has chosen two mythologised moments in post-war British history and combined them with a third, the myth of the yBa. The unjustified invocation of the Situationists is a strained attempt to construct a fashionably 'authentic' radical heritage for the yBa (and for punk), just as the chronology of art and social events from 1990 to 1995 which appeared in the British Council's catalogue for *General Release* is a crude attempt at the creation of a selective but legitimising history of the yBa. Myth not only conceals by exclusion and sly editing but also by providing an excess of official 'facts' and 'evidence'.

London and the Tate Gallery of Modern Art

The myth of the yBa reached a low in *Vogue* when Andrew Graham-Dixon, after a summary of the restless wanderings of 'modern art' from Berlin, to Zurich, to Paris and New York, wrote how 'quietly, without telling anyone, modern art moved to London'. The 'British' in 'young British artist' rarely means what it implies: a broad-based, nation-wide phenomenon. The yBa is

typically a young, London-based artist. However, London itself has its own regional squabbles, especially when many of the new gallery and studio spaces are tied in with plans for urban regeneration and real estate ventures. The Shoreditch 'scene' is a clear example of this. This particular area has been described by Richard Gott in *The Guardian* as:

> filled with warehouse galleries and studios where property developers rub shoulders with avant-garde artists and artistic entrepreneurs, in a fruitful relationship peculiar to the post-socialist society which we all now inhabit.

The economic importance of the arts for 'post-socialist' London has become a recurrent theme in much yBa literature: Simon Tait in the *Evening Standard* wrote that 'London is acknowledged as a world centre of contemporary artists', and that 'London's artists are worth, at an informed guess, around £6 million a year to the capital'. There are an estimated four thousand artists living in the East End alone, and Hackney is often used as an example of what a community of artists can do for a depressed local economy. Although not quite 'Europe's new Montparnasse', could Hackney become another item on the tourist itinerary? According to a report in *The Sunday Times*:

> Two weeks ago the first coach load of tourists... turned up at a canal side 'nest' of 120 artists behind Hackney town hall. The visitors were chasing Damien Hirst, this year's Turner Prize winner, who is dubbed 'the godfather of Hackney' despite working in Brixton, Southwest London.

The promotion of the London-based yBa as a successful and entrepreneurial art 'movement' has come hand in glove with the campaign to build a new Tate Gallery of Modern Art at Bankside close to the City of London. With £50 million provided from the Millennium Fund, the new museum will form part of the redevelopment of the Borough of Southwark and the South Bank complex. According to *South Bank News* in December 1995, 'The £106 million project is expected to create 650 jobs locally and 2,400 throughout London, generating £50 million in new economic activity each year'. The area was also the prime target for a relocated Institute of Contemporary Arts. The impending Tate Gallery of Modern Art and the continuing need to promote London as a world-class cultural and financial centre, are interconnecting issues. London is required to reassert its claim to cultural significance in order

to remain a major financial centre. Terence Conran, for instance, wrote recently, in *The Independant* that the visual arts are 'vital for the success with which it attracts both visitors and businesses from overseas.... Why Frankfurt seems to have lost its bid to become the financial centre of Europe is that the city is so dreary that nobody wants to work there. Imagine the fate of the country as a whole were London to become so bleak that major financial institutions relocated.'. Contemporary visual art is the prestigious 'avant-garde' of the culture industry.

Goldsmiths, Michael Craig-Martin and Damien Hirst

The myth of the yBa is inextricably connected with the myth of Goldsmiths College and by extension the myth of British fine art education. Craig-Martin began teaching at Goldsmiths in 1973. In *The Independent*, he describes himself as a radical artist, but 'there's no reason why you can't be radical within conventional means'. More recently, the January 1996 edition of *Art Review* quotes him as describing the present as 'the most exciting period for British art'. Craig-Martin is repeatedly cast in the role of father figure in the myth of the yBa, almost literally by Sarah Greenberg in *Artnews* (September 1995) when she describes how Goldsmiths has become 'the by-word for neo-Conceptualist art—meaning, loosely, a multimedia, idea-based art bred by artist and professor Michael Craig-Martin'. This focus on a particular art school as a centre of excellence has its precedents in previous moments of dominance for the Slade, the Royal College of Art and St. Martin's. Each of these moments corresponded with the promotion of a particular art movement so there is no surprise in the close relationship between the myth of the yBa and the promotion of Goldsmiths. It also represents a 'return to power' of the art schools and their vital role in the increasing professionalisation of fine art and the creeping academicism that has began to characterise the contemporary art world. Where you took your degree and who 'taught' you has never been more important. Eton and Edinburgh University educated Jeremy ('Jay') Jopling is a relative newcomer to the yBa scene, but he has quickly established himself as the dealer with the highest profile. Jopling is the son of the Conservative MP for Westmoreland and Londsdale, Michael Jopling, and since 1993 has been a member of the Executive Committee of the Tate Gallery's Patrons of

New Art. He began dealing in 1986, buying and selling American minimal art. Jopling has described in *everything* (February 1994) the type of work he supports:

> ... a great piece of art can transcend various ephemeral, cultural situations. To give you a clearer idea, I'm not at all interested in issue-based art; for an issue-based idea would have to be pretty extraordinary to stand out beyond the relevance of that particular issue. I'm interested in art which has a certain degree of universality and is able to transcend certain cultural and generational differences.

This strictly 'non-political' agenda and its recourse to metaphysics reveals the essentially formalist and aesthetic core of the work he promotes. Jopling represents Hirst, the star of the yBa myth. Graham-Dixon in *Vogue* (June 1995) compares Hirst to David Hockney, but describes Hirst as 'an even more astute manipulator of media attention'. For Cosmo Landesman in *The Sunday Times* it is difficult to evaluate the art work because of the mass of media attention given to Hirst as a 'celebrity': 'Hirst's greatest creation of his career so far has been a walking talking installation that goes by the name of Damien Hirst.'. Many yBa commentators confess to an anxiety that the art work is being corrupted by media hype but, with the yBa, the value of their stock is based on their visibility and the recognition factor associated with their names. Hype is also the vanguard of myth and in this sense the myth of the yBa is a self-fulfilling prophesy. As the feature articles build up, they take the place of empirical evidence; the hype becomes the substance.

The Propagation of the Myth

The origin and propagation of the myth are initially the responsibility of the contemporary arts establishment. The myth then becomes a feature of the mediation between the art world and the wider audience provided by the mass media. According to Jopling in the *Evening Standard*, the 'visual art world is working hand in hand with communications—media, film and rock 'n' roll'. There is still some derisory comment from the tabloids, but generally the media are playing a full supporting role in sustaining the general euphoria surrounding the yBa. This partial, and possibly temporary, cessation of hostilities between the art world and media is the result of the realisation that art can

be newsworthy in forms beyond the usual 'waste of taxpayers' money' headlines. Art is now glamorous, sexy, and entertaining. According to *i-D*: 'Openings are full-on glam events, see-and-be-seen affairs more popular in many ways than even the most exclusive club nights.' Of course there is still some knee-jerk reaction from die-hard traditionalists like Brian Sewell, but this is merely the spectacle of opposition, ineffectual against the yBa's powerful media supporters.

Brilliant!

The apogee of the myth of the yBa was the exhibition *Brilliant!* held at the Walker Art Center, Minneapolis. Not only did it rudely reiterate many of the characteristics of the yBa so far outlined but it also, more importantly, revealed how myth loses its coherence and disintegrates when it reaches the end of its useful life. In the exhibition catalogue, Stuart Morgan, Neville Wakefield and curator Richard Flood all attempted to highlight the allegedly oppositional relationship between the artists and the gallery system. Waldemar Januszczak in *The Sunday Times* described the work as:

> produced by a squad of urban singles unencumbered by the responsibilities of family life. A confidence born of having taken on the art establishment and running rings around it pervades the proceedings.

What these commentators are trying to construct is a reading of the work that 'markets' it as avant-garde, even though the yBa's exhibit few, if any, oppositional intentions. The yBa's have been described by Brooks Adams in *Artforum* as a 'new cultural phalanx' but this is an avant-garde, according to Wakefield in *Tate Magazine*, conveniently 'unburdened by the usual accusations of market opportunism'. This unburdening is the result of the avant-garde as no longer having to represent an 'alternative': 'Why be alternative when the alternative has already become the mainstream?' asks Gillick in *Technique Anglaise*. Archer in *États spécifiques* also sees the yBa as representing the end of a meaningful oppositional practice, in that they reject 'the twin conventions that art needs to be "oppositional" in order to be interesting, and that if it is oppositional it needs to be so in a particular way'. But the mainstream's need for an avant garde is too strong for the concept to be wished away,

therefore mere traces of subversion found within the yBa are necessarily exaggerated out of all proportion. So this is not a case of the 'establishment' recuperating 'dissent', but of the establishment constructing a manageable dissent. The yBa is recuperated from the start. It would be a mistake, though, to believe that everything is under control. The contemporary art market remains volatile and speculative, and the only thing certain is that an emergent 'new generation' of artists will come to replace the yBa. Such a 'backlash' is inevitable as it is the conclusion of every 'success' myth.

An earlier version of this paper was published as 'Myth Making' in *Art Monthly*, no. 194, March 1996.

𝒜ddenda −13

The plane of the imaginary. The imaginary is curated by the blind subject, conveyed to the deaf subject, and relayed by the dumb subject. A three-fold articulation, it remains extraneous to its representation, a meme heretic to itself and which brings about the memetic plague. The plague is a reverse ordering of the material which equally refuses its own representation and demands that nothing is given, everything re-enacted.[16]

It is curation in its virtual state; capable of materialising connections beyond the networks of connectivity. The plague does not destroy the networks; it invisibly propagates its own connections, remaining imperceptible to the spectacle and to discourse. It is a *dérive* whose movement configures continuities, reconfigures discontinuities endlessly; an ecosophic clotting process. This is a silent operation. Its aesthetics remain in the shadow. The shadow refuses stabilisation, it is fluid, endlessly renewable whilst the reified idea is delineated and cast. The imaginary articulates the shape for the shadow space. It is the moving link, not the isolated reification. Its task is pure articulation; it articulates the absurd possibility of a curation of reality through the production of affinity. A *dérive* between nowhere and nowhere, anywhere and anywhere, everywhere and everywhere; a *dérive* which curates and simultaneously is the subject of curation.[17]

Frontispiece: Damien Hirst, 1997

Of Monsterology

Mark Hutchinson

You're so very special,
I wish I was special,
I wish I could love you,
But I'm a creep.[1]

Introduction

Something's stirring in the unkempt undergrowth of art. Young artists seem to be abandoning the manicured lawns and bridleways, and diving into the bushes to partake of dark and lurid activities. The demanding concerns of care, craft and contemplation seem to have largely given way to the light-heartedness of risk, play and gratification. Or, to put it another way,

> Britart is high on its own vulgarity, tripping on its own coarseness, unable or unwilling to muster the patience necessary for quiet contemplation, or to allow space to those who want to evade its tyrannous, well marketed rule.[2]

In his article, Jeffries is obviously making a moral point about the degenerate and irresponsible state, the *monstrosity*, of current British art. It is undoubtedly full of monsters, replete with vulgarity and coarseness: what is at issue is what this might mean. I think that these monsters, like most monsters, are here for good reasons, and reasons which are formed in relation to the inability of knowledgeable, patient and contemplative practice to express the experiences of the actually existing subjectivity of young artists.

Frontispiece: John Isaacs,
Say It Isn't So, 1994

Right: David Crawforth & Ian Hinchliffe,
Pin Drop, 1994

Jeffries, on the other hand, sees at best political and moral failure, and at worst, cultural culpability. I think he is haunted by the ghost of Adorno: a demanding and worthy spectre, but one that, I feel, current artists are trying to exorcise. Jeffries is looking for resistance to the commodifying power of the culture industry in art's stubborn negativity, vigilance and refusal to indulge in pleasures which are the debasement of true freedom and therefore true happiness. Adorno stated that 'impulse, subjectivity and profanation, the old adversaries of materialistic alienation, now succumb to it'.[3] Adorno theorised how pleasure had been commodified by the authoritarianism of the capitalist culture industry, so that it no longer resists that power but confirms it. He continues:

> All 'light' and pleasant art has become illusory and mendacious. What makes its appearance aesthetically in the pleasure categories can no longer give pleasure, and the promise of happiness, once the definition of art, can no longer be found except where the mask has been torn from the countenance of false happiness. Enjoyment still retains a place only in the immediate bodily presence. Where it requires an aesthetic appearance, it is illusory by aesthetic standards and likewise cheats the pleasure-seeker out of itself. Only where its appearance is lacking is the faith in its possibility maintained.[4]

The ghost can be seen in the morality with which Jeffries sets up oppositions such as vulgar versus contemplative, and tyrannical and well-marketed versus authentic. In other words, pleasure is conceived as the seducer of truth; vulgarity as the agent of cynical reason. So the indulgence of youngish artists in the unmediated pleasures and experiences of everyday life is seen as an abandonment of principle and a failure of political nerve in the face of the harbingers of the triumph of capitalism. What is at work here is what might be called a hierarchy of pleasures: philosophers have always ordered pleasure according to the register of knowledge and truth. Judging by these standards, monstrous 'appetites' are, at best, inferior and distracting but at worst, they lead the subject astray: the enemy of higher, reflective pleasures.[5]

Bringing vulgarity under the spell of morality is what Jeffries does, whether he is considering it as a moral lapse signifying a dearth of content; or as being out to shock in avant-garde style; or as an authentic expression of a particular subculture. He concludes that vulgarity does not, in fact, shock, but is boring and jaded. Jeffries takes the offensive against anyone who would

criticise him by characterising opponents as saying: 'criticising vulgarity is snobbish... vulgarity is a term of middle-class rebuke to working-class culture. Thatcher... drove the underclass to righteously express itself with all the verbal violence at its command'.[6] He defends himself against this by saying Thatcherism introduced 'a culture of short-termism in the arts, whose quick profits and cheap shocks are all'.[7] It is rarely the working class who make such defences of their culture. It is a branch of cultural studies, so eager to find traces of resistance to a dominant culture, who will so often interpret almost any non-conformism as resistance and political expression. Whatever, the debate is characterised in terms of morality.

It is my contention that today's vulgar and monstrous work is not conceived in relation to quiet contemplation; nor is it some kind of intuitive political expression (despite the obvious influences from working-class culture and the fact that an ever increasing number of artists are working class). For anyone desperate for political protest, our art is either going to look like pathetic failure or 'tragic hedonism'. This is a scheme which always puts aesthetics at the service of morality, so that vulgarity can only be thought of in terms of bad aesthetics. But if Thatcherism is important, it is not because it engendered the political expression of an underclass, but because it marked a point of disillusionment in the rule of political expression and moralism.

To some, this disillusionment sounds like moral and political failure: a retreat from the difficulties of political and moral commitment and sacrifice to the seductive, easy embrace of pleasure and popular culture. To those of us artists who have gone through this change, the failure seemed to be on the part of the conceptualist model of self-reflexive, politicised, critical practice. It was this that seemed easy: to make art from a position of 'malingering within the belly of the monster'.[8] Despite the cast-iron theoretical justifications and intellectual niceties of such a practice, two problems became overwhelming. Firstly, the monster seemed to thrive on its malingering, recuperating meanings and selling medium-sized dry goods. Secondly, it was its remoteness from the vivacity and complexity of our everyday lives that became increasingly troublesome: conceptualism relied on a very particular model of spectatorship, subjectivity and pleasure (if it had anything to say about pleasure at all). This careful and vigilant subjectivity now appears continuous with the disciplined subjectivity of Western culture, which would denigrate deviancy, excess and irresponsibility under the name of alienation.

Jeremy Deller has expressed how Acid House engendered a sense of community in the summer of love.[9] Today's art has more to do with club culture than galleries; Ecstasy is more of an influence than art history; a guy called Picasso is nothing to a guy called Gerald. I feel part of a generation (or part of a part of a generation) whose concerns and practice share *some* assumptions *despite* all our differences, which are at odds with our immediate predecessors. David Burrows and Paula Smithard have written recently of the *differences* in the practices of some of the better-known women artists in Britain at the moment, in terms of the role of pleasure or enjoyment in the art they have produced.[10] However, the Zizekian title of their essay, 'Enjoy Your Alienation!', could be a provocative slogan for what's interesting right now.

The monster has a bad sense of aesthetics. I want to look at the potential for a monsterology in terms of what it might mean for the relation of aesthetics and morality. I'm writing this from the point of view of a monster who makes art. This is not a theoretical defence of what's going on (like it needs a defence), it is more of a tour of the different attitudes to alienation, pleasure and identity which, of course, also articulate what we have in common. But all monsters are not the same.

Monstrous Behaviour

Monsters are routinely extrapolated as some kind of 'other'. They are frequently shown as the dark side of the psyche: Mr Hyde is the hidden, the animal within. The idea of the monster is also routinely used to impose some kind of hierarchy: the monstrous is normally, and normatively, a primitive desire or base impulse. All such terms imply that behaviour cannot be helped and we judge persons precisely by their ability to control, and be accountable for, their actions. In everyday life, we excuse unconsidered and vigorous behaviour with phrases such as 'I was beside myself', 'I lost myself', or 'I don't know what came over me'. Such disclaimers show how deeply, in our culture, the true self is thought of as the rational, moral and controlled elements of one's self and one's behaviour.

A routine monsterology might be an exploration of these moments, repressions and representations of the 'dark' side of our nature. This would go to confirm the status of the rational subject: to patrol that boundary between the rational and the moral, on the one hand, and the primitive and

unthinking, on the other. This is *not* my point. I wish to impugn this division and this hierarchy which places the moral (and contemplatively rational) in charge of all of subjectivity. All else is judged by the criteria of morality: especially pleasure. My interest is in the ways pleasure and experience escape morality and rationality. If these breed monsters, these monsters will not be the dark destructive forces of myth. They might, however, threaten the hierarchy that places the rational and wise over the harmful and unwise; the thoughtful over the spontaneous; the original over the habitual. We are not governed by acting in our own best interests: this is the myth.

Monsters are the embodiment of the socially unacceptable. The monster is characterised by strength, brutality, amorality, ugliness, lack of discipline, immediacy and selfish desires or appetites. The monster can be used as the antithesis of the good art spectator. Whether predicated on the connoisseur's supposedly natural good taste; or the liberal's adequately informed and sensitive judgement; or the conceptualist's cognitive engagement (to name but three), the subjectivity of the art spectator is characterised by reflection, discrimination and cerebral pleasure. Some, at least, of the current interest in monsters in art stems from a disquiet with the rationality that such a deep-seated model of subjectivity (and attendant spectatorship) entails. In a sense, the monster might prove to be a more complete idea of subjectivity than the rational, moral western subject.

Some Real Monsters

David Burrows has pointed out the distinction between fantasy monsters and real monsters. The latter he takes to be, for example, drug-crazed rock stars such as Liam Gallagher or your typical night-club bouncer. This distinction locates violence, excess and destructive behaviour in the world as well as in the psyche and its cultural and psychological projections. Monstrous qualities are part of lived experience—that which is pilloried as debased, inferior and a sign of weakness; this is in opposition to controlled, self-reflective and enlightening experience.

Burrows has pictured this clash of what is good in the way of experience, by having Enlightenment thinkers take on leading Britpop icons in a big fight.[11] The fight is physical, not intellectual, and Thomas More is up for it

as much as Jarvis Cocker. This is not an attempt to rehabilitate the monstrous as somehow part of a rational and enlightened subjectivity. Rather it is an acknowledgement that the constitution of subjectivity does not take place on a register of rational self-interest alone.

More recently Burrows has been making roughly life-sized heads of real monsters out of bubble gum.[12] Here the work itself becomes monstrous, as well as depicting real monsters. Of course these sculptures do not carry the same threat of physical intimidation that the company of thugs does, but they are equally as ugly. In fact they are ugly twice: not only are they of ugly thugs, but they are ugly objects.

Ugliness is not the opposite of beauty: it is not an aesthetic judgement. Ugliness works on a psychological register. The ugly object is one that is there but should not be there: matter out of place. It is this displacement of matter which is a threat to the subject, to the ego. The ego lives in a world of order and signification: in a world of surfaces. Ugliness is the rude intrusion into, and thus disruption of, this smooth world of surface by stuff.

On a psychoanalytic register, each object can be said to exist twice: once as its stuff or its inside, and again as its surface or its outside. All is right with the world for the ego, and the subject feels safe, when the outside of an object fits over the inside. Trouble starts when the inside starts to escape the signification of surface or its outside. Stuff escapes signification. Things get ugly. This is why so many monsters drool or spew out stuff: it is their insides escaping.

Moreover, in horror movies the monster is always coming to get you. This is the logic of the ugly and all this matter out of place. If this stuff just sat there the subject would not be threatened. But psychologically it does not. The ugly holds our attention, draws us to it, inevitably gets closer. This is an attraction and identification of the unconscious.[13]

Burrows' real monsters have the most unstable of surfaces. The bubble gum is soft and globular. It is obvious that these faces are made out of horrible sticky, gungey stuff, which looks as though it might fall to pieces any moment. Every feature on every face threatens to revert to insignificant, meaningless debris at any moment. This is the thinness of the order of things. Not only this, but the gum has come out of the artist's mouth like drool escaping from a monster. The spitting out of amorphous stuff is an ugly form of creation: it's almost as if the work is made literally out of the artist, from his inside.

Previous: Dave Burrows, Twisted Fire-Starter, *1997*

Above: Elizabeth Condon, work in progress, 1997

In a sense, Burrows is now drooling himself, this ugly ill-defined stuff issuing from his mouth: the depicting of monsters is making him into a monster.

The ugly is contagious. It tends not only to come to get you but then to turn you into a monster, too. Predominantly one loses one's subjectivity and becomes stuff. This can be seen in horror movies but in life too. Stickiness is ugly not only because it is ill-defined but also because it clings to the subject making her ill-defined, too. Stickiness can be avoided. Smells cannot. The ugly smell is already within one. The subject's response is often to puke— to get rid of the contagion. But this bringing the inside out is to drool in a big way: to make the subject a monster.

The bubble gum stinks. Before you get to look at the monstrous heads the smell has already got inside you. Smells are not usually tolerated in the gallery. The traditional and usual model of artistic spectatorship is one of reflection and perusal which actively discourages the spectator from having any more of a body than eyes and a mind (or perhaps soul). Gallery-goers are not used to having noses. However, the intrusive smell of the bubble gum means that spectators cannot forget their own bodies in relation to the work. With smell, the spectator does not have the same detached judgement of value or taste as she has with sight. It is always already too late. The spectator's body is monstrous in relation to the spectator's desire for sublimated visual and cognitive pleasure.

It is the detached pleasures of perusal that are under attack, in much contemporary art, from the monstrous and the neighbouring constellation of categories such as messiness, horror, philistinism, excess, sex, perversion, jokiness, abuse and so on. This is not an attack on the logical or ontological status of 'the visual', a battle I take to have been won by some conceptualists a long time ago.[14] Conceptual art attacked the existing ontology and epistemology of art: what counted as art and what art had to do with knowledge. The artists I am concerned with here are more interested in aesthetics but not what John Roberts and Dave Beech have called 'the new aestheticism',[15] which is a leftist attempt to rehabilitate taste, judgement and sensibility. Rather, these artists are interested in pleasure. From this perspective, the ideal conceptual spectator seems continuous with its predecessor, the purveyor of taste, in that both are reflective and controlled characters. Rather the attack on perusal is now a question of installing the spectator's body (not reinstating because it was

never there in the first place) in relation to the work. This is not, however, a *politics* of the body, but rather a concentration on the existence of the body and its pleasures. John Roberts and Dave Beech say of the philistine:

> The concept of the philistine gives us the space and confidence to allow into the aesthetic those pleasures of the body and forms of attention that the discourse of aesthetics has historically sought to marginalise and control. In this, the philistine as spectre is the partisan of the excluded pleasures, the excluded body and 'inappropriate' forms of attention.[16]

This is not necessarily anti-intellectualism, although Dave Beech tells of a friend who keeps his theory books under lock and key in a trunk in case the knowledge that he reads such things gets out and ruins his reputation. Rather it is an attempt to explore the diversity and multiplicity of different pleasures and ways of behaving, and to get away from an aesthetic register which privileges some to the detriment and denial of others. What the monster is not, is a subject of rational self-interest, and its pleasures are not those of perusal and contemplation. Like the philistine, which may be a particular instance of monstrosity, the monster has excluded pleasures, an excluded body and 'inappropriate' forms of attention.

Sight has been the model sense for the philosopher both because of its apparent certitude and because it can be interpreted as placing the outside world so securely on the outside, and the perceiving subject so securely on the inside. Hearing is not so certain; touch collapses the distance of the subject from the world; and smell and taste are always already within the body. Looking does not threaten the self-reflective coherence and rationality of the self.

So the monster, by definition, behaves in ways outside the bounds of acceptable behaviour. When individuals, rather than cultural characters, are labelled as monsters, this is a way of foreclosing debate or explanation. That the story of someone's horrific behaviour should be put down to inherent evil or monstrosity, is a way of distancing ourselves from the non-rational. This is a defence to keep the world out and our passions in.

The clergy, media, politicians and judges were falling over themselves to condemn the evil of the two young boys who killed Jamie Bulger.[17] They all saw the deviancy of the two boys as absolutely exceptional. As such, there is no explanation for their behaviour other than inherent evil. This stifles

any thought of how their monstrosity might have been *made*: of how the boys' behaviour might be extreme but nevertheless conforming to, and reproducing, the patterns of male violence and power embedded in our culture. These monsters are fetishes, whose role is to protect the boundaries between, on the one hand, the rational, wise and controlled and, on the other, the irrational, unwise and deviant.

The evil fetish easily resides in icons, as is evident in the recent brouhaha over Marcus Harvey's painting *Myra* shown at the Royal Academy's exhibition *Sensation* in the autumn of 1997. He has reproduced *the* picture of Myra Hindley (a police mug-shot), using the stencil of a child's hand. It is interesting that in debates about whether she should be released, it is usually this picture which is shown, not a contemporary photograph. This icon, predictably, provokes hysterical outrage, whilst having only a tenuous connection with the real Hindley now.

The cliché that we all have our monstrous side is a way of keeping the monstrous out, rather than letting it in: a way of reinforcing and patrolling the boundaries of the good life. It is a denial that our everyday lives are governed by monstrosity as well as rationality. The distance of the subject from the world is reinforced rather than infringed: the horrors of the world are put in their place or at least removed from the immediacy of experience.

One of the things I'm trying to explore in this essay is a broader and less stable idea of monstrosity or, to put it another way, what it might mean for how we experience our lives if we remove monstrosity from the rule of law. Having 'a monstrous side', I would suggest, could mean the opposite of the cliché of passion subjugated to reason. Gilles Deleuze has analysed the difference between sadism and masochism.[18] He sees sadism as *institutional and apathetic*, inflating the authority of the father whilst negating the mother; he sees masochism as *contractual and cold*, disavowing the love of the mother and abolishing the father. The sadistic monster is cruel and apathetic to his or her victims, imposing the ruthlessness of the law. The indifference of irony assuages guilt. This is roughly the schema of Mr. Hyde. Extrapolating from Deleuze, I would suggest that a monstrosity of masochism might undercut the rule of reason and the law. This might suggest how pleasure exists on a different register from that of reason and by implication morality. Masochism makes pleasure escape the law.

A close examination of masochistic fantasies or rites reveals that while they bring into play the very strictest application of the law, the result in every case is the opposite of what might be expected (thus whipping, far from punishing or preventing an erection, provokes and ensures it). It is a demonstration of the law's absurdity. The masochist regards the law as a punitive process and therefore begins by having the punishment inflicted upon himself; once he has undergone the punishment, he feels that he is allowed or indeed commanded to experience the pleasure that the law was supposed to forbid.[19]

I am interested in suggesting a subjectivity which uses humour and paradox to allow its pleasure to escape from morality.

Monstrous work by young artists today is a way of escaping the law of morality. It could also be seen as a way of escaping the strict intellectual tyranny of conceptualism, the artistic father. It could also be that the strictest application of irresponsibility is, in fact, the opposite of what it appears.

Bad Omens

Fictional monsters, too, can have clear and stable identities. They are *made to be seen*, as a kind of warning before the fact: an expression of fear, or perhaps, an omen.

John Isaacs' monsters are the product of a mad scientist and science gone mad.[20] The scientist himself has got a stuffed chicken for a head, which does not seem to hinder the enthusiasm with which he is waving a test-tube about. Science is the unknowing victim of science. The fear is that this is

Previous: John Isaacs,
Untitled (Monkey), *1995*

Left: BANK, Zombie, *1995*

here already and that this is the future. These monsters all seem to be grotesque, ridiculous and pointless genetic hybrids, mutations or collisions. The fear of a powerful yet uncontrollable, irresponsible and incomprehensible science is clear. The fear behind science being out of control and breeding monsters, is the fear of the powerlessness of the individual in the face of cultural or social forces. It is also the fear that *no-one* is in fact in control, that collectively we have lost it.

These monsters are not so much actors in a narrative as products of a narrative. They are ontological monsters: for us, it is what they are rather than what they do, that makes them monstrous. I think it is intrinsic that they are deformed or dysfunctional in some way, with excesses and absences and misplacements. But these abnormalities are not unhappy accidents such as with freaks at a freak show. A freak's deformities go to reassure the 'normal' subject of her normality. The freak is the product of an ugly accident whereas the iconic monster has a very particular causal narrative behind it, explaining why it looks the way it does. Isaacs' monsters are *created* by society, in bad faith. Unlike the ugly monster which in some way fails to signify, these monsters signify *all too clearly*.

In *Untitled (Dodo)* of 1994, a metal shell of a Dodo houses a motor which flaps useless wings and nods an empty head. This is an incompetent, dysfunctional replica of an obsolete oddity and it is on a plinth. The humour of the work lies in an inappropriate technology mimicking an irrelevant failure of nature. The damn bird couldn't fly to start with, so making artificial wings in its image is kind of daft. Culturally, we have a soft spot for Dodos because they are extinct and because we made them extinct; the failure of technology to revive the Dodo hardly gives us confidence in what it can do for us. There is also the fear that science is utterly misdirected, pointlessly meddling. This 'creature' is the outcome of some warped inventor's imagination: a spectacle. On their own, the nostalgia of either the luckless Dodo or of the mechanical technology might be reassuring, but their awful combination is disturbing. The hybrid does not have a place in a narrative: it just exists and endlessly draws attention to its futile existence.

The other monsters don't have anything to do, either. *Untitled (Monkey)* of 1995 sits on the floor, a monkey with human hands for both its hands and feet. It is injecting itself with an unknown drug. It has not only been

bred by the brutality of science but now suffers again through drugs. It may be attempting to relieve the boredom or pain of its monstrosity. But the more chilling thought is that it has been bred to experiment on itself. Thus science is seen as a incestuous circle of debased morality, where cruel experiment is carried out for the sake of experiment alone: the nature of the monster is unnatural, so there is no way that it could escape its monstrosity. A more absurd hybrid is the cross between a potato and a schoolboy in the work *In Advance of the Institution*, but here, too, the monster has nothing to do, not even anyone to terrorise. It can only sit there in meaningless isolation, the result of someone else's story.

Also monsters of the spectacle are the mannequins of the brothers Chapman.[21] These show a deformed, excessive and pre-pubescent sexuality, as children fuck and play and merge together in an orgy of mutation. The children are young, yet obviously sexual. The idea of childhood as a time of innocence is contradicted and the monstrosity of young desire thrust at the spectator. Despite the challenges of psychoanalytic thought, the view of childhood as innocent is remarkably well entrenched in our culture. Hence the fuss around representations of childhood sexuality, for example, in Larry Clark's film *Kids*. The Chapmans' kids are monsters because they show the repression; and they show it in a blatant, positive way: these are not melancholy monsters, such as Isaacs' are.

Whereas Isaacs' monsters are likely not to be what they seem (as a head turns out to be a stuffed chicken, for example), with the Chapmans you get what you see. Despite the fusion of bodies and stray appearances of sexual organs all over the body, these monsters are clearly defined. There is no drool or breaking of surface. Amongst the multitude of vaginas and penises and arses there is not a drop of sweat, blood, sperm, spit, vaginal fluids or anything else. All surfaces are clean, ordered and smooth. The emphasis here is on signifying clearly the transgression of adult sexuality. These monsters are not coming to get you, they are just telling you loud and clear what you don't necessarily want to know.

Like Isaacs' monsters, these are ontological monsters. Despite the rampant sexuality, there is no hint at movement, or action, or narrative here. These monsters are what they are: a perverted oddity of mutation, petrified in their act of transgression. There is no danger of them doing something.

Monstrous Lives

One way that a monsterology might get going, is by asking where monsters live. Isaacs' monsters live on plinths, for the most part. They certainly have no natural habitat. If they have a place to live, it is an unnatural place: a laboratory or, perhaps, an art gallery. There is an ambiguity and thus analogy between them in Isaacs' work: both seem to be cold and hostile places removed from everyday life. These are not places where the monsters' lives can unfold, but somewhere they are stuck.

The Chapmans' monsters, or at least some of them, live in the woods. Woods are places which escape surveillance. Epping Forest is full of corpses, drug users, perverts, courting couples and drunk children, amongst other things, as far as the local press is concerned anyway. Woods also have this role in fairy tales: they are places where one gets lost, or is led astray, and where monsters lurk. This is an appropriate setting for the illicit sexual identities of the Chapmans' kids. It is where real kids go to have sex. By placing their monsters here, in a place of symbolic darkness, the Chapmans emphasise the spectacle of it all, the *sight* of the monsters: the fact that one is seeing what should not be seen, or what is usually hidden.

The truly ugly monster has no home because its home is *you*. The monster in the film *Alien* wanders around, a parasite, homing in on the humans. It has no home to go to, no hobbies, nor any other interests in life: its sole purpose is to get to you.

Some monsters live amongst us and do not always display their monstrosity. They appear to be just like you or me, but live out a particular story, or stories. Vampires are exemplary, although what their narratives of seduction, power and exploitation mean, is open and various (questions of sex and class seem important to me, though).

Vampires are like us and not like us. Their passion is both excessive and unsightly: they cannot bare the light of day. The vampire moves in darkness: an unsightly scene for a narrative of what is hidden or repressed. The logic of the vampire is not one of symbolism but one of narrative: not a sign but a story. In fact, vampires are typically suave and desirable; they are a deceptive sign which hints at a story other than their true one.

Not only dwellers in darkness, vampires cannot be seen in mirrors. Like

Above: Lindsay Seers, Self Portrait of a Camera (Vampire), (detail) *1997*

ghosts, the ontology of the vampire is made suspect by the failure of sight, of the eyes, in relation to its presence. The reality of the vampire resides in its mouth. Not a mouth of speech and rationality, but one of consumption and passion.

In her recent work, produced at the Irish Museum of Modern Art, Lindsay Seers has adopted the identity of a vampire. But her mouth doesn't suck blood, rather it sucks light: she turns her mouth into a pin-hole camera. She does this by holding a pin-hole in her open mouth and squashing photo-graphic paper into the back of her mouth. At the same time, she is wearing a pair of vampire's fangs. These leave their trace as protrusions of the white border into the negative image formed on the photographic paper. Vampires see the world through their mouths.

The first pictures in this exhibition were of the building which houses IMMA. The building, a kind of monument, is eaten up by the narrative and presence of the vampire, or of the tourist. In fact, Seers goes on to use the identity of the vampire-camera to take photographs of herself and of others: the vampire, as seducer, prays on the genre of the family snapshot. Seers puts on a mask of Darth Vader, also turning her mouth into a camera, to take tourist photographs around Dublin. Here she literally overlays the narratives of the alien and the tourist. In both cases, the other, the monumental or the object of desire, is reduced to a scale smaller than the subject: it is, in fact, as if the monument has come to the subject rather than the other way around. Mark Cousins has talked about how the contemporary, post-Kantian, subject is 'inside out'. By this, he meant that the scale of the subject, psychologically, is larger than the scale of the world, which becomes internalised by the subject. Our experience of the world is no longer governed by a schema of intrinsic and extrinsic (inside and out). For the modern subject there are no extrinsic barriers, beyond which we can have no comprehension. Everything can be brought within our framework of knowledge and experience. Exploration is no more a confrontation with unimaginable forces and places but gathering up, internalising, the last few bits of the world we haven't yet visited. This process of internalisation is the experience of the tourist.

The tourist is post-Kantian. The pre-Kantian aesthetic register is based on order: the production of symmetry and harmony in contrast to the disordered and brutal external world. Here the scale of the subject is small in relations

to the forces of externality. But the Kantian sublime changes this relation of scale. The subject confronts the awesome externality. This squaring up to the unimaginably large and unpredictable world does not end up reinforcing the smallness of the subject by putting the sublime on the aesthetic register. Rather, the subject takes on the scale of the world. To confront the awesome power of nature and survive is to prove that externality is internal to experience. The snapshot taken by the tourist is Kant with bathos.

Tourist snaps are thus, in a sense, more about the size of the tourist than their subject matter. Those who take pictures of themselves in front of every monument seem to be more honest, psychologically, in this respect. Seers has gone on to picture herself, as a vampire, in front of IMMA. She makes trouble for the viewer of her photographs by adopting fake, monstrous identities for the takers of pictures. The extraordinary narrative of the vampire does not seem easily reconciled with that of ordinary, domestic photographs (nor, indeed, that of the artist). So these are pictures which are of the taker of the photograph, the maker of the picture. The adoption of a monstrous narrative behind whoever is taking the picture tends to make it an object of epistemology rather than ontology: it is a question of how it came about rather than what it is. From a monster's point of view, taking a photograph is a monstrous (deviant) thing to do. At least it seems a safe bet that a vampire would not claim the same motives for photography as we would.

The images produced out of, and of, the monster herself are themselves monstrous. Unlike either the holiday snapshot, which is boring, or a picture of the ugly, which is repellent (at least on the surface), these pictures are

Right: Dave Beech,
THUD,THUD, THUD, *1997*

seductive because of their simultaneous similarity and difference. These are photographs like other, ordinary photographs, which are yet utterly unlike them: both familiar and strange. They are misshapen and small; they carry traces of the body that made them; and they are negative. Day is turned to night and the face of the vampire becomes monstrous in negative. But they are intimate, engaging in their strangeness. These images are uncanny. As vampires are uncanny in their duality of seduction and destruction.

It is somewhat paradoxical that Seers is producing fixed images to deal with the narrative of monsters. At the same time as domestic photography is made troublesome by disrupting and inverting its normal protocols, these monsters are engaging in humour. The idea of the denizens of evil taking photographs is obviously laced with a certain humour, for they should have something worse to do with their time. But more than this, these monsters are absurd, not so much as photographers, but as cameras. Caught in a different narrative, they are out of place. But this humour brings into question the identity and motivations of the photographer. It is not clear what a monster might do with domestic photography and this is probably because it is not clear to us what a monster might do with a domestic, prosaic life. Or perhaps it is all too clear that ordinary monstrosity escapes domestic photography, or even that this is what domestic photography hides.

These are humanist monsters, whose monstrosity lies in the way that they behave rather than what they are. They are epistemological rather than ontological monsters, in that their behaviour routinely expresses repressed knowledge. Fairy-tale monsters, at least in their original, pre-Disney forms, are invariably of this type. It is therefore unsurprising that so often these monsters carry the threat of contagion. This contagion threatens to steal away one's subjectivity, as with the ugly monster, but in a very different way. Rather than a violent collision with reality, the subject is at risk of being seduced: rather than being too ugly, these monsters are too attractive.

This seduction can be more or less violent in itself—werewolves seem pretty violent—but the idea of contagion is the threat of becoming one of them: going over to the other side. This is the repetition of the story of the Fall, in a way, where the gaining of knowledge or having a particular experience is the downfall for innocent subjectivity. Tales of vampires and werewolves are narratives which warn against the pleasures of being seduced and the

dangers of abandonment. What is being abandoned is a subjectivity that is in control, self-reflexive and independent.

These are stories both of power and knowledge, and of passion. The monsters are knowing and their power comes from being able to tell the difference between them and us. The traditional logic of such stories pits the wits of the humans against the danger of seduction. Seers, amongst others, does not seem so sure about this.

Sex, Drugs and Drum 'n' Bass

Perhaps the most pervasive of current monstrous trends in art, is the adoption of monstrous identities. The Wilson Twins video their first acid trip in a hotel room; Rebecca Warren gets covered in spunk, repeatedly; Graham Ramsay turns into a be-Parkered scum monster; Gillian Wearing does stupid things; John Isaacs lurks in the undergrowth dressed as a he-man. These things revel in the marginalised and the improper. These actions are not characterised by knowledge and power, but rather by eschewing a normative culture of the sensible in art. In various ways these artists have 'gone over' to the everyday from the moral high ground of critical, proper culture. What seems to be happening with this trend is an embracing of the everyday pleasures and pains of sex, drugs and rock 'n' roll.

Marina Warner, in tracing the myth of female monstrosity, has shown how the adoption of the monstrous is a way for the scorned to gain power:

> This is a form of well-proven magic, uttering a curse in order to undo
> or claim its power... Former misogynist commonplaces are now being
> seized by women: in rock music, in films, in fiction, even in pornography,
> women are grasping the she-beast of demonology for themselves. The bad
> girl is the heroine of our times, and transgression a staple entertainment.[22]

However, she fears that these defiances end up in collusion rather than emancipation: 'the mythology of ungovernable female appetite can't be made to work for women; ironies, subversion, inversion, pastiche, masquerade, appropriation—these postmodern strategies all buckle in the last resort under the weight of culpability the myth has entrenched'.[23] For me, what is interesting about this statement is not whether these strategies work, but the fact that the monstrous is being brought under the sway of the political, moral

and rational. Pleasure is being judged and justified in terms of its political effects. The personal is political, of course. But the continual subjugation of pleasures under the rule of morality seems like an intellectual suspicion of fun and frivolity. I want to suggest that a Warneresque view of monstrous subjectivity is not monstrous at all in any radical sense. The experiences, pleasures, and preferences of such a monster are still measured by the conventional register of knowledge and truth.

Getting into Popular Culture

The dialogues between high culture and popular culture, art and the everyday, are nothing new. What is interesting is the move away from a critical appropriation of popular cultural icons and means (typified by Pop, but also, say, early Jeff Koons, Barbara Kruger and other self-declared postmodernists generally) to the whole-hearted immersion within other, excluded bits of cultures. At the end of the 1980s, the ironic and playful art of say, Damien Hirst or Gary Hume, was still referentially about art, even when at the expense of art. This kind of practice has been cast away by many younger artists indulging in the contingencies of lived experience and the vivacity of everyday life.

This process is paralleled in the split between cultural critique and cultural studies and how they deal with the split between the intellectual and the popular. Whereas cultural critique takes on the role of outsider, or ethnographer, in relation to the popular, the adherents of cultural studies like to think of themselves as immersed within popular culture. The equivalent terms in art would be those who appropriate popular culture for high art contexts and those who work in popular forms.

Art has been dominated by 'artistic mimicry' in relation to the everyday, the incorporation of popular motifs into high art strategies. But we could also detect what might prove to be artistic ethnography, artists slumming it in popular culture—this is apparent in a lot of recent young British art. Slumming it, though, is not necessarily belonging. The point is, that whilst artists are keeping their identity as artists, they are preserving a difference from popular culture. Moreover, it is impossible to know if the fun and games to be had here by artists are fundamentally an ironic pleasure. We are always being asked to suspend judgement and risk not understanding

at all if we take it too seriously. So adopting the monstrous seems to be a provocative and effective way of placing one's concerns *outside* the conventions of legitimate working practice and perusal of art.

On Being a Monster

How much more appetising, alluring, and enticing, how much more heavenly and delicious is the smell of wine than the smell of oil! I shall be as proud when men say of me that I spent more on wine than on oil as was Demosthenes, when he was told that he spent more on oil than on wine. To be called a good companion and fellow-boozer is to me pure honour and glory.[24]

The subject who makes a deliberate choice to engage in unwise, unhealthy and damaging activities is anathema to the rationality of Western philosophy. Neither Aristotle nor Davidson could fathom 'incontinence of the will': knowing that one thing is in one's best interests and doing something else. Indeed Davidson's *Essays on Actions and Events* contains many examples of activities such as turning on lights or building squirrel houses.[25] They are all rational, productive, goal-orientated activities; they are not like dropping an E and dancing all night or having a laugh with your mates. Nor are they activities such as watching crap TV because you can't be arsed to do anything else or getting pissed by yourself just to kill the time.

These are just the kind of things that Dave Beech's monsters might do. In *Thud, Thud, Thud* he showed a collection of small plasticine monsters.[26] These are basically people who have gone wrong in various ways. Despite their afflictions, they are getting on with their lives and indulging in a great variety of non-productive and not necessarily healthy activities. These monsters stand around bored; hit things; fuck, more or less violently; get pissed; and so on. Their physical monstrosity is almost a sign of, or perhaps an infliction because of, their aberrant behaviour.

The monsters are made physically monstrous by violations, distortions, being crossed with foreign bodies or having to carry them as burdens. A man has a completely squashed head; a woman has a large tail; another character has useless, long wires flowing out of its back; another has a vase of twigs for a head; and so on. These monstrosities are at once absurd in an amusing way and pathetic. These are not threatening monsters. Unlike Isaacs' monsters,

who have been made to be the way they are by evil intention, these afflictions are random. This is most unusual in itself because most monstrosity has a clear rationality to its particular monstrous traits. There is usually a narrative as to why the monster looks the way it does, or behaves the way it does, or both. These monsters, rather disarmingly, just are this way.

Beech's monsters are living with their abhorrent physicality with neither regret nor celebration. Of course this is to place them in another kind of narrative: one of everyday life. It is not hard to see these monsters as ordinary people or, perhaps, the projection of the monstrous in us all. These monsters are monstrous not because their actions are exceptional or marginal but because their actions are so ordinary and unexceptional.

Monsters and the monstrous do not necessarily challenge the philosophical and actual construction of the subject as always already rational. They do, however, provide evidence of those ideas at work, by being a repository of what is judged to be bad behaviour. A recovery of the margins is never enough. But monsters provide a broad heading and context in which to talk about much contemporary art. Sex, drugs, violence, music, are repetitive themes which go to give the art spectator a body, and all the pleasure that goes with that. If aesthetics has previously demanded both artist and spectator to be aliens, then the new art might require them both to be monsters instead.

Notes

1. Radiohead, lyrics from 'C.R.E.E.P.' on the album *Pablo Honey*.

2. Stuart Jeffries, *The Guardian*, 19 April 1997.

3. Theodor Adorno, 'On the Fetish Character in Music and the Regression in Listening', in *The Culture Industry*, ed. J.M. Bernstein, Routledge, London, 1991, p. 28.

4. Ibid., p. 29.

5. Of course, Adorno is far more thoughtful than Jeffries. Adorno was explicit about considering all culture damaged by the machinations of capital. Nevertheless, his model of resistance to this cultural tyranny was to remain alert to the seduction of vulgar, simplistic and thoughtless pleasures, which threaten to steal away one's individuality, one's ability to choose and thus one's subjectivity.

6. Jeffries, op. cit.

7. Ibid.

6. A phrase that the conceptual art group Art & Language liked to use in the 1980s.

9. Jeremy Deller, talking at the performance of his *Acid Brass* at the Queen Elizabeth Hall, London, 19 April 1997.

10. David Burrows and Paula Smithard, 'Enjoy Your Alienation!', *Make*, no. 77, September-November 1997.

11. This work was shown in the exhibition *Cocaine Orgasm* at Bank, London in December 1995.

12. This work was shown in the show *Dog-U-Mental IV* at Dog, London in January 1997 and at *THUD, THUD, THUD* at The Conductor's Hallway, London in September 1996.

13. These thoughts on ugliness are stolen from Mark Cousins, from his lecture series on ugliness at the Architectural Association, 1994-95.

14. However, Terry Atkinson and Art & Language are still arguing over this in the pages of *Art Monthly*.

15. See John Roberts and Dave Beech, 'Spectres of the Aesthetic', *New Left Review*, no. 218, July-August 1996, pp. 102-127.

16. Ibid., p. 126.

17. See David Jackson, *Destroying the Baby in Themselves*, Mushroom Publications, Nottingham, 1995.

18. Gilles Deleuze, *Coldness and Cruelty*, Zone Books, New York, 1991.

19. Ibid., p. 88.

20. These works were shown at the Saatchi Gallery in January 1997.

21. Among many other outings, this work had a major show at the Institute of Contemporary Art in 1996.

22. Marina Warner, *Managing Monsters: Six Myths of Our Time*, Vintage, London, 1994, pp. 10-11.

23. Ibid. p. 11.

24. François Rabelais, The Histories of Gargantua and Pantagruel, trans. J.M. Cohen, Penguin, London, 1955, p. 39.

25. Donald Davidson, Essays on Actions and Events, Clarendon, Oxford, 1980.

26. THUD, THUD, THUD at The Conductor's Hallway, London, September 1996.

A Place of Pleasure:
Woodwork, Vauxhall Spring Gardens
and Making Audiences for Art

Julian Stallabrass

Verdant Vistoes, melting Sounds
Magic Echoes Fairy Rounds
Beauties ev'ry where surprize:-
Sure this Spot dropt from the Skies![1]

The Spring Gardens in Vauxhall is a curious place—an open expanse of
green where nothing much seems to happen lying in the middle of a busy
neighbourhood. On one side there is a flat area of grass, on the other some
strangely shaped hillocks. At one corner, horses and donkeys monitor the
space from a paddock, at another a little games field is scooped out of a
bank, but both cling precariously to the edges of the open space. The Gardens
fit uneasily into their surroundings of road and railway, office blocks and
houses, as if created by chance, as if dropped from the skies amongst the
ordinary urban fabric.

Although it is far from obvious now, the Gardens are, in fact, a relic of
another era. For two centuries they were used as a pleasure ground by
Londoners who went there to enjoy music and entertainment in an exotic
display of illusion and architectural folly. Before Westminster Bridge was
built, they would arrive directly at this magical land by boat, sailing up
river from the centre of town, though now the Gardens are severed from
the Thames by a railway line and a major road. Today the passing of trains,
whose steam-driven ancestors drove out the pleasure ground, is the most
prevalent noise in the Gardens. That there is a park here at all, or that it
roughly follows the boundaries of the old Spring Gardens, is accidental, for
in the nineteenth century they were torn down and built over. The resulting
buildings stood until they were destroyed by German bombs and rockets
during the Second World War. Now people use the area for walking dogs,
for sports, as a shortcut and, in the summer, for having lunch. Adults tend
to stick to the paths, so the grounds are little traversed except by birds,
dogs and children. People without homes also spend much time in the
Gardens, sleeping there day and night. Today, if this neglected space has a
reputation, it is as a dossers' park—for the homeless can always be seen
there, sticking together for company and protection.

For three days one May, the Gardens underwent a change: visual artists,
musicians and choreographers held an event called *Woodwork*.[2] The title of

Frontispiece: Mr Simpson at The Royal Gardens, Vauxhall

Above: A General View of Vauxhall Pleasure Gardens...

the collaboration is curious, too. There was plenty of work with wood and trees, as might be expected and also the hope that, from it, something might come of the dense 'woodwork' of the contemporary art scene. In the eighteenth century, 'woodwork' also meant an artificially laid out grove or plantation, so the old pleasure ground was remembered in the title. During this event, the change made to the Gardens was sometimes very slight, and people hurrying through would hardly have noticed. It was not that the Gardens once more became a place of spectacular entertainment, but more that there were diversions which might side-track people from their customary thoughts and actions, and that, sometimes inadvertently, historical spectres were raised against the grass banks and office buildings. Passing through the Gardens on these days, you might have noticed ribbons fluttering from trees, or flower girls, or some potted trees moving about, or an eccentric figure in a frock-coat haranguing a small crowd. Or you might not.

Woodwork was a marginal event if ever there were one—under-funded, little seen, receiving almost no press attention, and quickly forgotten. Why, then, remember and think about it? Because *Woodwork* previewed some later developments in British contemporary art and more importantly because it provides an example of an alternative model of artistic practice—one which, for all its faults, was collaborative and open to a wide public.

Vauxhall Spring Gardens

Woodwork, which was made for the Spring Gardens, cannot be understood without knowing something of the place. On the face of it, the Gardens have an illustrious past and a degraded present, but each is not quite what it seems. The present Gardens, with a slight amputation on the east side and a more substantial one on the west separating them from the river, map out the borders of the old, magnificent place of pleasure. Hillocks hunched strangely about the grounds are the rubble of bombed buildings heaped into piles and grassed over. They provide vantage points over the bare ground, just as supper boxes and pavilions once did over the decorated pleasure garden. In the old Gardens, the theatrical wood and canvas constructions, some of them meant to give the illusion of ruined ancient cities, were premonitions of these current amphitheatres, the actual ruins of London.

The Gardens were devoted to an assortment of pleasures, some of them innocent. From around 1660 Londoners went there to wander in a rustic setting. One writer described the early Gardens before they became a place for organised entertainment:

> Foxhall, where there is a large garden of matchless elegance called the Spring Garden, because it is most agreeable in spring, when vast quantities of birds nest and sing there. It consists entirely of avenues and covered walks where people stroll up and down, and green huts, in which one can get a glass of wine, snuff, and other things, although everything is very dear and bad. Generally vast crowds are to be seen here, especially females of doubtful morals, who are dressed as finely as ladies of quality, most of them having a gold watch hung around their neck.[3]

In the late seventeenth century, the Gardens were formally laid out. Elms were planted in straight lines, forming avenues which bordered triangular 'wildernesses' where visitors would happen upon pavilions and architectural follies. From 1728, under the direction of Jonathan Tyers, the Gardens became yet more organised, with pavilions, supper boxes—and entrance charges. A fashionable crowd came to enjoy performances, music, painting, architecture and the spectacle of one another.

Some of the best descriptions of the Gardens are found in novels. Tobias Smollett describes the reaction of an impressionable girl seeing the Gardens for the first time:

> Image to yourself... a spacious garden, part laid out in delightful walks, bounded with high hedges and trees, and paved with gravel; part exhibiting a wonderful assemblage of the most picturesque and striking objects, pavilions, lodges, groves, grottoes, lawns, temples and cascades; porticoes, colonnades, and rotundas; adorned with pillars, statues, and paintings; the whole illuminated with an infinite number of lamps, disposed in different figures of suns, stars and constellations; the place crowded with the gayest company, ranging through those blissful shades, or supping in different lodges on cold collations, enlivened with mirth, freedom and good humour, and animated by an excellent brand of music.[4]

This gushing account gives a rosy, uncritical impression of the place, but also an idea of its impact on a public unfamiliar with such sights. Although there are many similar descriptions, the old recreation ground should not be imagined as a lost paradise. Its reputation was always morally ambiguous, and from the beginning the art shown there was political.

The Gardens were far from being just a place of fun—they were a product, a mirror, and even in part a cause of profound changes in the nation. From the time of their formalisation until their demise in 1859, Britain had made of itself a self-conscious and powerful nation, concentrated its population in cities and factories, traded and enslaved across the globe, becoming in the process the pre-eminent world imperial power. The current Gardens have a melancholy resonance, as Britain lives with the legacy of its pernicious greatness, fumbling with or sometimes just forgetting the past, sometimes recasting it in saleable heritage form.

Why stage art here? In many ways the setting was highly inappropriate. The present Gardens seem to have little focus or coherence. The passing audience, one might think, is unlikely to have the time or inclination to appreciate contemporary art. With each of these considerations, what could have been weaknesses were taken as strengths. In the long preparation for *Woodwork*, the artists discussed the environment and history of the place. Vauxhall Spring Gardens was thought a suitable setting for a collaborative venture because of its history of performance, music, painting and spectacle.

The scrappy, contingent space of the Gardens proved a suitable backdrop to an art which did not impose itself on its audience and gave people time to arrive at their own conclusions. The public, it was hoped, would in large part create the event.

Underground

Woodwork started early one morning, not in the Gardens, but in nearby Vauxhall Underground station.[5] As rush-hour built up, the confined atmosphere was thick, only stirring when trains pushed the heavy air out of the tunnels. Strip-lighting made colours look sickly and passengers bilious; grime covered everything, even the over-cheerful ads, and on top of all this, there was the noise of the aged trains, sighing and screeching.

On this particular morning, commuters first noticed the music: David Crawforth was working with a stereo and microphone to produce first classical music, sometimes with an ecclesiastical air, then interference noises. Around 7.30 Simon Whitehead, positioned in the passageway between the two platforms, stripped to the waist and began to wash himself from a tin bowl. Most

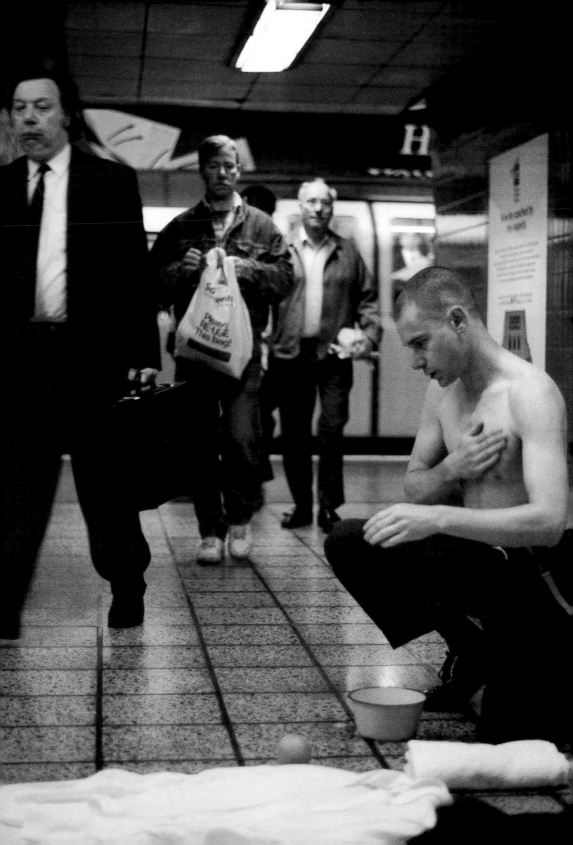

commuters, as they hurriedly passed by, looked on with bemused suspicion. Yet the speakers set up on each side of Whitehead, and the London Transport staff standing around calmly, gave them some slight pause—maybe he was meant to be there after all.

Later, when the station became busier, and there was a gap between the trains, Whitehead's washing suddenly became accepted as a spectacle, and people no longer looked at him furtively. Some started to laugh, clustering about the entrances to the platforms, peering back at the artist. Someone said, 'What's the point? It's just meant to be arty is it?'. Another quipped, 'I love my saucepan too'. Whitehead offered passengers bread rolls with tightly wound messages hidden in the dough. Hardly anyone would take them from his hand. Even when they were offered from a box, he was largely ignored. People were right to be suspicious for the messages in the rolls were potentially poisonous: they read 'Making Bread', 'What's your Role?', 'London to Tivoli, 2 hours', and other holiday destinations and flight times. They asked questions about why people were using the tube, and what they spent their time and money on. Most people are, after all, as they well know, coerced, grumbling, below ground on their way to earn a crust.

If the overriding response was suspicion, it is because commuters are already assailed by so much—beggars, newspaper and leaflet distributors, one another. On that morning, a homeless man sat begging in the passageway above the platforms, nursing a can of Tennants; later he started to sell *The Big Issue*. Further down, two buskers were playing guitar and flute. It was natural that people should regard the performance as just another obstacle, or as a request for money. An air of ritual hung about much of *Commuter Action*, as if some religious ceremony were being performed before a congregation of heathens. It was deliberately inappropriate, turning an act of necessity into the appearance of a willed communal gathering.

There were other actions on the Underground. Bruce Gilchrist made endless trips around the platforms carrying a large suitcase which periodically emitted odd noises. When people noticed the noises, which came from no obvious source, they looked about in confusion. Ian Hinchliffe hung around the platform as though waiting for a train. He was dressed in the kind of suit which seems to imprison its occupant and was reading a *Beano* album with fierce intensity. No-one paid him much attention. Both Gilchrist and Hinchliffe's work took the

form of diversions which were intermittently effective, disorientating people and perhaps making them more aware of their environment and actions.

In *Vauxhall Vanitas*, Naomi Siderfin worked on the stairs between the escalators, gilding the little spikes that stop people sliding down the hand-railings. Above her empty Tennants Extra cans, dipped in gold, were suspended from springs and swung lightly in the breeze made by passing trains. Tiny fragments of gold leaf blew down the stairs on to the stained floor. Siderfin's work was slow and painstaking, and people standing on the escalators were carried past it, having a few moments to wonder what she was doing and why. In contrast to Whitehead's more direct approach, this was a gentle interaction with an audience. But the meaning of these works was not so gentle—the gilded spike, like the gilded cage, is a loaded image. The act of gilding gave value to the undervalued Underground, a public space done down in favour of private affluence. The tube tells the people who use it that they are not worth much. In one sense, Siderfin's decoration of this space with valuable material was in direct opposition to this neglect, but in another it was ironic. She used gold leaf, covering the steel spikes and the tin cans with the material which is the basis of all value. There were echoes of false gold in this work, of a glittering veneer that masks, but none too effectively, a degraded reality, allowing one to stand out sharply against the other.

Blossom and Jetsam

On Thursday morning, people passing along Kennington Lane, or through the foot-tunnel to Vauxhall Cross, were confronted with several strange occurrences: a large banner reading 'How Does Your Garden Grow?' had been run over the railings of the foot-bridge (the way pedestrians cross the lethal entrance to Kennington Lane), buckets containing flowers were being set out in single file, and the air smelt strongly, and most unusually, of Parma Violets. Eventually, as more flowers were added, the line which began at the entrance to the tube, ran over the foot-bridge and continued through the tunnel to the entrance of the Gardens. Women in elaborate hooped skirts tried to sell the blooms.

The light, whimsical air of this fragrant piece by Clare Palmier was under-mined by its setting. The Arcadian image of delicate blooms—flowers and

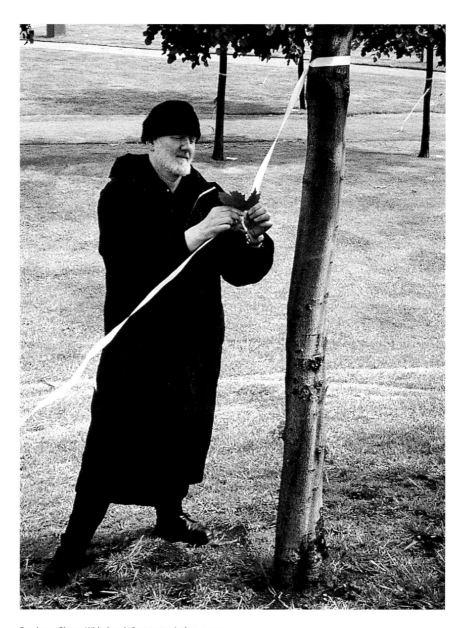

Previous: Simon Whitehead, Commuter Action, *1993*

Above: Alastair Maclennan, Treework, *1993*

maidens—clung to the periphery of one of the busiest junctions in London; perfume competed with traffic fumes, and wind chimes swinging from the bridge's railings were drowned out by the noise of trucks. It was as though some bizarre flotsam, a floral tide-mark, had been washed up by the sea of traffic. The work took on an even more disturbing feel in the foot-tunnel—a sinister place, dark, decorated with graffiti, embellished with excreta, beer cans and the remains of fires. Here the flowers' hues struggled to enliven the gloom, and the perfume sprayed on the pavement was overpowering, and obviously served to mask the tunnel's usual stink.

The aroma of the old pleasure Gardens was often remarked upon: 'When I considered the Fragrancy of the Walks and Bowers with the Choirs of Birds that sung upon the Trees, and the loose Tribe of People that walked under their Shades, I could not but look upon the place as a kind of *Mahometan Paradise*'.[6] The perfume returned and that loose tribe, who had never really left, had decorated the tunnel walls. Those who passed through the tunnel might have taken it as a gallery, enjoying the flowers and viewing the textual works: one would come across choice examples of skinhead and Nazi graffiti, along with vigorous responses, SWP posters partially ripped away, reminders of diverse sexual preferences ('Black rent boy', followed by a phone number; 'Mickey is a poof'), declarations of passion ('Kelly Hilton is the one I love so go and fuck your mum') and other dedications in a similar vein.

Palmier's work was a sardonic introduction, a flowered path, leading people to the Gardens and to *Woodwork*. It was also a deliberate confrontation with the area which offered an ironic glimpse of something better. The fragility of this alternative and its immersion in noise and grime were poignant comments. Moreover, *How Does Your Garden Grow?* was a critique of nostalgia, of those sweet, TV-induced images of the past, of the fancy-dress figures employed in the heritage industry, of looking back and seeing only lost perfection. Bringing kitsch dreams into touch with urban reality, it criticised them both.[7]

The first activities which took place in the Gardens themselves were planned to continue throughout the day, and sometimes over the entire event. They formed a backdrop against which briefer performances could be seen. One of these activities was Alastair MacLennan's *Treework*, which lasted two days. On the first day, he tied a long white ribbon to each of the

Gardens' many trees. This was a deliberately slow, quiet activity, done with great care. On the second day, he tied leaves into the ribbons. In doing these things, MacLennan spent time caring for a neglected space and evoked the formal Gardens of the past. Part of the importance of this work lay in his constant presence in the Gardens. Dressed in a long black coat and black hat, he made a striking figure against the damp greens and greys. Sometimes he approached or crossed over other works, acting as a recurring motif against which other pieces were set.

From 1836 onwards the Gardens had been used as a site for ballooning. In *Political Balloons*, David Crawforth tethered red weather balloons to a line, moving them one by one, leap-frogging over one another, tracing old pathways. These paths might be seen as avenues, and the balloons as trees with immensely attenuated and lengthened trunks. The balloons rose very high and were blown far off vertical, sometimes being lost from sight, or becoming so distant that it was difficult to believe that they were still attached to the ground of the Gardens. Each balloon was meant to carry a single painted word but, as they were inflated, the words were stretched out of all recognition and then further wiped out by rain. They were, then, speech balloons, like those in cartoons and in the old prints of Vauxhall crowds, filled not with helium but hot air. The balloons aroused a great deal of curiosity. Some were lost when kids tried to steal them or see how the lines worked. One man on a bicycle accidentally ripped one out. So the political balloons escaped—passing from aspiration and inflation to brief freedom.

In his work *Poop Scoop*, Andre Stitt spent each day clearing up the prodigious quantities of dog shit deposited in the Gardens. In place of each portion of the offensive substance, he left a little 'Poop Scoop' sign, showing a dog with a crossed out turd. Stitt was marking out the surface of the Gardens, this time tracking the pathways and territories of dogs. One of a group of homeless men seated on a wall shouted to Stitt as he passed by: 'You've got some dog crap sitting on the wall here'. When at the weekend the sun emerged and the park filled, toddlers assiduously collected Stitt's signs as though they were bubble-gum cards.

In a corner of the Gardens, Naomi Siderfin and her assistants painted vanitas symbols on the grassy banks. An upturned cup, a dagger, a flower, a death's-head moth and a £ sign were mapped out and painted in different

colours. Each symbol had a double significance, historical and contemporary. The upturned cup, for instance, is an old symbol of the futility of ambition and worldly pursuits, but may now serve as an emblem for the Gardens' residents.

Bruce Gilchrist, wearing a kilt and an Indian head-dress, was surrounded by potted trees which formed a mobile shrubbery. Throughout each day he endured, dragging the heavy trees about the Gardens, while from within the mobile forest his sound suitcase played a mix of bagpipe music and Native American chanting and drums. Again, his passage over the Gardens carrying trees was a reminder of the formal avenues which once graced them, and a reminder also that Native Americans had been brought there to set up camp sites as entertainment for the public. Gilchrist's link between the Scottish and the Native American was not merely arbitrary. At the time the pleasure Gardens opened, legislation suppressing Highland culture was still very much in force, although some commercial carrots for the population were also on offer. Highland troops were highly prized by the British army, and Scots played a pre-eminent role in the military and in imperial administration, and indeed in constructing intellectual justifications for repressive legislation at home and abroad.[8] Both Scottish and Native American cultures and people were suppressed, but one was also active in the suppression of others. Their experience of being uprooted was expressed by Gilchrist in the movement of trees normally fixed in the soil.

The links with the past went further than these general associations. It was Gilchrist's work, on the surface so far removed in its pursuit of 'hardship art' from the carefree concerns of the pleasure gardens, which came closest

Right: David Crawforth, Political Balloons, *1993*

to evoking their historical past. At one time in the Gardens there were tall trees in the 'wildernesses' which were the abode of 'feathered minstrels, who in the most delightful season of the year ravish the ears of the company with their harmony.'.[9] There were also apparently subterranean sounds produced by a small orchestra concealed in a thicket dubbed 'musical bushes' or 'fairy music'.

In Ben Hillwood-Harris' *Garden Ensemble*, photographs taken from the high windows of buildings surrounding the Gardens were printed on sheets of steel. These were then placed as notices in the park creating a puzzling mismatch between the depiction and the place itself. Their soft, grey tones were set against the rich colour of the Gardens' early summer foliage; their fuzzy, low definition quality resembled the images of security cameras. These pictures were about different kinds of surveillance; sometimes it is casual, the views which office workers have as they glance up from their work over the green area where they might lunch or pass through on the way home. The intelligence services' buildings (MI5, MI6) and those of linked organisations, including British Telecom, overlook the park. In an ambivalent gesture, Hillwood-Harris provided surveillance information to those who are normally watched. This might be a return of images to the people from whom they are 'taken', or equally a repressive reminder that someone is watching, like the security monitors displayed in shops.

The combination of the various all-day events produced both planned and impromptu collaboration between the artists. Each had something to say about the history of the Gardens or their present condition, and each

Right: Andre Stitt, Poop Scoop, *1993*

sought to value the environment by working within it. The works were seen against the backdrop of the city and the park, and each other, producing complex interactions. Gilchrist's strenuous labour with his mobile trees was seen alongside MacLennan's gentle transformation of fixed ones, and Siderfin's vanitas symbols commented on Stitt's Sisyphean cleaning activities.

Mechanical Movements

At lunchtime, passengers in Vauxhall Underground were surprised to see a set of weirdly-dressed dancers emerging from the tube, then out along the foot-tunnel and into the Gardens. These were Melly Still's dancers, performing *Lunch and Tea Dances* each day of the event. The dancers were mere points of activity in a much wider environment of movement and noise. Once, as they passed along the road, one driver swore loudly at another; cars waiting at the lights coughed in the heat; as the dancers entered the Gardens, a group of construction workers leant out of the new MI6 building, laughing exaggeratedly, and catcalling. The dancers' action stopped and started, progressing sometimes swiftly through the Gardens, and paused at a place where the hillocks seem to form a grass arena. Here they ran and capered, marched up the hills, toppled over and rolled back down again. They performed among Stitt's *Poop Scoop* labels, a collaboration which was both aesthetic and practical. Their clothes, a kilt, a cloak and a gown, in colours which complemented the greens of the Gardens, blew in the breeze. At times the work, with its chivalrous gestures and flowing garments, took on a mock medieval air, matched by MacLennan's ribbons fluttering like pennants in the breeze.

Their angular, jerky movements, with frequent abrupt stops, starts and changes of direction, were derived from the actions of joggers. Improvisation in the dance was contained within an eccentric but strict structure. Certain actions were triggered by external events (for instance a train or plane passing), varying according to the dancers' position in the Gardens. A combination of these external elements yielded forms of considerable complexity and variety so that each performance bore only a family resemblance to the others. Each was modified not only by unscheduled events, but also by the audience and their occasional participation.

Another day, there was a new variation. This time the dancers did not finish in the Gardens but capered off to Vauxhall Cross, that grim junction looking even greyer and grittier than usual, the sky loaded with rain and the air with exhaust. Taxis honked angrily as the dancers skipped across the broad road, even though the lights were against them. The dancers then disappeared for a time, to re-emerge, extravagant figures against a soft grey sky, dancing across the footbridge on the other side of the junction. There was something touching and funny about these tiny points of activity and colour against the expanse of traffic movement and noise, a free, lyrical element against a directed, commercial, polluting procession.

The work also pointed to the mechanical automatism of modern activities, including recreational sport, and to the external events (such as the arrival of a train) which set people off in a particular direction. These voluntary but mechanical acts were echoed in the circularity of the course of the dance, in its apparently unstructured, endless movement in which one thing arbitrarily followed another.

Old Faithful

One of the best known characters of the old pleasure gardens was Mr. Simpson, the Master of Ceremonies, who held his post for thirty-six years. Thackeray called him 'the gentle Simpson, that kind, smiling idiot'.[10]

> He was a man of short stature and his plain face was pitted with smallpox, but his manner and dress made ample amends. He wore a shirt with an enormous frill, a coat of antique cut, and black silk knee-breeches and hose. In his uplifted left hand he carried his tasselled and silver-headed cane, and with his right hand raised his hat to everyone he met....[11]

On the benefit night for his retirement, 19th August 1833, his effigy was built from coloured lamps on a gigantic scale. This character was revived for the three days of *Woodwork* by Ian Hinchliffe, a veteran of performance art since the 1970s. He first appeared in the Gardens dragging several black rubbish bags with great apparent effort. Again the work element in *Woodwork* was to the fore, as Hinchliffe reminded viewers of the generations of servants who worked in the Gardens, catering to the pleasures of the wealthy. He

wore a frock-coat and knee-breeches, decorated with feathers—a fine costume which became increasingly begrimed and tattered as the event wore on. The bags contained plaster torsos. Hinchliffe began by laying them out on the ground in two parallel lines, connected by pieces of string. They were reminiscent of a railway line and an avenue, and of structures dotting a promenade. As in the laying of railway track, progress was marked by ceremonies as various stages were reached. Mr. Simpson's addresses to his Vauxhall audience were described as 'masterpieces of florid humility'.[12] Hinchliffe's speeches and dialogues, as he declaimed over the plaster bodies, were certainly florid but far from humble—suggestive, funny, hectoring and full of strange connections. It was like listening to a radio which drifted across the spectrum, in and out of reception, producing snatches of sense.

Over a long period, bags and torsos were carried back and forth; sometimes slung over the shoulder, sometimes cradled gently as babies. The torsos were laid to rest, each a plaster tombstone, and were decorated by Hinchliffe where they lay. They represented important events in the rise of the nation as an entity—the struggle between an authoritarian aristocracy and an expanding middle class, the eventual accommodation between them, and with it of a new audience for art: the founding of, in turn, the Bank of England (1694), the British Museum (1753), and the Royal Academy (1769). They were spoof memorials which sent up not so much the events themselves as people's memories and forgetfulness about them, filtered through half-remembered lessons at school and heritage dramas. Dotted across the grass, they were the modest graves of history.

The Loose Tribe

In her preparatory notes for *Woodwork*, Clare Palmier wondered, 'If you see me in Spring Gardens would you say hello?' On Friday morning, her *Natives* was installed in the subway tunnel leading to the tube. A series of black-and-white photographs of local people or those travelling through the area were stuck to the wall along with an identifying label. Beneath these were a series of pictures of the Gardens in green photocopies. The subjects of the portraits could come into the tunnel to collect their pictures, which would then be replaced by a monochrome photocopy of the same image in red or green.

The grouping of portraits and pictures of the locality suggested a communal link between them. As commuters in the crowded tunnel hurried past these portraits, they would glance at them. Sometimes people recognised portraits, and a small, somewhat dubious sense of community was created. The work was obviously a way of conferring an importance on local people but, as in the display of flowers, there was a deep ambivalence about the task. There was an irony in the juxtaposition of these portraits and their bald descriptions. Our assumption is that these portraits tell us something about their subjects— and they may, but we are hard-pressed to say exactly what. This work was again about the lack of an organic community, and about the divisions in a locality, between rich and poor, black and white, gay and straight, residents and homeless, but also about a general indifference and lack of connection, as powerful within such divisions as across them. The transitory was a strong feature of *Natives*, apparent in the viewers, the subjects and the temporary nature of the work itself.

Portraits in this public space obviously might compete with pictures of the victims of crime and faces in adverts, also seen on the tube. In the latter, unseeing eyes solicit glances from a passing trade; there is a one-way traffic of cursory examination in which attention is exchanged for beauty, or something humorous or intriguing. In Palmier's work, passers-by saw faces like their own which sell only themselves.

Stagflation

Dickens described ballooning in Vauxhall Gardens, making fun of the childish reactions to this novelty, of people gawking at the rising and falling of an inflated bag of air. In this, nothing much has changed. As part of Crawforth's work on ballooning, *Woodwork* included a balloon which was to fly at night and crowds gathered in the twilight to watch the preparations for its ascent. On the playing field, the envelope gradually inflated, lying on the ground like a giant slug, and there was a constant bustle as lines were secured and flames were noisily squirted into its cavity.

Finally, by which time it was dark, the balloon stood up uncertainly in the air, listing drunkenly from side to side. The plan was that the singer Mary Genis would ascend in the tethered balloon and, using a radio-mike, relay eighteenth-

century songs to the people below. Unfortunately, each time the balloon rose to the extent of its tether, it bounced back from this terminus, and despite frequent blasts of the burner only succeeded in yo-yoing up and down, from ground to the end of the rope and back again. Genis bravely continued to sing from this unstable platform, but because of the radio-mike's malfunction, only faint snatches of her unamplified voice were carried to the audience.

An innovation was produced from this misfortune — a large number of people held the balloon down so that it momentarily became a part of Susanne Thomas' dance, *Field Piece*. At times the flame made the balloon glow like a giant light bulb, momentarily revealing all the detail of the dancers, the Gardens and the spectators. This brief, violent flaring of flame and light, like a controlled explosion, matched the sharp, fast movements of the dancers, and their sudden cries. *Field Piece* was otherwise harshly and partially lit by car headlights. The dancers dashed in and out of the light like moths. On the playing field with its surrounding walls, they rushed, cried, fell and squirmed in the dirt. The burner roared menacingly, the only accompaniment to the dancers' frantic movements. The dance was a reminder of the character of the modern Gardens, for the time being transformed by Woodwork, but not normally somewhere one would choose to take a walk at night.

The lighting of the dance again referred to the history of the place, where fireworks had often been seen, and where visitors were drawn from dark London by the lure of its many lamps: 'Here are fine pavilions, shady groves, and most delightful walks, illuminated by above one thousand lamps, so disposed that they all take fire together, almost as quick as lightning, and dart with such a sudden blaze as is perfectly surprising.'.[13] When the dance was finished, David Crawforth set off a pyrotechnic display; one very fast burning explosive action, followed by a much slower one which burned along wires, making grids again reflecting the formal layout of the old Gardens. Watching the turning wire burn, imagined letters and words were traced in fire.

Bankrupt

Ian Hinchliffe, once more in the guise of Mr. Simpson, conducted a ceremony which closed *Woodwork*. He declaimed maniacally and drunkenly to the

Above: Bruce Gilchrist, Bushworks, *1993*

crowd. Someone said, 'You've had one too many, mate', and this was certainly true—his torsos appropriately made a track towards the beer tent. Their double line formed a railway line which Mr. Simpson shuttled up and down, a manic engine, stopping briefly at each plaster station for a quick rant. They were also Stations of the Cross, at which he was abused, not by the Jews, but by the Philistines. Hinchliffe collected a following of children and young homeless from the Lord Clyde hostel. 'You're a nutter, you are', said one, understandably. Another: 'Can I have half a gram of whatever you're on?' Nevertheless, they ran up and down outside his 'rails' and imitated his actions. In his dialogues with them, Hinchliffe matched their in crudity and eccentricity.

Near the beer tent Hinchliffe remarked that something was bankrupt: 'Bankrupt!?' echoed one of the homeless in disbelief at so alien and nonsensical a concept. What a word this is for them—it assumes you had something to start with. At one point Hinchliffe foppishly plucked at his long shirt sleeves. One girl wearing a short-sleeved T-shirt complained that she could not do the same. Without hesitation, Hinchliffe reached up beneath his frock coat, ripped off his sleeve and handed it to the astonished girl.

Woodwork and Contemporary British Art

Woodwork passed swiftly out of mind and matter, but perhaps it deserves to be remembered because it raised important issues about the current practice of art. The event was highly site-specific. The history of the Gardens, mediated through an awareness of their current condition, was approached with more irony than nostalgia, establishing a productive opposition between what might be thought of as the authentic and the sham. There was no attempt to revive the past, but rather to indicate it, bringing it to consciousness for contemporary uses.

Performance and installation work are not usually suited to the entertainment of those with short attention spans. Perception must be adapted and slowed in order to follow a work, and this is part of its point. Those who stayed in the park for long enough would become aware of the changes made by various works, the movement of Gilchrist's trees or Crawforth's balloons. Even Hinchliffe's more spectacular performances were often long, drawn-out affairs—slow, discontinuous ceremonies. Few would sit through the performances without distraction. In the Gardens, though, there always were distractions:

other people and their participation, other events, dogs, children, changes in the weather, ambient noises.

Aside from a programme leaflet, there was no guidance for the viewer, no labelling, and not much of a centre to *Woodwork*. The lack of managing or shepherding of the audience increased their sense of an encounter with something 'real'. If people were puzzled, they could ask what was going on. The artists who worked all day in the Gardens (especially Andre Stitt because of his overalls and his *Poop Scoop* cart which made him look 'official') had a lot of contact with a curious public. Simon Whitehead had wanted to perform without speaking, but found himself being questioned so insistently that finally he had to give in and reply. From a performer's point of view, there was a lack of control, and of a managed, theatrical space and fixed audience to which they could play. The anonymity of art in the Gardens was an aid to its collectivity. Alastair MacLennan and others' self-absorbed activities were ideal in this setting, proceeding quietly but being open to people who wanted to know what they were about. In the noisy and porous space of the Gardens where events took place under the open sky, improvisation was a necessity. In the hermetic space of the modern gallery, by contrast, a sanctum which turns in on itself and away from the world, viewers are controlled, policed by guards and agreed rules of decorum.

MacLennan has written of collaboration as an ethical practice, and in *Woodwork* there was a clear ethical model operating in which ideas and work were shared, especially in the long, collective preparation for the event. Various unplanned collaborations took place in the unmanaged space of the Gardens as artists came across each other's work, or as performances took place against the background of installations. The audience, too, often improvised their own complementary activities.

To make such a project involved putting some faith in the local inhabitants. Some of the work was intrinsically hard to understand, but was made accessible by the fact that it was created as people watched or even helped, and in this way the work was demystified and made material. The mute, definitively finished art object was dissolved, to be seen rather as a practical thing achieved through everyday ingenuity and labour.

Common to many of the artists in *Woodwork* was a dialectic of positive and negative themes, as seen, for instance, in Palmier's flowers and Siderfin's

vanitas symbols. The aspects of ritual and of unmotivated work, which has an organic relationship to the community, was cultivated in the face of the lack of an actual community which would be a ready-made audience for art. A connection between work and life had to be simulated, and there was a conscious irony in doing so, carried over into the work itself. But this irony was intended to be productive and was thus very unlike the toothless grin of so many postmodern productions. Perhaps dominant cultural forms might be infected by non-utilitarian, collaborative, ecological elements. Old and abused symbols might be pushed beyond their revival as commodities, without losing a remembrance of their history and their assimilation by the image marketers.

In a divided society, there is always guilt attached to the pursuit of the luxury and privilege of art. The great length of time which some of the works took to make could be seen as conspicuous consumption ('time is money' was the lesson first pressed on industrial workers in the eighteenth century).[14] *Woodwork* brought together in the Gardens the excess of artistic activity and the depths of a society which undergirds it; art confronted the derelict, the crazy and the poor, alongside the averagely fed. An individual work of art, as opposed to art as a whole, can make this sense of guilt conscious in the form of a contradiction, which is included in its content or material.[15] This is very much what *Woodwork* sought to do, to act as a provocation, a difficult event, which brought separate worlds into contact.

For *Woodwork* the audience consisted of people from the art world, but also local residents, the homeless, office and manual workers. The negative side of this mix, and of the lack of a collective understanding, was manifested in apathy, hostility, ridicule and even vandalism. Alastair MacLennan has written of art as revenge—a society gets the art it deserves, but even from this position the possibility of salvaging the positive from the negative remains.[16] If there was sometimes a desultory edge to *Woodwork*, there was also a positive side manifested by the audience's curiosity, openness, thoughtfulness and a pervasive resistance to being managed.

The people who were present for all of the events in the Gardens were those who live there. They may seem an unpromising audience, yet there were positive aspects about the relationship between *Woodwork* and the homeless. The routine of their lives was altered for a time by the event.

There was also much that the artists could learn from the homeless: they were told of the claustrophobia of being indoors after so long outside, of the realisation that the only people who really care for the homeless are other homeless and the violence they receive from people who come to the Gardens at night to bolster the work ethic. The relations between them were close and direct—what Wyndham Lewis called 'the freemasonry of the propertyless', and their constant ribbing sometimes concealed a background of affection.[17] A community could be found in Vauxhall, after all, in the Gardens themselves. The homeless have a 'freedom' forced on them similar to that of an uncommodified art—and if art remains uncommodified, this, too, is usually not a matter of choice. They are remarkably free of the cultural flotsam in which the rest of us bathe—radio, TV, popular music, even to an extent newspapers, magazines or shopping. While they are excluded from many places, they alone know a different London which is always walked over, and they venture into places few others know.

The theme of the identity of the onlooker and the quality of their engagement was perhaps the most important thing about Woodwork, and is also the most pressing issue facing contemporary art today. To take the homeless as your audience is an extreme solution, and a partial one, but it is no more extreme than that currently taken in the fashionable 'alternative' galleries— to draw entirely upon an enclosed and ironically self-conscious bohemia. If the art shown in those galleries is overly safe, it is not because of its content, but because it always talks to itself. The audience for contemporary art has expanded recently but it remains highly homogeneous, and, as we shall see by looking back once again at Vauxhall, such audiences have been constructed many times before.

Creating an Audience for Art

The making of an audience for art was closely tied to the creation of the middle class. The pleasure Gardens flourished at a time when working people were thrown together in ever increasing concentrations and were supposed to be divided by ever more specialised tasks, a time of conquest and systematic plunder, which involved as a by-product the creation of a modern state and economy. In a well-planned symbiosis, government and business, war and

commerce, fed off one another. Imperial conquests and wars with rival powers brought substantial material benefits to Britain and were widely praised. They made luxury goods readily available—silk, rice, coffee, tobacco and, above all, tea and sugar.[18] The exotic styles of the Vauxhall pavilions conjured up the often subject territories from which these goods came.[19] Military successes were celebrated in the Gardens, sometimes by re-enactment (in 1827 the Battle of Waterloo was replayed with one thousand cavalry and infantry) and sometimes in painting. In the only substantial classical pavilion built in the Gardens, historical paintings celebrated British military triumphs and magnanimity in victory.[20] Vauxhall verses inscribed beneath an engraved scene of cricketing read:

> Britons, whom Nature has for war designed
> In the soft charms of ease no Joy can find:
> Averse to waste in Rest th'inviting Day
> Toil forms their Game, & Labour is their Play.

These sentiments are not as remote from our experience as one might think for the British economy is still highly militarised. Just as in the eighteenth century national identity was partly forged in war against France, under the long Conservative reign the force of arms has twice been used to try to create a sense of national coherence and legitimate government. In another sense, the relation of these verses to the pleasure Gardens is deeply ironic, for British people went there precisely to enjoy the recreational fruits of their military and commercial endeavours. If in the eighteenth century imperialism,

Right: Vauxhall Pleasure Gardens

racism, the work ethic and games were all found in the themes of Vauxhall entertainment, they are still highly pertinent to the Gardens as they exist today. Each theme may be turned against the current orthodoxy (just as C.L.R. James showed how cricket could be turned against its creators and disseminators).[21]

The rapidly expanding urban middle class was the main audience of the Gardens under Tyers. No ties of breeding or innate qualities linked the diverse individuals who made up this class. Rather, it was argued, they were an assembly of private people bound by affection and benevolence who, in pursuing their own individual interests, would also act for the good of the whole.[22] This development was part of a wider phenomenon (though at first very much London-based) as the middle class became self-conscious, recognising itself as a social and cultural entity and founding its own meeting places: coffee houses, assembly rooms, spas and, of course, pleasure gardens.

So the audience was new and developed alongside the Gardens. Naturally there were those who questioned its quality and coherence: Oliver Goldsmith has his character Mr. Tibbs, 'not expect to see a single creature for the evening above the degree of a cheesemonger...',[23] while a snobbish character of Smollett's complained of Vauxhall's visitors:

> The gayest places of public entertainment are filled with fashionable figures; which, upon inquiry, will be found to be journeyman taylors, serving-men, and abigails [ladies' maids], disguised like their betters. In short, there is no distinction or subordination left—The different departments of life are jumbled together—The hod-carrier, the low mechanic, the tapster, the publican, the shopkeeper, the pettifogger, the citizen, the courtier, all tread upon the kibes [chilblains] of one another: actuated by the demons of profligacy and licentiousness, they are seen every where rambling, riding, rolling, rushing, justling, mixing, bouncing, cracking, and crashing on one vile ferment of stupidity and corruption—.[24]

Another of Smollett's characters provides a corrective to the venom, if not the accuracy, of this view: 'It grates old Square-toes to reflect, that it is not in his power to enjoy even the most elegant diversions of the capital, without the participation of the vulgar; for they now thrust themselves into all assemblies, from a ridotto at St. James's, to a hop at Rotherhithe.'.[25] Tyers' business was to make his patrons feel that they were part of an art public by virtue of their participation in the sphere of polite discourse, bound by

common interest.[26] Strong links were drawn between civility, politeness, virtue and appearance, to the extent that the self was considered as a work of art: 'Let us imagine ourselves, as so many living Pictures drawn by the most excellent Masters, exquisitely designed to afford the utmost Pleasure to the Beholders'.[27] So in this sense, at least, each member of the audience was also a performer, each made of themselves a work of aesthetic civility, believing in the power of art to unite the individual sensibilities with the general interests of society as a whole.[28]

In the eighteenth century, popular carnivals and fairs were still a political force which met with concerted, though far from successful, attempts to stamp them out.[29] Under Tyers, the Spring Gardens took on the form of carnival, but at the same time their middle- and upper-class audience were careful to distinguish their pursuits from those of the general populace.[30] To do this, it was necessary to regulate the performers, exclude undesirables, create a firm distinction between audience and spectacle, and to enforce polite, if not moral, behaviour. When Tyers opened the Gardens after renovation in 1728, a guard of one hundred soldiers was present with fixed bayonets.[31] Music in the Gardens, which before Tyers' direction was impromptu and performed by buskers or members of the crowd, was afterwards managed, programmed and separated from the audience.[32] Large crowds were known to be potentially dangerous and, if Handel was often heard at Vauxhall, his reputation was in part based upon the supposed ability of his harmony to charm 'even the greatest Crouds into the profoundest Calm and most decent Behaviour'.[33]

The changes at Vauxhall were part of a more general assault on manners. When appearance could no longer be relied upon to indicate status, manners took on increased importance. David Solkin has argued that it was standard in the propaganda of the age to argue that the politeness which accompanied commerce had refined the barbarous past of the nation.[34] An anonymous poem, 'The Turkish Paradise or Vaux-Hall Gardens' (1741) described the period before Tyers:

In Times, not yet forgot, this Ground was trod
By Lust and Folly, this was their Abode;
The Evening Shade that fell but serv'd to hide
The Shame of Drunkards, or the Harlot's Pride.

And afterwards:

> The Paths that lead to Knowledge daily swept,
> A bright Idea of Proportion kept,
> Impertinence and Errors lopt away,
> And all is smooth, and uniform and gay.
> Thus Art has govern'd here, and by Degrees
> Conquer'd the Rudeness of the stubborn Trees,
> To equal Heights has taught their Shades to rise,
> Stop'd their Ambitious Tendence to the Skies....[35]

Tyers was commended for 'having chang'd the leud Scene' to one 'of the most rational, elegant and innocent kind'.[36]

Despite these measures and the propaganda that accompanied them, the audience of the pleasure Gardens was often far from ordered and polite. Vauxhall retained its reputation for immoral behaviour—in 1763 Tyers was ordered by magistrates to fence off the walks so that courting couples would be prevented from committing indecencies in the woods. There were regular riots on the last night of the season when, 'the folks run about—and then there's a squealing and squalling! and all the lamps are broke, and the women run skimper scamper'.[37] Yet the intention, at any rate, was that the Gardens retain only the form of popular carnival, including its anti-hierarchical elements which were convenient for the bourgeoisie in its power struggle with the aristocracy, while excluding its vulgar elements. Old carnival, subject to repression in the real world, became a strong presence in satirical verse and prints, and in the very paintings shown in the Spring Gardens, where Hayman portrayed traditional pursuits in which the poor appear as innocent, if frivolous, children, providing a marked contrast to the polite adult activities against which those depictions were seen.[38]

Woodwork participant, Roland Miller, has written of the roots of British performance art, which has always depended on improvised action and dialogue, in music hall and folk theatre, even mystery plays. This tradition was just that carnivalesque activity from which Tyers had sought to dissociate the pleasure gardens whilst assimilating its empty form. Such a tradition cannot be simply recovered. The need to confect a community for the purposes of an event means that now carnival generally serves the prevailing system by providing a temporary release from its constraints. *Woodwork* showed how an open, outdoor art could be anti-carnivalesque yet still radical, taking

not the form of carnival without its spirit, but its spirit without its form. In carnival, simple oppositions are set up in order to be subverted: high and low, birth and death, male and female, lord and serf. At its best, *Woodwork* brought history into this simple subversion, producing a sense of impetus and development, and holding out a promise for the future.

The audience for art has been created and recreated as the middle class stirred and grew over the centuries. Vauxhall in the eighteenth century had its radical aspect as the interests of the rising class worked against aristocratic authority.[39] The same can hardly be said of the current audience for 'new British art' which defines itself only against suburban philistinism. The audience for live art is even more restrictive, the work often being seen only by a narrow circle of other live art practitioners and critics. A paradox of performance art has been that, while it shifts the emphasis from object to audience which should open up a plurality of interpretation, the actual audiences tend to be highly enclosed and homogeneous. For *Woodwork*, as for the audience of the eighteenth century, there was an assumption that the power of the aesthetic can unite people—but it did not first require uniformity in its audience.

The Belated End of Illusion

With great regularity the pleasure gardens were described as being characteristically British, yet descriptions often compared them to mythical Eastern pleasure grounds. Oliver Goldsmith enthused:

> I must confess, that upon entering the gardens, I found every sense overpaid with more than expected pleasure; the lights everywhere glimmering through the scarcely-moving trees; the full-bodied concert bursting on the stillness of the night; the natural concert of the birds... all conspired to fill my imagination with the visionary happiness of the Arabian lawgiver [Mohammed], and lifted me into an ecstasy of admiration.[40]

Here Vauxhall, become a Muslim paradise, is presented as a realm of unbounded sensual delight.

This middle-class heaven, and the wider national success which it embodied, was achieved at great human cost at home and abroad. As one critic of the system succinctly put it, 'The veiled slavery of the wage-workers in Europe

needed, for its pedestal, slavery pure and simple in the New World'.[41] European economic superiority was partially founded on the exploitation of the New World from which profits were regularly repatriated, above all from sugar plantations.[42] In Britain wealth also exacted its price. Generations of ordinary people were sacrificed to the creation of an industrial base, a process which created an impoverishment of the working population as wages fell, prices rose and customary privileges were withdrawn. A landless population was created that had few options outside the factory or the ever-expanding army.[43] This was accompanied by the spread of radical ideas and political organisation among artisans, and expressions of discontent over food, tax and working conditions.[44] One response to this development was straightforward repression: Daniel Defoe noted the curious fact that, 'There are in London, notwithstanding we are a nation of liberty, more public and private prisons, and houses of confinement, than any city in Europe, perhaps as many as in all the capital cities of Europe put together...'.[45] A similar boast could be made today. In the late eighteenth century, these developments are reflected in changing representations of the poor who had been pictured as an idealised, happy class of innocents, but were increasingly seen as a collective, troubled mob, a problem for the propertied.

Like the skin of a postmodern office building in which cladding and smoked glass conceal the structure and activities beneath, the Gardens were a fragment of the luxurious gilding produced by, and laid over, the workhouse beneath. So it is hardly surprising that time and again the pressing feeling was expressed that the garden paradise was a mere illusion:

Right: Ben Hillwood-Harris,
Garden Ensemble, *1993*

the imagination full of the enchanted groves and rose-bowers of
eastern lore, we eagerly passed the barrier, and found ourselves
amid illumined groves and fountains playing in beautiful unison
with the soft strains of unseen music. Alas! that the creative poetry
of infancy should be so readily dispelled by the stern realities of after-life!.[46]

In the newly born middle-class brain, the objective fabrication of an earthly
paradise, which cannot quite be admitted, is transferred on to a subjective
yearning for childhood.

Both the entertainment and the decorative schemes played on these
themes of illusion and vanity. In the Vauxhall paintings, the most recurrent
themes were those of chance and imbalance; the subjects included leap-
frogging, people losing their balance on a see-saw, blindman's buff, sliding
on the ice, and flying a kite.[47] Illusion was central to Vauxhall. The Gardens
were a vast *trompe l'oeil* assemblage; the landmarks, mere stage scenery,
were flimsy affairs. This was well recognised by some of the visitors. Smollett
has one character complain (and let this stand for the culture as a whole):

Vauxhall is a composition of baubles, overcharged with paltry ornaments,
ill conceived, and poorly executed; without any unity of design, or propriety
of disposition. It is an unnatural assembly of objects, fantastically illuminated
in broken masses, seemingly contrived to dazzle the eyes and divert the
imagination of the vulgar.... The walks, which nature seems to have
intended for solitude, shade, and silence, are filled with crowds of noisy
people, sucking up the nocturnal rheums of an aguish climate; and through
these gay scenes, a few lamps glimmer like so many farthing candles.[48]

The structures at Vauxhall were nevertheless at least partially effective,
because the Gardens were only visited from the late evening onwards, and
the lighting was managed and selective. When, in the nineteenth century,
the Gardens were opened in the daytime for displays of ballooning, the sense
of disillusionment was intense. Dickens wrote of the contrast, sardonically
describing the Gardens by night:

The temples and saloons and cosmoramas and fountains glittered
and sparkled before our eyes; the beauty of the lady singers and the
elegant deportment of the gentlemen captivated our hearts; a few
hundred thousand of additional lamps dazzled our senses; a bowl or
two of reeking punch bewildered our brains; and we were happy.[49]

And by day:

> then we saw, for the first time, that the entrance, if there had ever
> been any magic about it at all, was now decidedly disenchanted, being,
> in fact, nothing more nor less than a combination of very roughly-painted
> boards and sawdust. We glanced at the orchestra and supper-room as
> we hurried past—we just recognised them, and that was all.... We walked
> about, and met with disappointment at every turn; our favourite views were
> mere patches of paint; the fountain that had sparkled so showily by lamp-light
> presented very much the appearance of a water-pipe that had burst; all the
> ornaments were dingy, and all the walks gloomy.[50]

Yet this awareness had always been held at the back of visitors' minds, and
perhaps the very fragility of the illusion contributed to its loaded charm.
One writer acutely described the diversions of Vauxhall as having 'an effect
desired before it is felt!'[51] As we have seen, many of the Vauxhall paintings
illustrated idle pursuits, parables about fate, vanity and ambition. Apparently
harmless objects could become tokens of futility and death, like Siderfin's
superficially charming paintings on the grass banks.

For a brief time, the *Woodwork* artists pointed to another way: a way of
living which is less bound up with material things, which is more aware of
its surroundings and their inhabitants, a way of living which values sharing,
participation and development. An event such as *Woodwork* may create for
those involved a brief tear in the unitary garment of the culture industry.
Again the site could not have been more appropriate, for in its stimulation
of all the senses, its mix of theatre, music and visual arts, Vauxhall was an
early development of phantasmagoria, that all-embracing culture from which
there seems no escape. There is undoubtedly vanity involved in even
attempting to break with it, like trying to rend water with a blade, but this
was a theme of the work itself. *Woodwork* was an attempt to go back beyond
modern illusion through the use of archaic devices—bricolage, ritual,
contemplation and the deliberate slowing of action and perception.

The victims of tyrannies other than our own have been obsessively
counted and recounted. For the most part, the millions who were and are
the victims of capitalism remain uncounted and unaccounted for. Their
shadows, decked out in festive garb, entertained the middle classes. The
vanity of this entertainment was intimately linked to the fragile structure on
which the means to entertain was supported. The Gardens are a palimpsest

linking these peoples past and present—the hungry, the dispossessed, the exiled, those exhibited as exotic specimens, the derelict and the homeless.

When the old pleasure Gardens finally closed, *The Times* published an article about the demolition of the pavilions, 'the wooden edifices that look like spectres of dead 'fun' to the travellers by the South-Western railway'.[52] The Gardens are still overlooked by the railway and spectres may still be seen for those who care to look—the banks of grassed-over rubble, and the forgotten inhabitants. An art event like *Woodwork* is by its very nature temporary. Returning even a week later, remarkably little was left, the event already having faded into an archaeology of the recent, appropriate to the Gardens. Someone had cut every ribbon from the trees. The only remnants were Siderfin's hill paintings, already beginning to fade, and the foot-tunnel which still smelt perversely of perfume.

Performance art vanishes like flame in air, no sooner produced than lost. Forgetfulness was a theme of much of the art in *Woodwork*, which placed emphasis on states of mind rather than material goods, on trajectory rather than position. There is a danger, though, even in remembering—that photography falsifies the event by presenting a series of particular moments, ignoring the space between events, and the expanse and air of the Gardens, all of which are very difficult to represent. Writing also threatens to turn what was a matter of process and becoming into something fixed. The effort to keep *Woodwork* in memory, to fix it like a photographic print, involves interpretation and reduction. The story I have told is only one set of memories—in itself a performance and an orchestration, and, like the works described, uncertain, and aware of its own likely futility.

The history to which *Woodwork* drew attention to is not that of costumes and clichés, but a knowledge which is needed to gain a sense of direction, of place, of evolving identity and, most of all, of current potential. Lethe, the river of forgetfulness, washes nightly through people's living rooms, a constant flow of images and sound erasing the traces left by previous ones, a manufactured and continuous present. Against this, some forms of impure art can offer resistance by using physical presence, actual space, slowness and an openness to an audience who participates in its creation. Material and audience may seem unsuitable, but such activity is a necessary first step and, as with working wood, the process is slow, much is discarded along the way, and one must work with the given material.

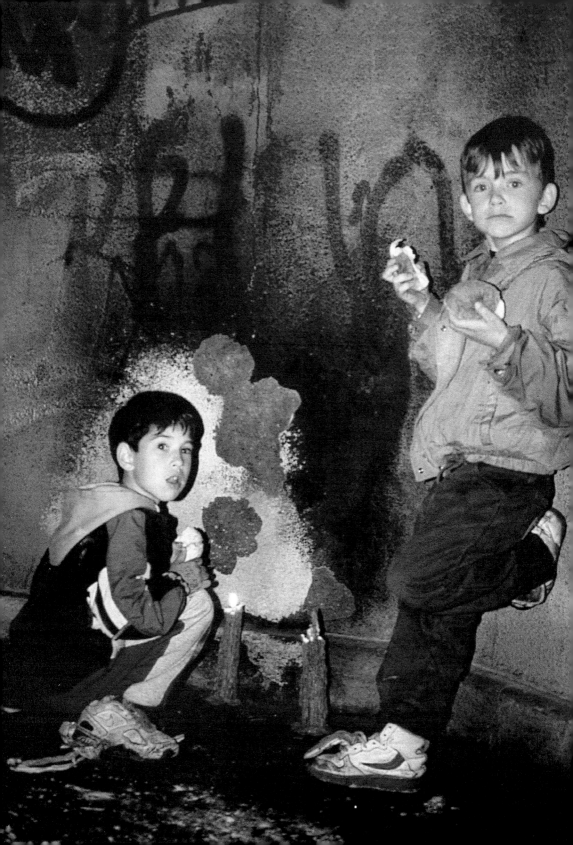

Notes

1. Longman, cited in Lawrence Gowing, 'Hogarth, Hayman, and the Vauxhall Decorations', *The Burlington Magazine*, vol. xcv, no. 598, January 1953, p. 6.

2. *Woodwork* was curated by Nosepaint (David Crawforth and Naomi Siderfin) and took place on 27-29 May 1993.

3. *London in 1710 from the Travels of Zacharias Conrad Von Uffenbach*, ed. & trans. W.H. Quarrel and Margaret Mare, London, 1934, p. 131.

4. Tobias Smollett, *The Expedition of Humphrey Clinker* (1771., Penguin, London, 1967, p. 124.

5. This account of *Woodwork* is necessarily an abbreviated and selective one; it omits some of the events and actions, and does not consider the open workshops which preceded it, the community events involving local schoolchildren, and an evening event held in a nearby railway arch.

6. Joseph Addison, *The Spectator*, 20 May 1712; cited in T.J. Edelstein, *Vauxhall Gardens*, Yale Center for British Art, New Haven, 1983, p. 11.

7. After the work was taken down, the unsold flowers were sent to local institutions, including Bondway and St. Thomas' Hospital.

8. Linda Colley, *Britons: Forging the Nation*, 1701-1837, Yale University Press, New Haven, 1992, pp. 119, 120; Peter Linebaugh, *The London Hanged. Crime and Civil Society in the Eighteenth Century*, Penguin, London, 1991, p. 273f.

9. Warwick Wroth, *The London Pleasure Gardens of the Eighteenth Century*, MacMillan, London, 1896, p. 302.

10. Thackeray cited in Wroth, *Pleasure*, p. 320.

11. Ibid.

12. Ibid.

13. *England's Gazetteer*, 1751; cited in Wroth, *Pleasure*, p. 293.

14. E.P. Thompson, *Customs in Common. Studies in Traditional Popular Culture*, The New Press, New York, 1991, Chapter 6.

15. Fredric Jameson writing of Theodor Adorno in *Late Marxism. Adorno, or, the Persistence of the Dialectic*, Verso, London, 1990, p. 130.

16. Slavka Sverakova, 'Alastair MacLennan', *Alastair MacLennan. Is No, 1975-1988*, Arnolfini Gallery, Bristol, 1988, p. 9.

17. Wyndham Lewis, *Rotting Hill*, Henry Regnery Company, Chicago, 1952, p. 10.

18. Colley, *Britons,* p. 69.

19. David H. Solkin, *Painting for Money. The Visual Arts and the Public Sphere in Eighteenth Century England*, Yale University Press, New Haven, 1993, p. 135.

20. Ibid., p. 150.

21. C.L.R. James, *Beyond a Boundary*, Hutchinson, London, 1963.

22. Solkin, *Money*, p. 157.

23. Goldsmith, Letter LXXI, 'The Citizen of the World'; cited in Edelstein, p. 13.

24. Smollett, *Clinker*, p. 119.

25. Ibid., p. 148.

26. Solkin, *Money*, pp. 190, 191.

27. Kellom Tomlinson, *The Art of Dancing Explained by Reading and Figures*, London, 1735, pp. 3 & 4; cited in Solkin, *Painting for Money*, p. 31.

28. Ibid., p. 212.

29. This is one of the major themes of E.P. Thompson's *Customs in Common.*

30. Solkin, *Money,* p. 115.

31. Wroth, *Pleasure,* p. 290.
32. Solkin, *Money,* pp. 114, 115.

33. *London Daily Post*, 18 April 1738; cited in David Coke, *The Muse's Bower: Vauxhall Gardens, 1728-1786*, Gainsborough's House, Sudbury, Suffolk, 1978, p. 76.

34. Solkin, *Money*, p. 95.

35. Ibid., pp. 108-110.

36. Edelstein, *Vauxhall*, p. 26.

37. Sudbury citing a character in Fanny Burney's *Evelina* (1778).

38. See Peter Stallybrass and Allon White, *The Politics and Poetics of Transgression*, Methuen, London, 1986, pp. 16, 103, 104; Solkin, *Money*, p. 144.

39. It has been argued that the rococo eclecticism of Vauxhall architecture was an expression of opposition to the official Palladianism of the government. See Marc Girouard, 'Coffee at Slaughter's. English Art and the Rococo, I', *Country Life*, vol. cxxxix, no. 3593, 13 January 1966, p. 61.

40. Goldsmith, Letter XXI, 'The Citizen of the World', 1760; cited in Solkin, *Money*, p. 120.

41. Marx, *Capital*, Vol. I; cited in Fernand Braudel, *Civilisation and Capitalism, 15th-18th Centuries,* Vol. III, *The Perspective of the World*, trans., Siân Reynolds, William Collins Sons & Co., London, 1984, p. 392.

42. Braudel, *Capitalism*, p. 429. There has been much controversy about the extent and type of contribution made to the development of British industry by profits from slavery and the colonies. For a review of the debate, and an argument that the contribution was highly significant, see Robin Blackburn, *The Making of New World Slavery. From the Baroque to the Modern, 1492-1800*, Verso, London, 1997, Chapter 12.

43. Braudel, *Capitalism*, pp. 614, 615.

44. Colley, *Britons*, pp. 283-4; Thompson, *Common*.

45. Daniel Defoe, *A Tour Through the Whole Island of Great Britain*, (1724-6), Penguin, London, 1971, p. 321. On the increase in gaols, see Linebaugh, *The London Hanged*, p. 52f.

46. Cited in Sudbury.

47. Edelstein, *Vauxhall*, p. 27.

48. Smollett, *Clinker*, pp. 120, 121.

49. Charles Dickens, *Sketches by 'Boz' Illustrative of Every-Day Life and Every-Day People*, John Heywood, London, n.d., p. 94.
50. Dickens, *'Boz'*, pp. 95, 96.

51. *Scots Magazine*, August 1739; cited in Coke, *Bower*, p. 78.

52. *The Times*, 26th July 1859; cited in Coke, *Bower*, p. 97.

Addenda Notes

0. The imaginary, the curation in reference to which the addenda follow, would have no enclosure—it belongs not to a static plane, but operates across alternating fields of meaning. Addenda acts as a progression in text, a single thread criss-crossing axes across the imaginary. It is an individuated drift. Its reference points are nebulous and its continuity is internal to the subject within the drift. The drift has no external structure, as for example the concentric circles of Dante's *Inferno*. However, the traffic is analogous and what matters is the transformation effected through movement.
Dante, *Inferno*, Canto III, trans.,Dorothy Sayers, Harmondsworth, Penguin, 1949.

> 'they press to pass the river, for the fire
> Of heavenly justice stings and spurs them so
> That all their fear is changed into desire'

1. Hal Foster, 'The Archive without Museum', *October*, no. 77, Summer 1996. If the curation is unrecoverable to the institutional, it relinquishes the disciplinary autonomy guaranteed by institutional frames in order to seek a different form of ontology, possibly a new strategic autonomy to escape the 'genealogy of the subject'.

2. Guy Debord, *The Society of the Spectacle* (1967), trans., Donald Nicholson-Smith, Zone Books, New York, 1994.

3. Thomas McDonough, 'Situationist Space', *October*, no. 67, Winter 1994. The altered conceptual geography of the spectacle in the age of Information Technology would alter the significance of the aerial map to the construction of a contemporary psychogeography. The *dérive* and its tactical constituent, the *détournement*, were contra-posed to a mechanical spectacle; its oppositional tactics then were purely kinaesthetic. The contemporary *dérive* would thus engage the subject with the new technological annexes and concrete space, whilst affirming the latter as the only common framework for all activities.

4. Brett Williams, *Upscaling Downtown: Stalled Gentrification in Washington, DC*, Cornell University Press, Ithaca, NY, 1988. Brett Williams has described the role of television to add density to daily narratives and contribute to the 'texture' of everyday urban experience within a working class, black neighbourhood in Washington, DC.

5. Gilles Deleuze and Felix Guattari, *On the Line*, Semiotext(e), New York, 1983. The rhizome is not based on any structural or generative models; it is not modelled on aborescent structures and bears no resemblance to roots and trees which fix points and therefore construct hierarchical orders.

6. On the plateau of the rhizome, the co-ordinates of movement are totally abstracted; super-strings of meaningful connections.

7. Mark C. Taylor and Esa Saarinen, *Passage Index for Imagologies*, http://www.ubalt.edu/www/ygcla/sam/pi/imagologies.html.

8. Rem Koolhaas' Generic City, the global city as the mirror-house of global capital. Like Simcult, the Generic City is another effect of symbolic disciplinary projection. The Generic City is a fractal, an endless repetition of a simple structural module. It is urban space, purely a form of left-over of social processes—'the generic city is what's left when important parts of urban life takes place in cyberspace.' The abstraction of life is measured by the surplus connectivity. 'The city used to be a sexual hunting ground. The generic city is like a dating agency: it efficiently matches supply and demand. The most obscene possibilities are announced in the cleanest typography: Helvetica has become pornographic.' *Domus*, Issue 791, March 1997.

9. The meme itself as an idea was first propagated by Richard Dawkins in *The Selfish Gene*, Oxford University Press, Oxford, 1976. It could be defined as a unit of intellectual or cultural information that can pass from mind to mind and exists long enough to be recognised as such. Memes could be regarded as living entities in the same way as viruses are. Memes are propagated through the communicative process of imitation. Prior to the Internet, cognitive processes which propagated themselves purely through communication were largely visualised as habits and clichés.
 With regard to meshworks, Artificial Intelligence (AI) provides new analogies for modelling the interchange between internal and external space. Think also of comparisons between non-linear 'dynamic' behavioural models of thinking and hierarchical symbolic thinking. The latter decomposes the mind into relatively large functional modules (perception, execution) interfaced

together by central representations (beliefs, desires, intentions)... the modules and the representations form a static 'model of the world'. In comparison, non-linear behavioural AI does not aim at the internal generation of a world model, but rather, it situates its robotic animals in the real world so that the objective features of the environment can be used as a form of external memory. This modelling strategy is sometimes expressed with the phrase: 'The world is its own best model'. See Manuel De Landa, *Homes: Meshwork or Hierarchy?*, http://www.mediamatic.nl/doors/Doors2/DeLanda/DeLanda-Doors2-E1.html.

10. Erwin Shroedinger, *What is Life/and Mind and Matter*, Cambridge University Press, Cambridge, 1967.

11. The absurd is Tertullian's *credo quia absurdum est*, I believe because it is absurd, a portrayal in transcendental terms. A well-known theological mis-attribution for in his *Treatise on the Incarnation*, Tertullian states 'And the Son of God died, which is immediately credible because it is absurd. And buried he rose again, which is certain because it is impossible.'.

12. Jean Baudrillard, *The Evil Demon of Images*, Power Institute Publications, Sydney, 1984.
The same paragraph in *The Evil Demon of Images* continues with:

> Take Nietzsche's treatment of God. What Nietzsche says is that God is Dead. This is a far more
> interesting situation than if Nietzsche were to say 'there is no God' or 'God has never existed'—
> that would be mere atheism. What Nietzsche does is to say something far more dramatic, and
> really something else altogether. It is an attempt to go beyond God. Similarly, the word 'immorality'
> is an attempt to go beyond morality and amorality. It is certainly an attempt to state the disappearance
> of morality, but also to situate the game at a different level.

13. Frances Tustin, *The Protective Shell in Children and Adults*, H. Karnac Books, London, 1990.

14. Donna Haraway, 'The Promises of Monsters/A Regenerative Politics for Inappropriate/d Others'. The regenerative traverse four possible maps, a. Real Space or Earth, b. Outer Space or the Extraterrestrial, not-b. Inner Space or the Body, not-a. virtual space or the science fiction world, Nelson Grossberg, Paula Treichler and Cary Nelson, eds., *Cultural Studies*, Routledge, London, 1992.

15. Antonin Artaud, 'Theatre and the Plague', in *The Theatre and its Double*, Calder and Boyers, London, 1970. In Artaud's theatre, the *dérive* would be analogous to the role of the tragic actor; the tragic actor who compared with a murderer's fury, remains within a circle. The murderer's anger accomplishes an act, and is released, losing contact with the power that inspired, but will no longer sustain it. The actor's assumes a form that denies itself progressively as it is released, merging with universality.

16. Felix Guattari has written about the possible invention of new universes of reference, and on 'heterogenesis', a becoming which produces ever new differences, and which works against digital homogenisation. See 'Subjectivities: For Better and For Worse', in Gary Genosko, ed., The Guattari Reader, Blackwell Publishers, Oxford, 1990.

17. The curation becomes the medium between the technological circulatory systems and the world of practice, which remains outside discourse. Pierre Bourdieu, *Outline of a Theory of Practice*, Cambridge University Press, Cambridge, 1977: 'Practices circulate and reproduce culture without their meanings passing through discourse or consciousness; in order to appropriate practice it has to be brought into discourse altering its ontological status for its defining feature is that it is not discourse.' See also Michel De Certeau, *Practice of Everyday Life*, University of California Press, Berkeley, 1984, on 'Walking in the City', a pedestrian speech act which is evasive and aimless. In comparison, the *dérive* is strategic aimlessness, an exercise in desire and imagination. Its terrain, the psychogeography, is understood as both geography and history. Its entropy is not one directional. It overrides the irreversibility of history and understands reality to be a pretext for imagination, not the goal of it.

Contributors Notes

Matthew Arnatt lives ALONE in North London. His favourite car is a BMW 6 series and he likes going to private views.

Malcolm Dickson is the director of Street Level Photoworks in Glasgow. He founded and edited *Variant* magazine (1984-94), initiated the *New Visions* film and video festivals (1992-94) and was one of the early members of the artist-led Transmission Gallery.

Simon Ford is a curator at the National Art Library, Victoria and Albert Museum, and a PhD research student at the Courtauld Institute of Art. He is author of *The Realisation and Suppression of the Situationist International* (AK Press, Edinburgh, 1995) and the *Wreckers of Civilisation: The Story of COUM TRANSMISSIONS and THROBBING GRISTLE* (Black Dog Publishing Limited, London, forthcoming).

Robert Garnett is a London-based critic and lecturer in the history of art.

Mark Hutchinson is an artist, designer, writer, songwriter, bookseller, cleaner and so on. At the moment he makes debauched aliens on drugs and sweet aliens on greetings cards. He wrote for *Artifice* magazine regularly and writes numerous bits and pieces elsewhere. Mark is normally on the dole.

Siraj Izhar is the artist-curator of strike. strike was set up in 1992, operating from the Public Lavatory outside Christchurch Spitalfields in East London.

Heidi Reitmaier is director of talks at the Institute of Contemporary Arts, London.

John Roberts is a writer and curator. He is the author of *The Art of Interruption: Realism, Photography and the Everyday* (Manchester University Press, Manchester, 1998).

Naomi Siderfin is an artist and curator. She co-founded and directs the artist-initiated organisations Nosepaint and Beaconsfield, in London.

Julian Stallabrass is the assistant editor of *New Left Review* and a visiting lecturer at the Courtauld Institute of Art. He is the author of *Gargantua: Manufactured Mass Culture* (Verso, London 1996) and a co-editor of *Ground Control: Technology and Utopia* (Black Dog Publishing Limited, London 1997).

Peter Suchin is an abstract painter, critic and teacher. His publications include essays and reviews in *Art & Design, Artists Newsletter, Variant, Here and Now, Circa, Art Papers, Art Monthly* and *Mute*. During 1996-97 he was Critic in Residence in the Department of Visual Arts at the University of Northumbria.

Archives

Based in London, **Beaconsfield** is an artist-led organisation conceived to fill a niche between existing public establishments, commercial enterprise and 'alternative' ventures. Founded in 1994 by David Crawforth, Angus Neill and Naomi Siderfin, Beaconsfield was developed from the resources of **Nosepaint**, a curatorial initiative started by Crawforth and Siderfin in 1991.

Established in 1993 by Jon Bewley and Simon Herbert, **Locus+** is an office-based arts organisation in Newcastle upon Tyne that commissions works by artists for non-gallery contexts and across different formats. It follows on from the artist-run organisations, **The Basement** (1979-84) and **Projects UK** (1984-92) and subsequently manages the largest archive of documentation of time-based artworks in the UK.

The **Infanta of Castile** was a mobile initiative, founded in 1992, with a shifting set of intentions and internal relationships. The founders, Marc Hulson, Elizabeth Price and Matthew Thompson, went onto work collaboratively with David Bate, Margarita Gluzberg and Susan Morris under the name **accident,** setting up a series of shows at an exhibition space in Shoreditch, London.

Shave is an annual, collaborative event organised by artists which takes place in the English countryside during the summer. Founded by Anna Best and Ella Gibbs in 1991, Shave contributes to the international network of artist-initiated events by creating the time and space for artists from different parts of the world to meet and work.

'**Transmission** is Glasgow's first artist-run gallery organised by the Committee for the Visual Arts (C.V.A.), a non-profit making association. A varied group of young artists dedicated to the exhibition and promotion of contemporary art and the integration of art into community life.' (Press Release 1983). Since its inception, Transmission has presented more than 200 exhibitions and events at home and abroad.

Picture Credits

Front cover: Ian Hinchliffe, *Commuter Action*, Woodwork, 1993, courtesy Nosepaint, London (photo Julian Stallabrass). **Endpapers**: Shave mailing list, courtesy Shave, Devon.

6 Beaconsfield, Advertisment placed in *Artifice* and *mute* magazines, 1997, courtesy *Artifice*. **12** Pedro Romhanyi (director) Pulp, *Babies* video, 1995, exhib. *Assuming Positions*, 1997, courtesy Institute of Contemporary Art, London. **17** BANK, *The BANK Friday 23rd May*, 1997, courtesy BANK, London. **21** Gavin Turk, *Pop*, 1993, courtesy the Saatchi Collection, London. **26** Ronnie Simpson, contribution to catalogue, *Creative Curating* MA course 1997, courtesy Goldsmiths College, London. **29** Clare Tindall *Tête à Tête*, 1992 courtesy Nosepaint, London. **30** Myles Stawman, *Pecu*, 1997, courtesy belt, London (photo Ella Gibbs).

33 Ridgeway/Bennett, *RAM*, 1992, courtesy City Racing, London. **34** accident (David Bate, Margarita Gluzberg, Marc Hulson, Susan Morris, Elizabeth Price, Andrew Renton, Matthew Thompson), *Collaborative Installation*, 1997, courtesy accident, London. **36** Silvia Ziranek, *A Deliberate Case of Particula*rs, 1983, courtesy Locus+, Newcastle-upon-Tyne. **37** Anna Best, *Bring and Buy Sale*, 1995, courtesy Shave, Devon. **39** *New Rose Hotel* (installation view), 1995, courtesy Transmission, Glasgow. **40** Sonia Boyce, *...they're almost like twins*, 1995, courtesy Beaconsfield, London. **44** Helen Robertson, *RCI/1995/Liverpoo*l, 1995, courtesy Infanta of Castile, London (photo Matthew Thompson). **52** Spice Girl doll, 1997, TV still.

55 Peter Blake, Illustration to the cover of *Face Dances* (detail), 1981, courtesy Tate Gallery, London. **57** Richard Hamilton, *Swingeing London 67* (detail), 1968-69, courtesy Tate Gallery, London. **60** John Stezaker, *The End*, 1995, exhib. *The Impossible Document*, 1997, courtesy Camerawork, London. **63** Image of uncertain origin, courtesy Transmission, Glasgow.

65 *ZG*, no.7, cover image (*Autoportrait* by Cindy Sherman), 1983, published by *ZG* magazine, New York. **68/69** Roddy Buchanan, *Players who associate themselves with Italian Football by wearing Inter Milan and A.C. Milan shirts amid the dozens of local tops on display every night on the football parks of Glasgow,* work in progress 1995-, courtesy the artist.

71 Maureen Paley selecting James Brown at *Turning the Table*s, Chisenhale Gallery, 1997, courtesy Tim Noble and Sue Webster. 73 Mark Wallinger, *A Real Work of Art*, 1993-, courtesy Anthony Reynolds Gallery, London. 80 *Festival of Plagiarism*, 1989, courtesy Transmission, Glasgow. 83 Simon Yuill, *Be My Baby*, 1996, courtesy Elevator, Glasgow. 84 Sophie McPherson, inagural installation at Independent Studio, 1997, courtesy Independent Studio, Glasgow. 86 Patrick Jameson, *Phat Tower 2*, 1997, courtesy of the photographer, Glasgow. 89 Patrick Jameson and Andrew Whitaker, *Tower Blocks*, 1997, courtesy of the photographers, Glasgow. 91 Douglas Gordon, *Mute* (former Glasgow Green Station), 1990, courtesy Event Space, Glasgow. 94 Carina Weidle *Dog*, 1992, courtesy Infanta of Castile, London (photo Elizabeth Price). 97 Marty St James and Ann Wilson, title unknown, 1986, courtesy Locus+, Newcastle-upon-Tyne. 98 Simon Patterson, *J.P.233 in CSO Blue*, 1992, courtesy Transmission, Glasgow. 99 Richard Wilson, *One Piece at a Time*, 1987, courtesy Locus+, Newcastle-upon-Tyne. 100 Stuart Brisley, *Red Army II*, 1987, courtesy Locus+, Newcastle-upon-Tyne. 101 Jon Bewley, *True Confessions*, 1982, courtesy Locus+, Newcastle-upon-Tyne. 103 Helen Chadwick, *Blood Hyphen*, 1988, courtesy Locus+, Newcastle-upon-Tyne. 104 Matchbox Purveyors (Hinchliffe/Stephens), *Two Dimensional*, 1979, courtesy Locus+, Newcastle-upon-Tyne. 106 Stefan Gec, *Trace Elements*, 1990, courtesy Locus+, Newcastle-upon-Tyne. 112 Fran Cottell, *A Meeting Outside of Time*, 1988, courtesy Locus+, Newcastle-upon-Tyne (photo Beryl Graham). 115 Catherine Elwes *Menstruation II*, 1979, courtesy the artist. 116 Sarah Lucas, *Black and White Bunny*, 1997, courtesy Sadie Coles HQ, London. 119 Allen Jones, *Chair*, 1969, courtesy Tate Gallery, London. 121 Sarah Lucas, *Round About My Size*, 1997, courtesy Sadie Coles HQ, London. 124/125 Cathy de Monchaux, *Cruising Disaster*, 1996, courtesy Sean Kelly, New York. 126 Elizabeth Price, *G.U.N.*, 1993, courtesy Infanta of Castile, London (photo Elizabeth Price). 130 Damien Hirst, first published in *The Idler*, London, 1997, courtesy of the photographer, Chris Draper. 142 John Isaacs, *Say It Isn't So*, 1994, courtesy Saatchi Collection, London. 144 David Crawforth & Ian Hinchliffe, *Pin Drop* (Nosepaint at the Ministry of Sound), 1994, courtesy Beaconsfield, London.

Preface

Developments on the British art scene in the 1990s have been the cause of a good deal of controversy—and rightly so. When the audience for contemporary art increases sharply, when the art itself becomes media-aware and media-friendly, courts attention, and becomes seen in many places outside the gallery, the consequences are likely to be various, and fought over by critics. It can be difficult, however, to separate the hype about this new scene from serious critique, particularly at a time when critique can serve the cause of hype, and when hype takes as one of its standard slogans the repudiation of critique.

This book is the first attempt to examine seriously what lies behind the vast publicity surrounding the 'new British art', to see whether beyond the obvious changes wrought on the contemporary art scene, there have been deeper and perhaps longer-lasting transformations—of the way works of art are looked at and thought about, of the art audience, or of the market and art's relation to the mass media. It asks, indeed, whether such shifts amount to a fundamental change in the work itself.

To do this, it is necessary to look backwards and to subject the contemporary art world to analysis from different points of view. *Occupational Hazard* is not focused exclusively on the art of the 1990s. It carries diverse accounts of the origin and current condition of 'young British art' itself from Robert Garnett, Peter Suchin and Simon Ford. While Ford sees it as largely a media confection, lacking coherence and bound together by an interest in riding the wave of attention, both Garnett and Suchin, while critical of much young British art, think of its particular qualities as having roots in art education and in responses to the recession, which from 1990 onwards put the art market into prolonged hibernation.

But for a full understanding of the contemporary scene, it is necessary to look back beyond the watershed of the recession. John Roberts places the

recent British art in the context of a thirty-year history of critical thinking, particularly on the Left in Britain, about forms of popular culture. These were first kicked off by reactions to Pop art, and so the often-made link with young British art and the 1960s is not entirely arbitrary. Julian Stallabrass, in recounting the responses to a collaborative art event held on the site of the old pleasure ground at Vauxhall, examines the rise, from the eighteenth century onwards, of a middle-class art audience in Britain, and its continuing strength. The creation of a homogenous and, in some senses, elite audience separate from the work of art is used to illuminate the current relationship of viewer to work, and to highlight the activities of those who struggle to alter it.

The controversies which British art in the 1990s has provoked are reflected in the differences between the contributors to this book (indeed, in the differing views of the editors), who often find themselves in disagreement with one another. Many of the contributors have participated in disputes about the theoretical and artistic significance of this art which have been conducted in magazines and journals such as *Art Monthly, everything, New Left Review, Third Text* and *Variant*. The views of Mark Hutchinson and John Roberts, for example, which are broadly in sympathy with at least some aspects of 'young British art', come up sharply against Heidi Reitmaier's feminist analysis of the 'laddism' of the scene, Peter Suchin's scepticism about the depth of its content and strength of its radicalism, and Robert Garnett's discriminating view that currently there are only a few artists capable of evaluating their own work's relation to the new conditions in which art is produced.

The British art world is notoriously parochial and enclosed. Matthew Arnatt has contributed a view from within this scene, presenting its conventional opinions and statements in an insistent, repetitive fashion, to see if the reader is really prepared to buy it, all of it. If we take him at his word, are we prepared to accept the logical conclusion at which he arrives?

A pressing aspect of that parochialism is the extent to which the art world is centred on London. In his sobering account of the trials of artist-led organisations in Glasgow, Malcolm Dickson (who runs Street Level Photoworks in Glasgow) goes some way to providing a different perspective, as does Peter Suchin in his account of the 'young British art' and his praise for the Newcastle-based arts organisation, Locus+. Dickson argues that behind rosy views of the supposedly radical nature of artist-led spaces lie a good many

hard choices, as artists struggle with the market, funding bodies and the meaning of what it means to be 'alternative'.

It is an ideological matter that, wherever they live and work, artists as a group (rather than as individuals) tend to be left out of accounts of the art world. Naomi Siderfin, in the essay which gives this book its title, writes about the conditions in which contemporary art is produced. Any capitalist economy needs a mass of unemployed workers to draw upon in time of need, and to keep down the wages of those fortunate enough to be in work. Yet in the art world the proportions of those gainfully employed are minuscule when compared with those whose work does not pay. Behind the few stars of the show lie many thousands of professional artists without a profession, struggling to remain free enough of financial entanglements to produce their work, and serving as the unpaid research arm of the art market.

The hype surrounding multimedia, the Internet and computer art, while considerable, has so far had little impact on the equally publicity inflated parts of British contemporary art—its participants are much more likely to be found down the pub than on-line. Nevertheless, much interesting work is being made. The relationship of this work to the art object as a commodity is a provocative one, and if the two scenes are so separate, it may be because as yet no-one is sure how to sell this apparently immaterial and perfectly reproducible art. In theoretical writing, however, the hype has been unrelenting, as an academic industry has sprung up around this nascent field with remarkable rapidity, frequently spreading obfuscation. Siraj Izhar's pastiche of the high-density cyber-bollocks which often passes for analysis in this field is laced with compelling images about the impetus of a technology which, whether we like it or not, leads us by the hand.

This book is not, and does not claim to be, a survey of current British art. The editors are acutely aware that many aspects are neglected. This is in part because, as described above, its focus is intended to be more specific, but also because of the book's origins.

Occupational Hazard began life as a modest attempt to document an ephemeral art project. In 1993, the artist-led curatorial organisation Nosepaint, aware that its time-based activities would evaporate without some form of recording, commissioned Julian Stallabrass to write a piece documenting the week-long event, *Woodwork.* The resulting essay, included here in a reduced

form, went further than anyone expected in terms of content and length, and funds could not be found to publish it. From this predicament emerged the idea to publish a collection of writings from artists and critics which would document the fast and fleeting nature of art practice in the early 1990s, examining its content and origins. Now in the late 1990s, events have moved on, and the situation has developed into a media phenomenon which requires broad analysis. What we are publishing here are the views of a group of people—critics and artists—who comment not only on the publicly acknowledged scene itself, but also on alternative practices.

The accompanying visual material, much of it drawn from the archives of artist-led organisations, deliberately includes obscure work of which only a few may be aware. This is an attempt to illustrate the breadth of art practice in the UK, much of which has escaped critical attention but which nevertheless informs the art world as a whole.

Of these organisations, Locus+ holds the archives of the Basement Group and Projects UK. The work commissioned by Locus+, predominantly time-based and site-specific, has a clear line of descent from the earlier, performance-based activities of the Basement Group in the 1970s. The continuing strength of this practice is not unconnected with the dearth of conventional, high-profile exhibition spaces for contemporary art in the North East, making site-specific commissions a necessary alternative.

Similarly, the curators of Beaconsfield hold the archive of Nosepaint, which for three years ran monthly events where more than three hundred artists made installations and gave performances to a large, broad audience. The early Nosepaint events felt like a cross between a night-club and an art space. At these events people could listen, look and participate in art, certainly, but also drink, eat, dance and have a good time. The founders of Nosepaint, David Crawforth and Naomi Siderfin, went on to found with Angus Neill the organisation Beaconsfield, a permanent venue for the development of contemporary art in Vauxhall.

Shave is active as an annual workshop set in the English countryside for artists from all around the world. The inclusion in this book of the Shave mailing list, which contains both familiar and unfamiliar names, serves to remind us of the interlocking networks which create the international art world, and of Shave's agenda which is to provide the chance to re-evaluate one's

function as an artist within a broad context. It is also an anti-commercial gesture, made at a time when company secrecy is becoming a pressing concern, and the sale of information is big business.

The Infanta of Castile, founded by Marc Hulson, Elizabeth Price and Matthew Thompson, was an initiative which co-ordinated annual exhibitions in London, Liverpool and Leeds. IOC maintained a degree of ambiguity over the description of its activities as a group of artists or curators, the name of a venue or of a show. Hulson, Price and Thompson have subsequently worked with *accident*, based at a more permanently sited exhibition space in Shoreditch, London. Transmission in Glasgow holds an impressive archive which documents its crucial role on the Scottish—and indeed British—art scene in the 1980s and 1990s. The gallery retains both continuity and freshness through the artists' committee system under which it operates (the longest anyone can serve on the committee is two years, so there is a regular changeover of personnel). It continues to serve as a place where new talent can find an outlet.

The generation of artists considered in *Occupational Hazard* is often called, with some justice, 'Thatcher's children'—though, like all children, they had no choice in the matter of their parents. They have had to make their way in a world which believes it owes them nothing. Nevertheless, the ghost of political engagement lies behind many of the contributions to this book—whether it be of an explicitly leftist art, or radical carnival, or an overt and unironic feminism. While the views expressed here are diverse, there is a general feeling that the facile irony of much contemporary work is insufficient.

British art in the 1990s forms a particular and somewhat parochial scene which has been the product of a peculiar mix of influences, many of which are explored in this book. Despite its remarkable success in drawing attention to itself, the scene is fragile, dependent on the whims of the media and the vagaries of the economy. The hope is that with some of the critical tools provided here, a glimpse is given of what might be left when the bubble of hype bursts, as it surely will.

Britpopism and the Populist Gesture

Robert Garnett

London, according to the international media, is now 'the coolest city on the planet', and its art scene is swinging like nowhere else. The 'new British art' (nBa) has become something of a popular spectacle, and right across the media its 'success', alongside that of its counterparts in fashion, design, music and even gastronomy, is being celebrated to the point of tedium. What has not yet been much discussed, however, is what the 'popularity' of art might actually amount to: what are its broader meanings and functions; what kind of investment does the media have in art and, vice-versa, what is the nature of art's commerce with the popular media? Does art's high profile necessarily mean that its audience has expanded, and has any significant reconfiguration of the interface between high and low taken place within the new British art?

To address these questions adequately, however, it is necessary to go beyond some of the recent responses to the nBa phenomenon. One of these criticises what it takes to be its populist and 'careerist' bent, accusing it of a wilful and knowing elision of 'difficulty', theoretical, ideological or otherwise, and of simply being 'out for a good time'. Although this accurately describes much of the nBa, this view is confounded by a significant amount of work that has self-consciously resituated itself both in relation to 'theory', and to pleasure and 'the practice of the everyday'. Another theoretical response has been to incorporate a demotic, 'populist' element within theory itself, foregrounding the 'everydayness' of art, its articulation of the 'voice of the philistine' and its enactment of a return of the repressed dimensions of the 'low', the 'base' and the 'popular profane'. The problem of this approach, however, is that it over-privileges the 'everyday' and over-invests in the potential of the low to such an extent that it ceases to occupy a position from which to be disaffected with or critical of the everyday. These two theoretical views form opposite sides of the same equation and tend, consequently, to be too one-dimensional to distinguish adequately aspects of what is a heterogeneous and contradictory phenomenon. For there are two distinct tendencies within the new British art: the first, and by far the least numerous, within which the 'everyday' is appropriated without serving to fetishise the 'low' and affirm the popular; the second, and by far the most numerous, in which a 'scene art' of cynical and attention-seeking populist gestures predominates.

This distinction can be further elaborated via a discussion of how the new scene, of which both tendencies are in different ways a product, developed.

216:217

Acknowledgements

The editors gratefully acknowledge the financial assistance of the
Henry Moore Foundation.

Special thanks are due to David Crawforth for his involvement in the early
stages of this project. Thanks also to Jon Bewley, Simon Herbert, Toby Webster,
Alexandra Bradley, Kitty Hauser, Anna Best, Ella Gibbs, Marc Hulson, Matthew
Thompson and Elizabeth Price.

Colophon

Edited and Produced by
Duncan McCorquodale,
Naomi Siderfin and Julian Stallabrass

Copy Edited by
Maria Wilson

Designed by
Ian Noble

© 1998 Black Dog Publishing Limited, the authors and artists.

Printed by Graphite Inc. Limited in the European Union.

Black Dog Publishing Limited P.O. Box 3082
London NW 1 UK
Telephone 00 44 171 380 7500

220:221

Related Titles from
Black Dog Publishing Limited

Desiring Practices: Architecture, Gender and the Interdisciplinary
Edited by Duncan McCorquodale, Katerina Ruedi and Sarah Wigglesworth

Ground Control: Technology and Utopia
Edited by Lolita Jablonskiene, Duncan McCorquodale and Julian Stallabrass

Acradia Revisted: The Place of Landscape
Vicki Berger and Isabel Vasseur

Low Tide: Writing on Artists' Collaborations
Jeni Walwin

wold Way
wood
nesburg 2196
Africa

 Allison
mans Cottage
tree Lane
ady Oxon
PZ

 Annand
ckitt Road
n

utno
 Rakica 15
ad
00

ne Baker
antock Road
iill Hill

Balcer
tage Close
n
RA

lch
pool
field
water
set
G

arsi
dova 27
na 61008
ia

 Bartley
of Mutton Road
nbury
set
HE

ayer

Beaworthy
Devon
EX21 5PW
UK

Wayne Bennett
1 West Farm Cottages
Toller Whelme
Dorset
DT8 3NU
UK

Amanda Benson
26A Penshurst Rd
London
E9 7DT
UK

Anna Best
Flat 2
48 Harleyford Road
London
SE11 5AY
UK

Randy Bloom
482 Broome Street
New York 10013
New York
USA

Michael Bramwell
295 York Street no. 1c
Jersey City
New Jersey 07302
USA

David Brody
327 Greenwood Acres
De Kalb
Illinois 60115
USA

Martin Brunsden
c/o Grays Farm
Toller Porcorum
Dorset
UK

Rupert Carey
Top Flat
21 Gillian Street
London
SE13 7AH
UK

Apt 731
75017 Paris
France

Nai Wee Chng
8 Camborne Road
Singapore
1129 Malaysia

Elizabeth Condon
105 Bowery
Third Floor
New York 10002
USA

Sacha Craddock
89 Great Russell
Street
London
WC1
UK

Andrea Crociani
Via Ugo Bassi 30
20159 Milano
Italy

Sean Cummins
331 Amhurst Road
London
N16
UK

Alexandra
Dementieva
177 Rue Saint
Bernard
1060 Brussels
Belgium

Ajay Desai
296 Defence Colony
New Delhi 11 0024
India

Paul Dignan
8 Woodhaven Terrace
Wormit
Fife
Scotland
DD6 8LD
UK

Veryan Edwards
PO Box 41616
Gaborne

Mary Evans
1st Floor Unit 7
36 - 38 Peckham
Road
London
SE5 8PX
UK

Sarah Feinmann
10 Newton Road
Urnston
Manchester
M31 3AE
UK

Judith Frost
27 Downside
Crescent
London
NW3 2AN
UK

John FitzMaurice
129a Newington
Green Road
London
N1 4RA
UK

Alexandra Fontoura
20a Ropery Street
London
E3 4QF
UK

Rob la Frenais
8 Arrow House
Phillip Street
London
N1 5NX
UK

Lynn Fulton
331 Amhurst Road
London
N16
UK

Helen Ganly
26 Hilltop Road
Oxford
OX4 1PE
UK

Ella Gibbs
unit 1

E2 9DG
UK

David Gittings
121 Sussex Way
London
N7
UK

Fay Godwin
6 Toot Coastgaurd
Pett Level Hastings
East Sussex
TTN35 4EN
UK

Nick Gurney
162a Franciscan Roa
London
SW17
UK

Mark Hedger
c/o 28 Downsland
Drive Brentwood
Essex
CM14 4JT
UK

Simon Hiscock
45Illiffe Street
London
SE17
UK

Vanessa Jackson
169 Bermondsey
Street
London
SE1 3LN
UK

Mamuka Japharidze
Tamarashvili 10-14
Tbilisi 380077
Republic of Georgia

Jacob Jari
c/o British Council
Kaduna
Nigeria

Sarah Kent
Time Out
Universal House
251 Tottenham Court